THE POST-IMPRESSIONISTS

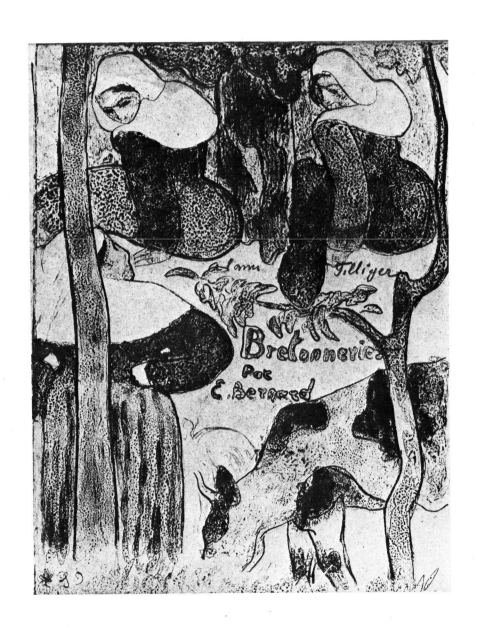

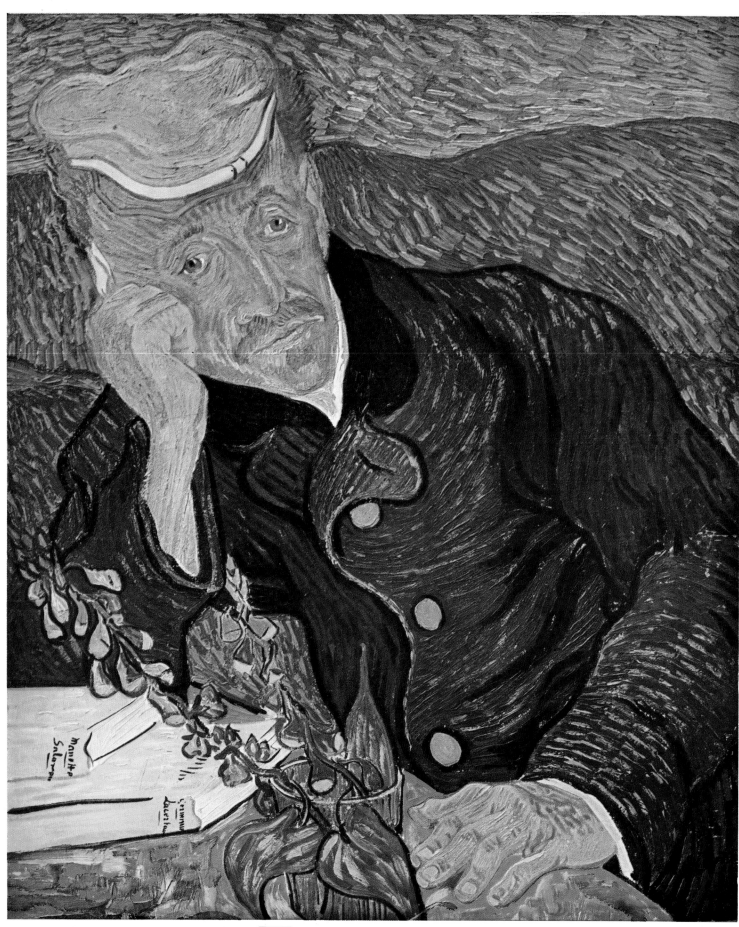

1 VINCENT VAN GOGH: *Portrait of Dr Gachet*. 1890
Oil on canvas, 26 × 22½ in (66 × 57 cm).
New York, Private Collection

THE
POST-IMPRESSIONISTS

Belinda Thomson

PHAIDON · OXFORD
PHAIDON UNIVERSE · NEW YORK

Published in Great Britain by Phaidon Press Limited,
Musterlin House, Jordan Hill Road, Oxford OX2 8DP

ISBN 0 7148 2662 6

A CIP catalogue record for this book is available from the
British Library

Published in the United States of America by Phaidon Universe,
381 Park Avenue South, New York, N.Y. 10016

Library of Congress Cataloging-in Publication Data

Thomson, Belinda.
 The post-impressionists / Belinda Thomson.
 p. cm.
 ISBN 0-87663-772-1
 1. Post-impressionism (Art) 2. Painting, Modern—19th century.
 I. Title.
 ND192.P6T48 1990
 759.05'6—dc20 90-30270
 CIP

First published 1983
Second edition (paperback) 1990

© 1983 by Phaidon Press Limited

Printed in Singapore under co-ordination of C S Graphics Pte Ltd

The Publishers are grateful to all museums, institutions and private collectors who have given permission for the works of art in their possession to be reproduced. They have endeavoured to credit all known persons holding copyright or reproduction rights to the illustrations in this book.

The Publishers should like to acknowledge the following sources: Albi, Musée Toulouse-Lautrec et Galerie d'Art Moderne, 56, 76 and 142; Alençon, Musée de la Maison d'Ozé (J.F. Denis collection), 44 and 49; Amsterdam, National Museum Vincent van Gogh, 19, 92, 101, 108, 109, 116, 118, 146, 155, 157 and 158; Amsterdam, National Museum, 42 and 129; Antwerp, Musée Royal des Beaux-Arts, 15 and 120; Basel, Kunstmuseum, 13 and 161; Basel, Kunstmuseum, Dr h.c. Emile Dreyfus Foundation, 103; Berlin, National Gallery, 165; Berne, Kunstmuseum, 18; Boston, Museum of Fine Arts, 46, 156 and 176; Bremen, Kunsthalle, 163; Brest, Musée Municipal des Beaux-Arts, 59 and 93; Brussels, Musées Royaux des Beaux-Arts de Belgique, 12, 45, 107 and 149; Buffalo, Albright-Knox Art Gallery, 2; Cambridge, Mass., Courtesy of the Fogg Art Museum, Harvard University. Bequest of Meta and Paul J. Sachs, 98; Chicago, Art Institute of Chicago, 20, 29, 65, 138 and 144; Cleveland Museum of Art, purchase from the John L. Severance Fund, 81; Copenhagen, the Ordrupgaard Collection, 74; Detroit, Mrs Walter B. Ford II Collection, 31; Dublin, George Morrison Archive, 128; Edinburgh, National Gallery of Scotland, 36, 89, and 99; Essen, Museum Folkwang, 152; Hartford, Conn., Wadsworth Atheneum, 41; Jacksonville, Cummer Gallery of Art, 151; Lausanne, Collection Josefowitz, 37, 50, 51 and 178; Lisbon, Museu Calouste Gulbenkian, 6; London, by courtesy of the Trustees of the British Museum, 24, 28, 78, 145, 173 and 177; London, Home House Society Trustees, Courtauld Institute Galleries, 64; London, Lefevre Galleries, 14; London, National Gallery, 3, 11, 125 and 135; London, Piccadilly Gallery, 171; London, Tate Gallery, 123 and 126; Lyon, Musée des Beaux-Arts, 7; Munich, Bayerische Staatsgemäldesammlungen, 97; New York, Metropolitan Museum of Art, 5, 9, 96, 102, 111, 122, 164 and 179; New York, Museum of Modern Art, Lillie P. Bliss Collection, 91; New York, Museum of Modern Art, gift of Mrs Saidie A. May, 54; New York, Museum of Modern Art, Grace Rainy Rogers Fund, 38; New York Public Library, Astor, Lenox and Tilden Foundations, S.P. Avery Collection, Arts, Prints and Photographs Division, 30 and 75; Nice, Musée des Beaux-Arts, 143; Otterlo, Rijksmuseum Kröller-Müller, 43 and 113; Oxford, Ashmolean Museum, 153 and 154; Paris, Bibliothèque Nationale, 39, 47, 55, 70, 71, 82 and 84; Paris, Musée du Louvre, 1, 8, 27, 32, 48, 52, 57, 67, 69, 77, 79, 88, 94, 105, 106, 112, 119, 121, 124, 132, 137, 139, 140 and 147; Paris, Musée du Petit Palais, 66 and 68; Paris, Musée Auguste Rodin, 23; Philadelphia Museum of Art: the Mr and Mrs Carroll S. Tyson Collection, 22; Prague, National Gallery, 26 and 115; Quimper, Musée Municipal des Beaux-Arts, 40; Rotterdam, Museum Boymans van Beuningen, 62 and 159; San Francisco, the Fine Arts Museums of San Francisco, 130; Shelburne, Vermont, Shelburne Museum, 4; The works of Bernard, Denis and Vuillard are © DACS 1990. Those of Bonnard and Ensor are © ADAGP, Paris/DACS, London 1990; Washington, National Gallery of Arts, 25, 33 and 148; Washington, the Phillips Collection, 90; West Palm Beach, Florida, Norton Gallery and School of Art, 117; Winterthur, Oskar Reinhart Collection, 131.

Contents

To my parents, John and Easta Greaves

Acknowledgements

I would like to thank the many scholars, too numerous to mention by name, from whose teaching, conversation and encouragement I have benefited over the years, and in particular my colleagues at the Open University for enabling me to carry out the research for this book and continually forcing me to revise my ideas. I am grateful to the people who, in practical ways, made the writing of this book possible—Ian and Mary Thomson, Susan Paine, Gillian Greaves, Julie Renshaw—and to Rupert who tolerated it all with remarkable patience! My main debt of thanks goes to my husband Richard who always offered constructive critcism and sustained me with faith and enthusiasm at every stage of the production. And finally my thanks to the editor, Bernard Dod, for his patience and helpful suggestions.

Introduction–Post-Impressionism?

For seventy years now it has been accepted practice to refer to the two decades of avant-garde artistic experimentation in France at the end of the last century—which, broadly speaking, form the subject of this book—by the term Post-Impressionism. The irony of this state of affairs is that most of the artists designated by the term did not think of themselves as being 'Post-Impressionists' first and foremost, and probably would not even have recognized themselves under that heading. Georges Seurat, Vincent Van Gogh, Paul Gauguin and Paul Cézanne (figs. 1, 2, 3), to take the four artists who created the most significant paintings during the period, were dead long before 1910 when the term was first coined. Post-Impressionism was not one of those smear-words such as Impressionism or Fauvism, invented by witty French journalists on first seeing the works of the artists concerned, words which caught the public imagination and were subsequently accepted and used by the artists themselves. On the contrary, it was the invention of an academic, cultured, but exasperated English critic, Roger Fry, faced with the difficulty of presenting a haphazard exhibition of recent continental art to an inexperienced English audience. It was *faute de mieux* that Fry hit in 1910 upon the title 'Manet and the Post-Impressionists'.

As used by Fry, Post-Impressionism encompassed a broad and cosmopolitan range of modern art: it grouped Cézanne and Gauguin with Picasso and Matisse, Denis and Vuillard with Gilman and Lewis. For the sake of coherence and manageability I have confined the present study to the immediate aftermath of Impressionism in France and to the rough chronological limits 1880 to 1900, but this is not to suggest that responses and reactions to Impressionism were so confined or that they came to an abrupt end as the twentieth century dawned.

Although the term Post-Impressionism has been and continues to be found useful in the absence of a workable alternative, in many respects it is problematic and unwieldy as a style label. On the surface it does no more than date the art it covers as 'coming after' Impressionism. Its drawback is that it suggests a firm and purposeful avant-garde movement, caused and unified by a relationship to a fixed style called Impressionism. In the light of contemporary thinking about the period, it is becoming clear that even in France such a movement never existed. Of course there were links, both at a personal and a stylistic level, between the original Impressionists and the progressive artists who succeeded them in the Paris of the 1880s and 1890s. The example of the Impressionists' eight group shows, held between 1874 and 1886, may well have been the spur to the various subsequent attempts to form close-knit avant-gardes and to find a space and a market for modern art. Certainly many of the freedoms the Impressionists had fought for in the 1860s and 1870s in terms of paint application, colour, choice of subject and working procedure became part of the artist's stock-in-trade in the 1880s. But it is misleading to see the artists of this period as drawn together before all else by their awareness of Impressionism. Other equally

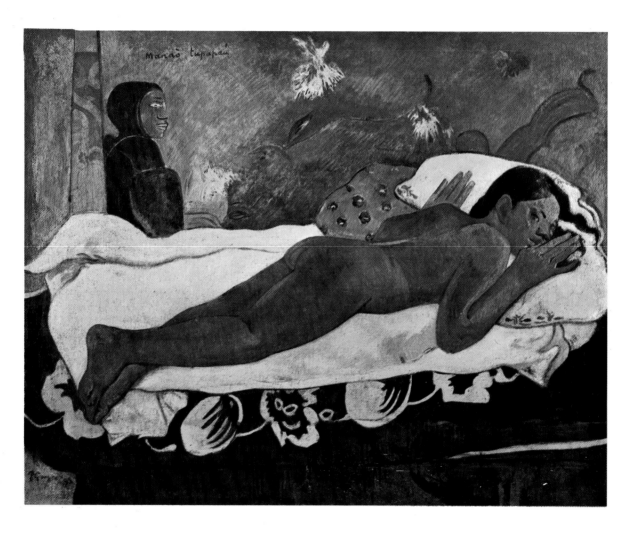

important factors were at work. Impression-
ism itself was far less of a stable entity, that
could be accepted or rejected, than is usually
allowed. By the 1880s its chief exponents
were themselves evolving new working pro-
cedures and responding, in some degree, to
the same intellectual and stylistic influences
as the younger generation. They were no
more immune than their successors to
changes in social, economic and political
circumstances.

What we find, then, in Paris-based art of
the late nineteenth century is a wealth of
talent, ambition, and drive to succeed, a
great variety of technical and stylistic innova-
tion, and a surfeit of theory. There were
complicated personal relationships, bitter
rivalries, arguments, feuds and self-imposed

exiles, groupings, regroupings and scissions.
Few periods offer the art historian such
beguilingly colourful biographical material
or such fascinating documentation as the
inexhaustible correspondence of Pissarro,
Gauguin and Van Gogh or the perspicacious
art criticism of Félix Fénéon and Maurice
Denis. The initial impression is a shifting
and perplexing one, and in an effort not
to gloss this over I have tended to make
sparing and cautious use of the term Post-
Impressionism. But at the same time there
are dominant issues and prevailing currents
beneath the chaos of events, images and
styles, and in an attempt to clarify these I
have found it necessary to abandon the
straightforward chronological narrative and
to adopt a more flexible, thematic approach.

2
PAUL GAUGUIN: *Manao
Tupapau, The Spirit of the
Dead Keeps Watch.* 1892. Oil
on canvas, 28¾ × 36 in
(73 × 92 cm). Buffalo,
Albright–Knox Art Gallery

3
PAUL CÉZANNE: *The Large Bathers.*
1906. Oil on canvas,
82 × 99 in (208.3 × 251.5 cm).
Philadelphia Museum of Art

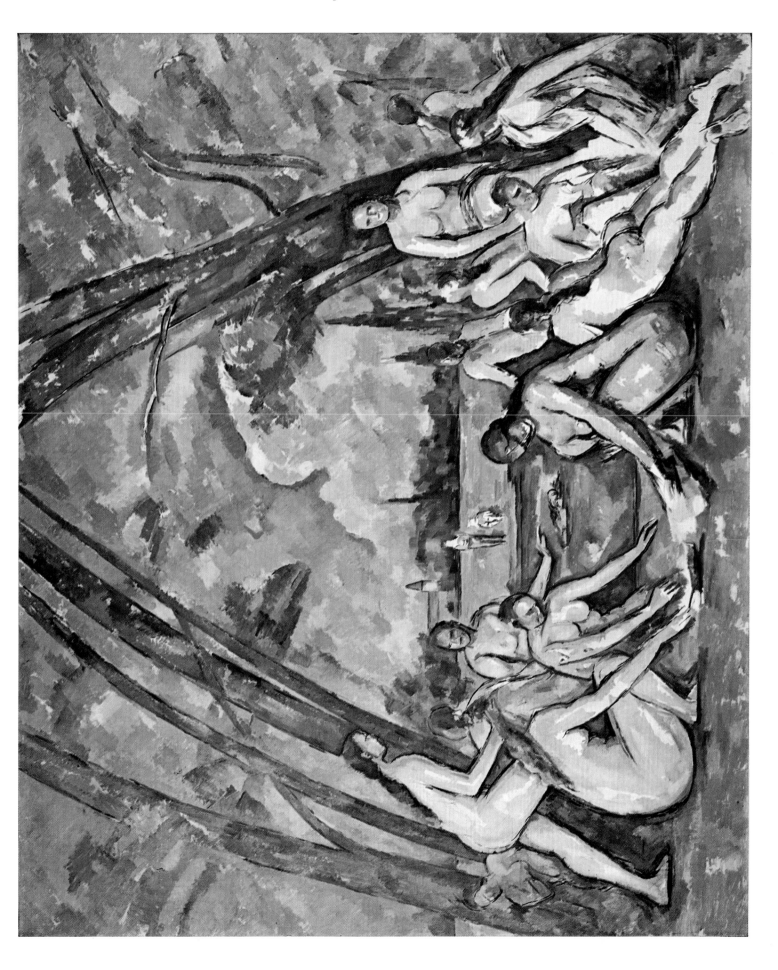

1 Exhibiting Forums Old and New

One way of establishing the main issues of the Post-Impressionist era is to look at some of the avant-garde exhibitions which punctuated the last two decades of the nineteenth century. In any era exhibitions tend to provide succinct and useful indications of the main stylistic trends and of the critical and public perception of those trends. They also throw light on the ways in which artists organized themselves and set about presenting new work to the potential buyer. But before we come to look in detail at four such exhibitions, it is worth reminding ourselves of the available options. What were the normal exhibiting forums in which an artist might seek to make his name in late nineteenth-century Paris?

The annual Salon still offered the seal of official approval to those artists whose works were accepted. Works that were shown there had a greater chance of being sold. For the vast majority of the Parisian bourgeoisie this was the only artistic market-place where they would venture to buy. Renoir, for one, complained of this state of affairs; he claimed that for every fifteen collectors prepared to invest in a work outside the official exhibition (and this figure is presumably some guide to the small number of regular Impressionist buyers in the 1870s) there were eighty thousand only prepared to buy work from the Salon. It was for such commercial reasons that both Monet and Renoir opted to send pictures to the Salon in 1880, a mere six years after the first independent Impressionist show. This move, which was seen by some of their colleagues, Degas in particular, as a compromise of their artistic

principles, forced them to produce pictures of a greater degree of finish. The *Ice Floes* (fig. 4) was in fact rejected by the Salon jury, despite being painted in what Monet called a 'discreet' manner, and only its more polished companion picture *Lavacourt* was accepted.

By 1880 the Salon jury was beginning to accept pictures that would previously have been rejected on technical grounds. A certain freedom of paint handling and lightening of overall tonality was allowed in the pictures of Jules Bastien-Lepage, for example, whose success was such that his unexpected death in 1884 was almost cause for national mourning. His *Joan of Arc* (fig. 5), shown at the Salon of 1880, was admired not only because its subject struck a chord of national pride but also because of the intense expression on the young model's face. The minutiae of naturalistic detail in the foreground vegetation, although criticized as excessive by some, probably prevented the splashy handling in other areas from being dismissed as impressionistic. At the same time there was a new vogue at the Salon for modern-life subjects of a kind previously judged distasteful. Paintings of modern urban or rural life by artists such as Pascal Dagnan-Bouveret (fig. 6) or Jean Béraud, because they were enlivened with anecdotal detail and rendered with a hitherto unheard-of naturalism made possible in an age when photography had become a widely available painter's tool, were now preferred by the Salon-going public to the traditional historical or mythological subjects. Puvis de Chavannes's vast decorative paintings (figs. 7, 17), with their idealizing, synthetic approach

4
CLAUDE MONET: *Ice-Floes.*
1880. Oil on canvas,
38¼ × 59¼ in
(97 × 150.5 cm). Shelburne,
Vermont, Shelburne
Museum

5
JULES BASTIEN-LEPAGE:
Joan of Arc. 1879. Oil on
canvas, 100 × 110 in
(254 × 279.4 cm). New York,
Metropolitan Museum of Art

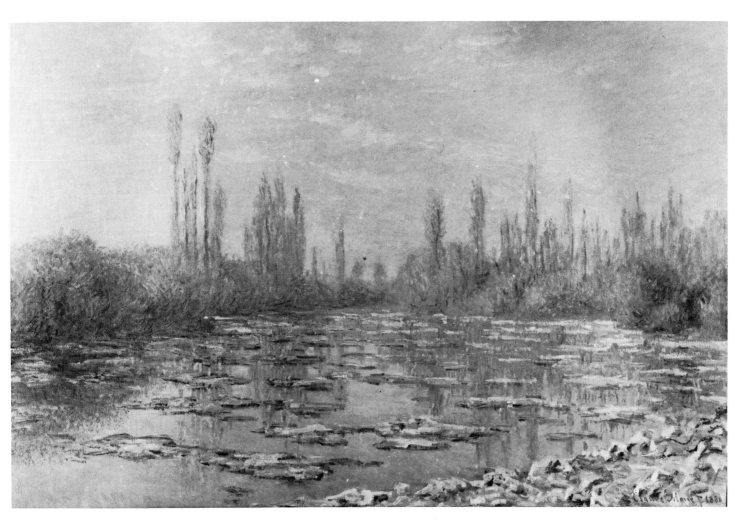

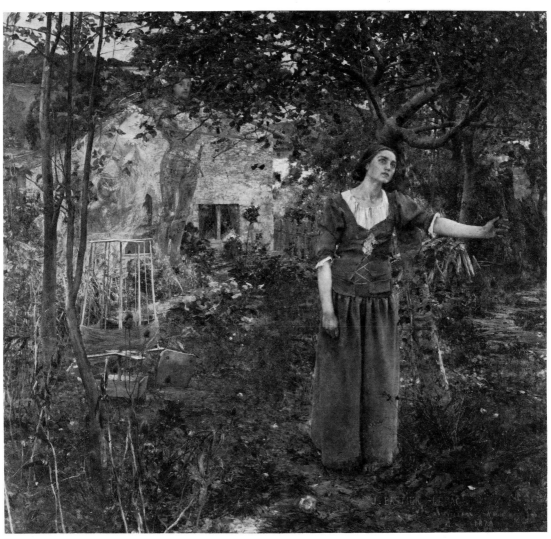

to reality, now stood out as belonging to a different aesthetic.

Because of the initial anti-establishment attitude of the Impressionists it is too often assumed that all avant-garde artists in the late nineteenth century rejected the Salon and the idea of exhibiting there out of hand. But it is worth remembering that to Vincent Van Gogh in the early 1880s the Salon still counted as the main annual event of the Parisian art world, and the peasant naturalism of the kind popularized by Bastien-Lepage and other followers of Jean-François Millet seemed the most significant modern painting around. And for the provincial Cézanne, despite his involvement with the Impressionist group in the 1870s, the Salon continued to pose a real challenge. He regularly sent in work (fig. 8) which was as regularly rejected, but by the mid-1880s he stopped attempting to exhibit altogether, having apparently lost his desire to impress the critics and having less need than Monet and Renoir to attract new patronage. Another artist who had private means and little necessity to find a market was Georges Seurat, but with his conventional academic training it was natural

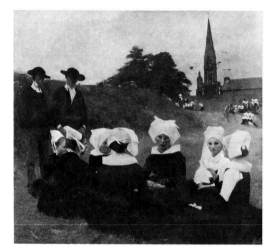

6
PASCAL DAGNAN-BOUVERET:
Breton Women at a Pardon.
1887. Oil on canvas,
49¼ × 55½ in
(125 × 141 cm). Lisbon,
Calouste Gulbenkian
Foundation

7
PIERRE PUVIS DE
CHAVANNES: *The Sacred Grove.*
1884. Oil on canvas,
181½ × 419½ in
(460 × 1040 cm). Lyons,
Musée des Beaux-Arts

8
PAUL CÉZANNE: *Portrait of
Achille Emperaire.*
c. 1866-8. Oil on canvas,
78¾ × 48 in (200 × 122 cm).
Paris, Musée d'Orsay

for him to submit a drawing (fig. 9) and then his first major painting, *Une Baignade, Asnières* (fig. 11), for adjudication by the Salon jury and public. Had he wished he could have played the system, moving up the rungs of the official hierarchy with his studio colleague Edmond Aman-Jean (fig. 93), for success at the Salon was as much a matter of having been taught by a voting member of the jury and emulating his style as it was of

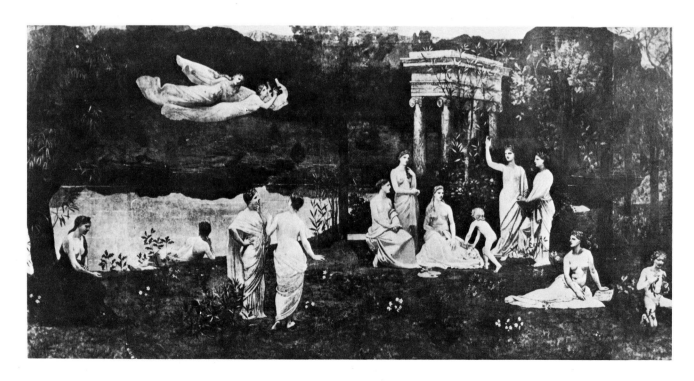

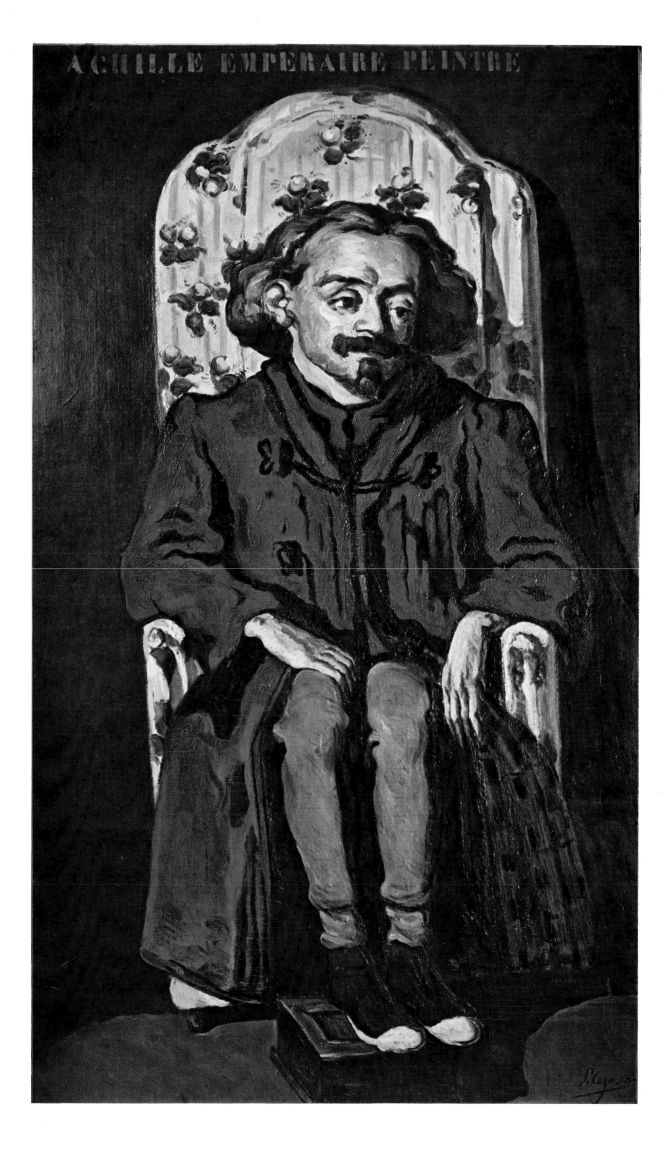

conforming to some abstract official standard of acceptability. Corruption was rife, or so it seemed to those outside. Despite the rejection of *Une Baignade* in 1884, Seurat's working methods and his rhythm of production continued to be essentially those of a Salon artist. Over the winter he worked in the studio scrupulously preparing his major exhibition paintings with preliminary drawings and oil sketches; in the summer he left Paris and pursued *plein-air* studies in the provinces.

One of the main disadvantages of the Salon which had led the Impressionists to seek their own exhibition spaces in the 1870s was its poor hanging arrangement (fig. 10). Paintings were hung several rows deep and a lesser-known or controversial artist was likely to find his work 'skied', that is, hung so high as to be virtually invisible. There was no attempt to hang similar works together, so those that departed from the norm in terms of colour or finish tended to seem even more outlandish in the company of conventional canvases. In short, the artist had no say over the display of his own work. This consideration and the ever-present risk of seeing their works rejected outright led a number of younger artists in the 1880s to form their own unrestrictive exhibiting organizations. Founded in 1884, the so-called *Société des Artistes Indépendants* held annual shows after 1886 in the Pavillon de la Ville de Paris, a construction dating from the 1878 Universal Exhibition. These were deliberate rival attractions to the official Salon, falling earlier in the year (the official Salon being held from May to June, the *Indépendants* from March to April) and occupying a similarly central site off the busy Champs-Elysées. The key distinctions were the lack of a jury and the freedom artists had to show a number of their works together, whatever the medium, framed according to their own tastes. Odilon Redon, for example, one of the group's founder members, regularly sent in batches of his *noirs*, charcoal drawings. Seurat showed his *Baignade* there in 1884, and from 1886 onwards he and his Neo-Impressionist followers enjoyed the particu-

9
GEORGES SEURAT: *Portrait of Aman-Jean.* 1883. Conté crayon on paper, 24½ × 18¾ in (62.2 × 47.6 cm). New York, Metropolitan Museum of Art

10
View of the official Salon in 1879.

11
GEORGES SEURAT: *Une Baignade, Asnières, Bathing at Asnières.* 1883–4, reworked 1887. Oil on canvas, 79 × 118½ in (201 × 301.5 cm). London, National Gallery

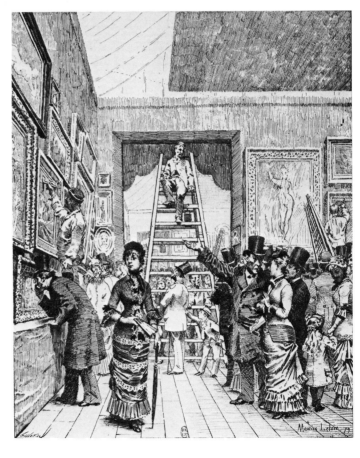

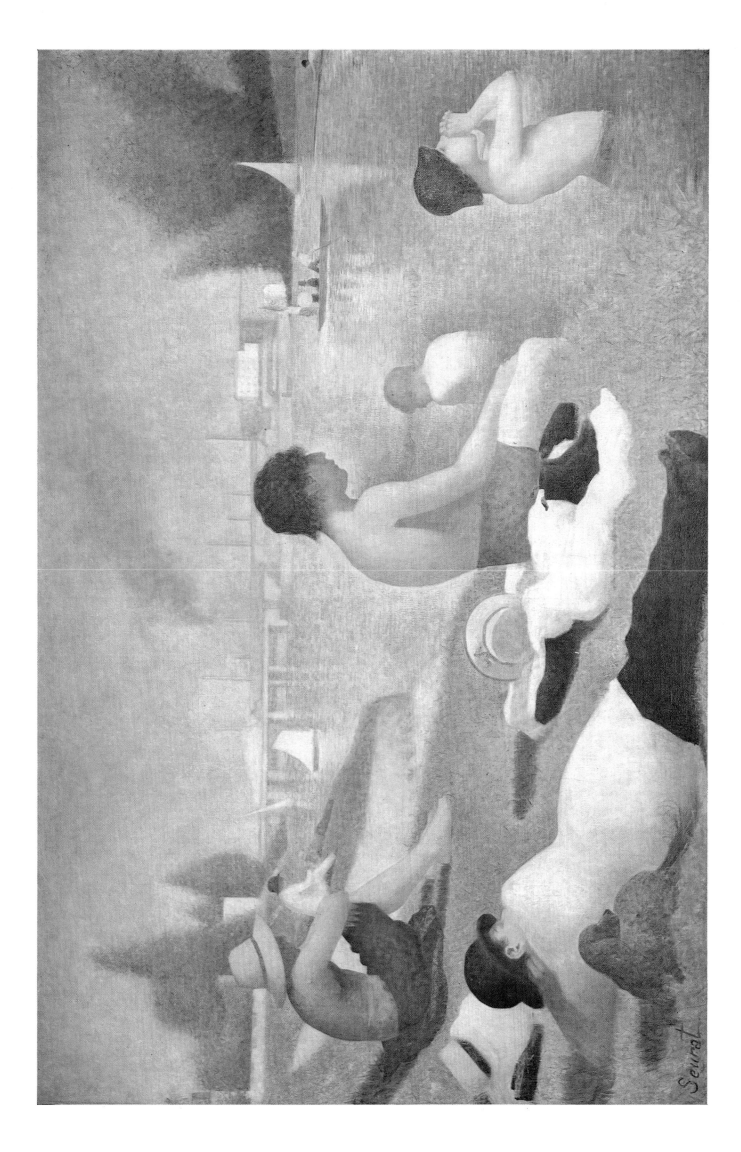

lar advantage of a room to themselves, thanks to the influence of two of their number, Albert Dubois-Pillet and Paul Signac (fig. 14), both of whom served on the hanging committee. It was this dominance of the Neo-Impressionists that deterred Gauguin from sending his works to an *Indépendants* Salon, but he was the exception. Most of the ambitious, progressive artists who came to the fore in this period found that the *Indépendants* Salon and the critical attention it aroused offered the most scope for ensuring that their work was noticed.

A similar enterprise to the Paris *Indépendants* was the Brussels-based *Vingt* group, which held an annual exhibition in February from 1884 onwards (fig. 12). The twenty founder members who gave the group its name were of no single stylistic creed and comprised artists as varied as James Ensor and Fernand Khnopff (figs. 13, 15). The *Vingt* shows were organized by Octave Maus with the help of the painter Théo Van Rysselberghe and the poet Emile Verhaeren. They soon gained a reputation for adventurousness by seeking the participation of promising, and often little-known, foreign artists as well as of more established figures.

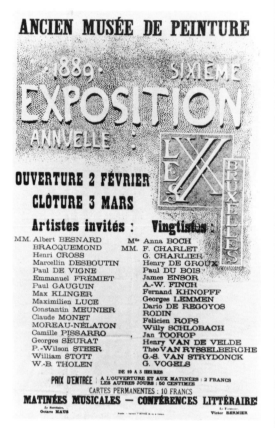

12
THÉO VAN RYSSELBERGHE: Poster for the Sixth Exhibition of *Les Vingt*. 1889. 9½ × 5½ in (24 × 14 cm). Brussels, Musées Royaux des Beaux-Arts, Archives de l'Art Contemporain

13
FERNAND KHNOPFF: *Memories*. 1889. Pastel on paper, 50 × 78¾ in (127 × 200 cm). Brussels, Musées Royaux des Beaux-Arts

14
PAUL SIGNAC: *Le Clipper, Asnières*. 1887. Oil on canvas, 18⅛ × 21¾ in (46 × 55 cm). London, Lefevre Galleries

15
JAMES ENSOR: *The Intrigue*. 1890. Oil on canvas, 35½ × 59 in (90 × 150 cm). Antwerp, Musée Royal des Beaux-Arts

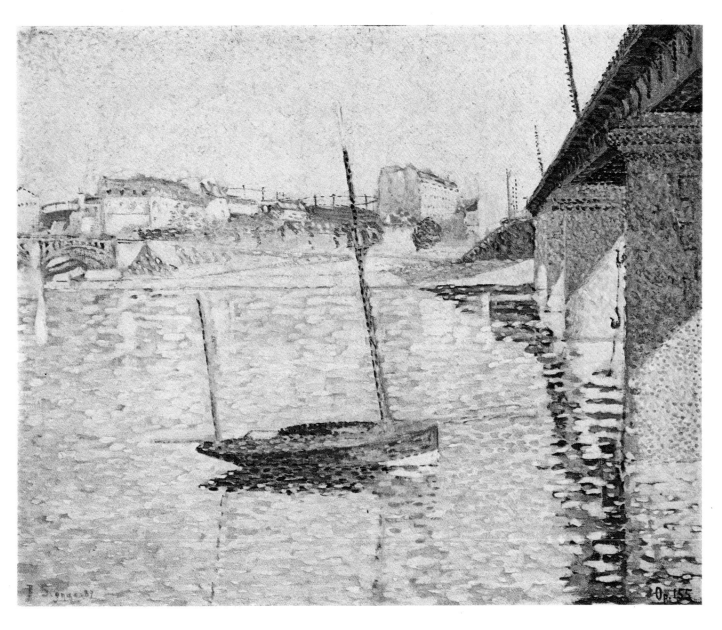

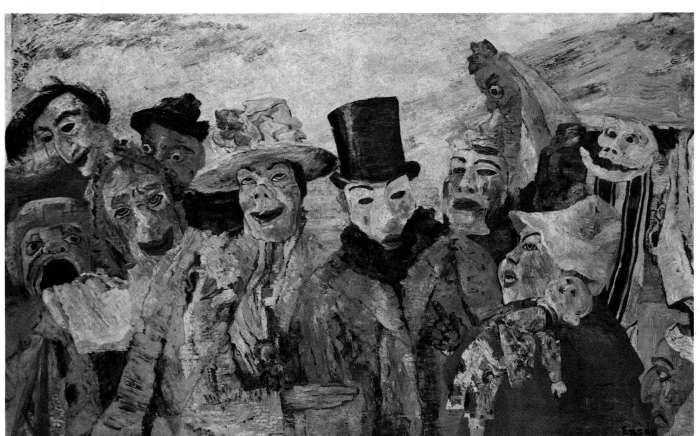

Van Gogh and Toulouse-Lautrec had good reason to be grateful to the Vingtists, the latter because he was spotted remarkably early in his career and invited to exhibit in 1888, the former because he made his only sale of a major picture at the *Vingt* exhibition in 1890. Seurat, Gauguin, and even the recalcitrant Cézanne were quick to take up Maus's invitations.

The 1890s saw two further attempts to break the monopoly of the official Salon, with a resulting erosion of the boundaries between independent and official art. The *Société Nationale des Beaux-Arts*, founded jointly by the four influential figures Meissonier, Puvis de Chavannes, Carrière and Rodin, opened the doors of its more liberal Salon for the first time in 1890 in a pavilion on the Champ de Mars. One of the main attractions of the first show was Puvis's *Inter Artes et Naturam* (fig. 17), destined to complete his decorative cycle of murals for the museum at Rouen. Foreign contributors were encouraged, and in 1891 included the Swiss artist Ferdinand Hodler with his large frieze-like composition *Night* (fig. 18). A more surprising contributor that year was Gauguin, who showed his carved wooden bas-relief *Soyez Amoureuses* (fig. 46) and a number of ceramics, making the most of the new salon's encouragement of the decorative arts. A second significant splinter group, which truly summed up the anti-naturalist

mood of the times, was the so-called Mystic Order of the Rose+Croix, founded by the novelist and Symbolist entrepreneur Joséphin Péladan. It held the first of six exhibitions at the Galerie Durand-Ruel in March 1892, and scored a considerable success with the smart public if not with the critics. Again a certain internationalism was the rule, and Péladan managed to draw in foreigners such as Hodler and the Belgian Symbolist Fernand Khnopff, as well as

16
ALEXANDRE SÉON: *The Despair of the Chimera.* 1890. Oil on canvas, 25½ × 13 in (65 × 33 cm). Paris, Collection Flamand-Charbonnier

17
PIERRE PUVIS DE CHAVANNES: *Inter Artes et Naturam.* 1890. Oil sketch on canvas for the mural in Musée de Rouen, 25½ × 67½ in (64.8 × 171.5 cm). Ottawa, National Gallery of Canada

18
FERDINAND HODLER: *Night.* 1890. Oil on canvas, 45¾ × 117¾ in (116 × 299 cm). Bern, Kunstmuseum

19
VINCENT VAN GOGH: *Fountain in the Garden of St Paul's.* 1889. Pen, ink and chalk on paper, 19½ × 18⅛ in (49.5 × 46 cm). Amsterdam, Rijksmuseum Vincent Van Gogh

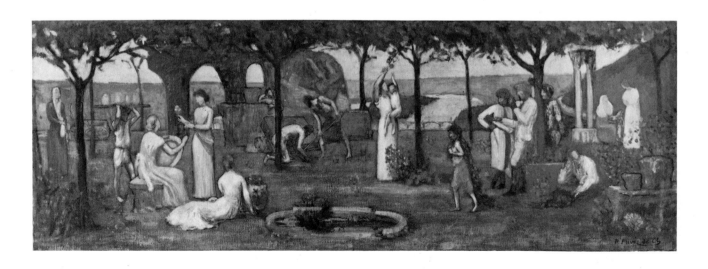

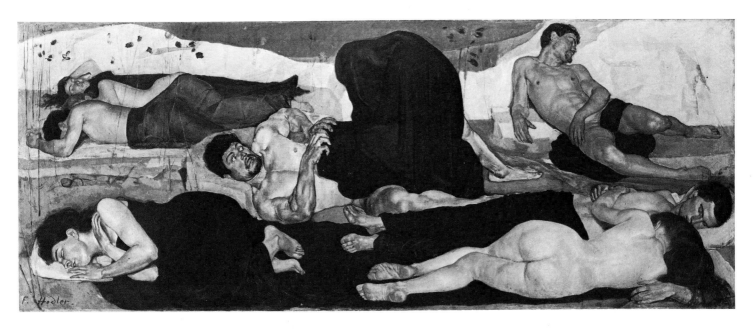

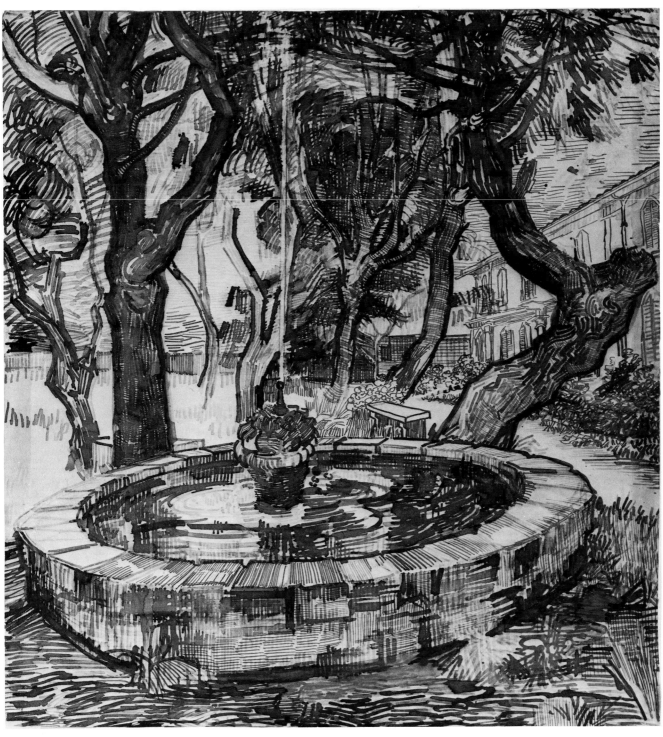

native artists such as Alexandre Séon (figs. 13, 16).

Despite their occasional claims to the contrary, for most artists of the period the ultimate if not the immediate aim of exhibiting was to find buyers. And while large organized exhibitions became critical talking points and created the initial contacts with the public, it was perhaps more important in the long run for artists to establish a good relationship with a dealer. Dealers after all could provide exhibition space throughout the year and spend the necessary time and trouble persuading clients to risk their money. The rise of commercial picture dealers with entrepreneurial methods was a new factor in the all-important relationship between artist and public in the late nineteenth century.

Paul Durand-Ruel, established as the Impressionists' dealer in the 1870s, suffered a setback in 1882 as a result of a severe Stock Market slump and the loss of his financial backer. He quickly recovered his position however and continued to be the main lifeline for Monet, Pissarro, Sisley, and Renoir throughout the later 1880s and the 1890s. He held the first of several one-man shows for each artist in 1883, marking a new phase of individualism in the evolution of the Impressionist movement (figs. 20, 21, 22). But the monopoly he would have liked to hold over their works was broken in 1885 when a rival dealer, Georges Petit, invited Monet and Renoir to take part in his prestigious 'International Exhibition'. Petit owned the finest gallery space in Paris, according to one observer in 1889, a spacious, top-lit and lavishly decorated room in the fashionable rue de Sèze; his successive shows became an essential event in the social calendar. Even Pissarro judged it expedient to overcome his suspicion of Petit's style of operating and accepted the dealer's invitation to take part in one of these shows in 1887. This was in fact to be one of the last occasions on which he would exhibit alongside his old Impressionist colleagues.

Georges Petit was solely interested in artists who had already made something of a

reputation. A number of smaller dealers, better described as enthusiasts rather than as serious entrepreneurs, provided important outlets for the less-known artists seeking to sell their work. Montmartre colour merchants and framers such as Julien Tanguy (fig. 23) and Arsène Portier were prepared to take in pictures in lieu of payment, but their shops were off the main art beat, with limited exhibiting space and poor lighting. The extrovert Père Thomas, a former wine merchant, was not afraid to provoke the indignation of passers-by in the boulevard Malesherbes by displaying works which more conventional dealers would have shunned. He even on one occasion mounted

20
CLAUDE MONET: *Bordighera.* 1884. Oil on canvas, 28¾ × 36 in (73 × 92 cm). Chicago, The Art Institute of Chicago

21
AUGUSTE RENOIR: Study for *The Bathers.* 1882–6. Charcoal on paper, 41¾ × 63⅜ in (106 × 159 cm). Paris, Louvre, Cabinet des Dessins

22
AUGUSTE RENOIR: *The Bathers.* 1884–7. Oil on canvas, 45¼ × 67 in (124 × 170.2 cm). Philadelphia, Museum of Art

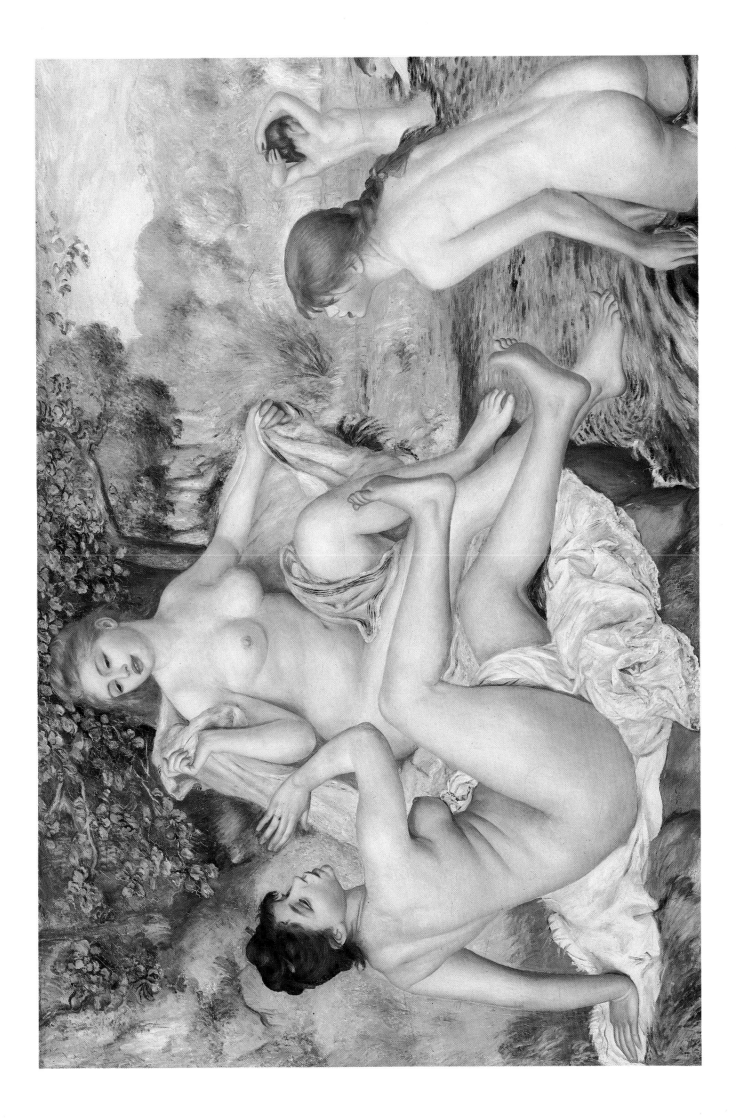

a visual joke at the expense of the Salon jury in his shop window.

A more important outlet for artists excluded by, or temporarily at odds with, Durand-Ruel and Petit was the dealer Theo Van Gogh. With several years' experience as representative of the Boussod and Valadon firm behind him (formerly Goupil's), selling the work of well-known Salon painters, in 1887 he began to branch out into the more risky field of independent contemporary art. Still under the aegis of Boussod and Valadon, he began to show the work of the Impressionists and their associates in the upper gallery of his employers' secondary branch on the boulevard Montmartre. His tastes in the later 1880s were influenced to some extent by the enthusiasms of his elder brother Vincent, who had himself worked for Goupil's a decade earlier and who nurtured ideas of establishing some sort of artists' co-operative with Theo as dealer. This venture was never realized, but for a few years Theo Van Gogh's active support was important for Monet, Degas and Pissarro (especially as the latter's Neo-Impressionist experiments in the later 1880s did not find favour with Durand-Ruel), as well as being a lifeline for Gauguin and, of course, his own brother Vincent. Sympathetic critics made a point of frequenting the upper room to see what new works the dealer had in stock, or to visit the occasional one-man shows he mounted.

Theo Van Gogh's early death in 1891, followed by that of Tanguy in 1894, left a vacuum which was to some extent filled by two new entrepreneurial figures, Le Barc de Boutteville and Ambroise Vollard. Already an experienced dealer in Old Master art, Le Barc had to be persuaded to offer his support to the younger artists, and he appears to have gone into the venture in a light-hearted spirit. No doubt he expected to make some notoriety in this way, and he can scarcely have been dismayed by the success

of his shows in the early 1890s. These included work by what one might call the second generation of Post-Impressionists, the followers of Seurat and Gauguin. Vollard on the other hand was a young man in his twenties who had more to lose when he decided to back the younger groups of artists (fig. 68). And his eagerness to take over from Père Tanguy the affairs of the notoriously unsaleable Cézanne does seem to have been based on a genuine feeling for the ageing artist's work and struggles, rather than on any confident expectation of financial gain.

A good relationship with a dealer was something that required careful fostering. Many letters of Monet, Pissarro and Gauguin reveal the strains of keeping their dealers happy without, as they saw it, compromising their artistic aims. Yet the commercial methods of Durand-Ruel, for example, were much criticized by all three, particularly when in the mid-1880s he seemed to be neglecting the Parisian market in favour of the American one, though the move in the long run turned out to be in both the artists' and dealer's interest. The death of Theo Van Gogh was a harder blow to Gauguin, who had spent several years building up a good understanding with the dealer.

Although the various commercial galleries and exhibiting societies provided the main outlets for independent art in the 1880s and 1890s, there were, however, a few occasions when artists mounted displays entirely on their own terms, outside the established venues. Two such occasions were the last Impressionist show in 1886 and the show organized by Gauguin, Bernard and their friends in 1889 at the Café Volpini. In both cases the artists were deliberately inviting comparison between their work and the kind of art being shown concurrently in official displays. Perhaps these were the only exhibitions of the period that fully meet our expectations of an avant-garde gesture.

23
VINCENT VAN GOGH:
Portrait of Père Tanguy. 1887.
Oil on canvas, 36 × 29½ in
(92 × 75 cm). Paris, Musée Rodin

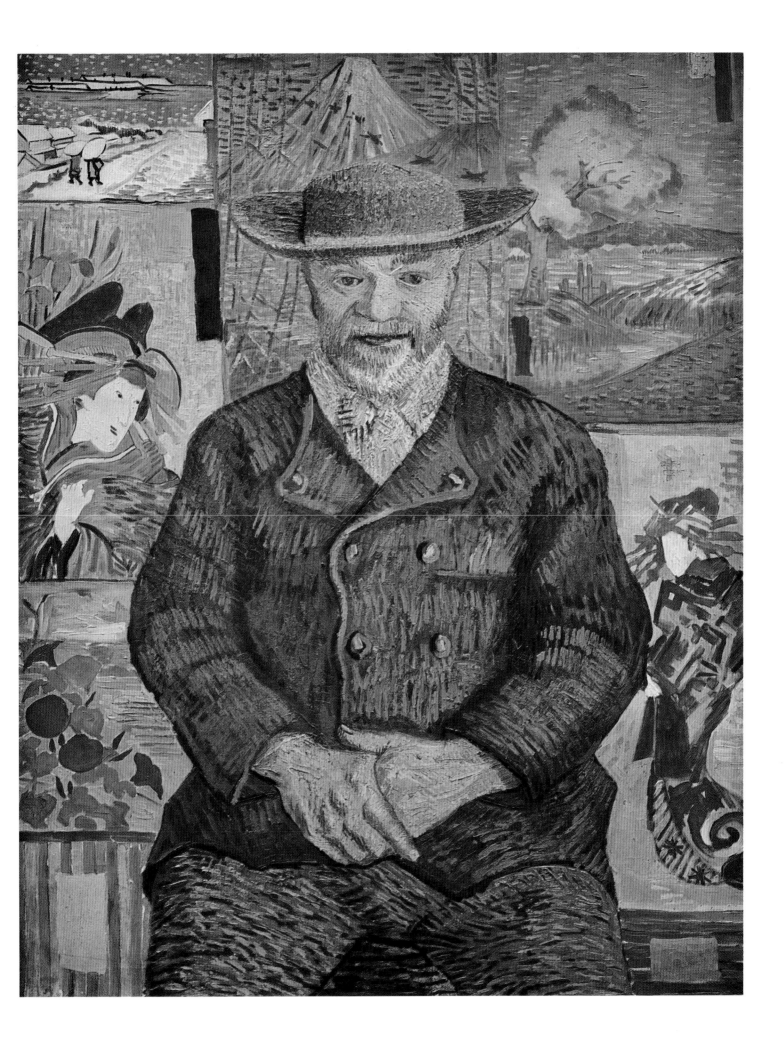

2 The Eighth Impressionist Exhibition—1886

From 15 May to 15 June 1886, the Impressionist group held its eighth and, in the event, final exhibition. The works filled five rooms on the second floor above a much-frequented restaurant, la Maison Dorée, on the rue Laffitte. Four years had elapsed since the previous group show and twelve since the artists first joined forces in 1874. Of the participants of the original show only Degas, Pissarro, Guillaumin, and Berthe Morisot were still to be seen. Monet, Renoir, and Caillebotte all made excuses for opting out. Monet, for instance, since exhibiting at the Salon in 1880, had been less committed to the idea of group shows, although he continued to profess his allegiance to what he understood to be the original concept of Impressionism—a *plein-air* spontaneous approach to the direct experience of nature. But he felt the group had become too tolerant of newcomers of doubtful talent, as he explained in a newspaper interview: 'The little church has become a banal school which opens its doors to the first dauber who comes along ...' Renoir too was suspicious of some of the newer recruits, particularly of Gauguin, who had joined the group in 1879, and was increasingly inclined to dissociate himself from artists he suspected of holding radical views—namely Pissarro, Gauguin and Guillaumin. He felt that to be linked to their names would tend to scare off his growing bourgeois clientele.

Berthe Morisot recorded the difficulties involved in organizing the 1886 exhibition which she and her husband helped to finance: 'This project is very much up in the air, Degas's perversity makes it almost impossible of realization; there are clashes of vanity in this little group that make any understanding difficult.' Degas's perversity, of which Gauguin also spoke at this time, manifested itself in an insistence on timing the exhibition to coincide with the official Salon. Pissarro opposed this idea, feeling it would hamper their chances of selling work, an intriguing indication of the two artists' rather different motives for holding another group show. Degas was also adamant that the word 'Impressionist' should be dropped from the title, not unreasonably since so many of the artists originally designated by that label were to be absent and it had never been entirely appropriate as a description of Degas's own work. Moreover, the last show was to include a number of Degas's figure-painter friends who had little stylistic affinity with the original Impressionists, such artists as Mary Cassatt, Forain and Zandomeneghi, as well as the totally isolated Odilon Redon, who sent in a selection of the original charcoal drawings on which his lithographic series were based (fig. 24). Pissarro too placed a condition on his participation—namely that his new friends the pointillists Seurat and Signac be included.

Clearly there were practical difficulties in getting the show off the ground. But what did the critics make of this exhibition? Was Impressionism perceived as being in a 'state of crisis', as it is generally presented by modern art historians? Firstly, of course, the critics of the 1880s were ignorant of the fact that this was to be the last of the group shows, so they were inclined to comment on Impressionism's present state of health or

24
ODILON REDON: *The Marsh Flower*, illustration from 'Hommage à Goya'. 1885. Lithograph on paper, 10⅞ × 8⅛ in (27.5 × 20.5 cm). London, British Museum

25
JEAN-LOUIS FORAIN: *Behind the Scenes. c.* 1880. Oil on canvas, 18¼ × 15 in (46.4 × 38.4 cm). Washington, National Gallery of Art

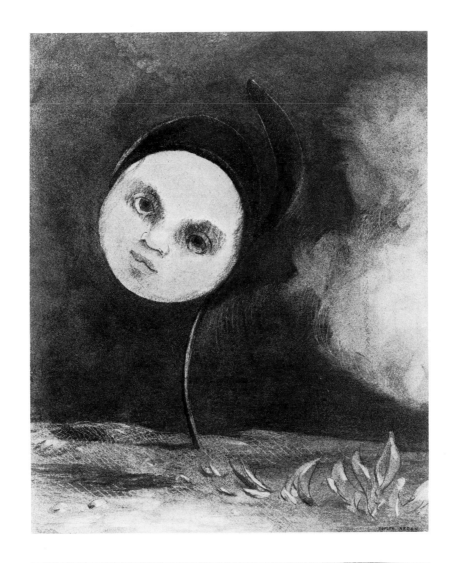

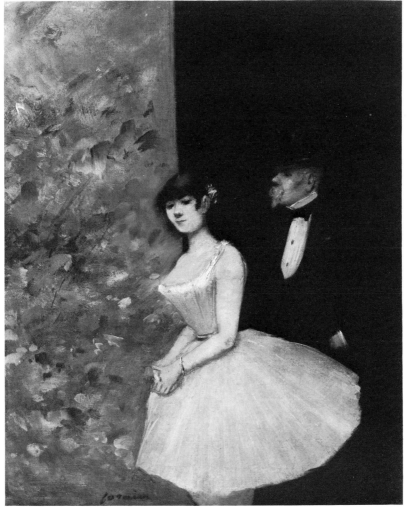

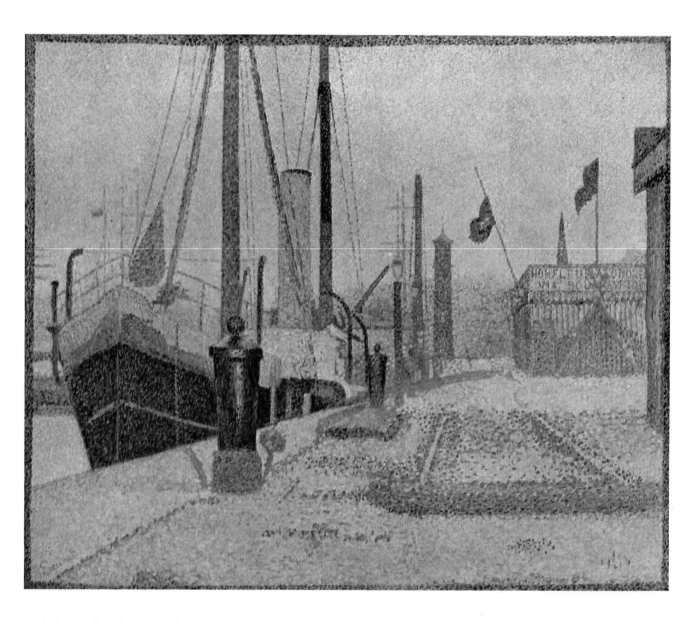

evolution rather than search for signs of its disintegration. A few critics could see no unified tendencies within the exhibition and judged each artist on his individual merits. One critic, interestingly, lighted upon the new importance the artists were giving to the expression of ideas, through drawing and line, rather than to the registering of purely visual sensations through colour (see figs. 25, 27, 30); for others it was Seurat's Neo-Impressionist technique, as it was dubbed by the critic Félix Fénéon, that dominated the show (figs. 28, 29), seeming to indicate a significant new direction for Impressionism. Seurat's new technique consisted of applying Impressionist broken colour in regular points or dabs, thus eliminating personal mannerisms of handling and imposing a quasi-scientific system onto the representation of light. His innovation had already been adopted by Camille Pissarro, his son Lucien, and Paul Signac, and the four artists had a room to themselves at the 1886 show. Many viewers complained that their pictures were indistinguishable one from another, an understandable reaction given the deliberate

26
GEORGES SEURAT: 'La Maria', Honfleur. 1886. Oil on canvas, 21½ × 25⅜ in (52.6 × 63.5 cm). Prague, National Gallery

27
EDGAR DEGAS: The Tub. 1886. Pastel on board, 23⅝ × 32⅝ in (60 × 83 cm). Paris, Musée d'Orsay

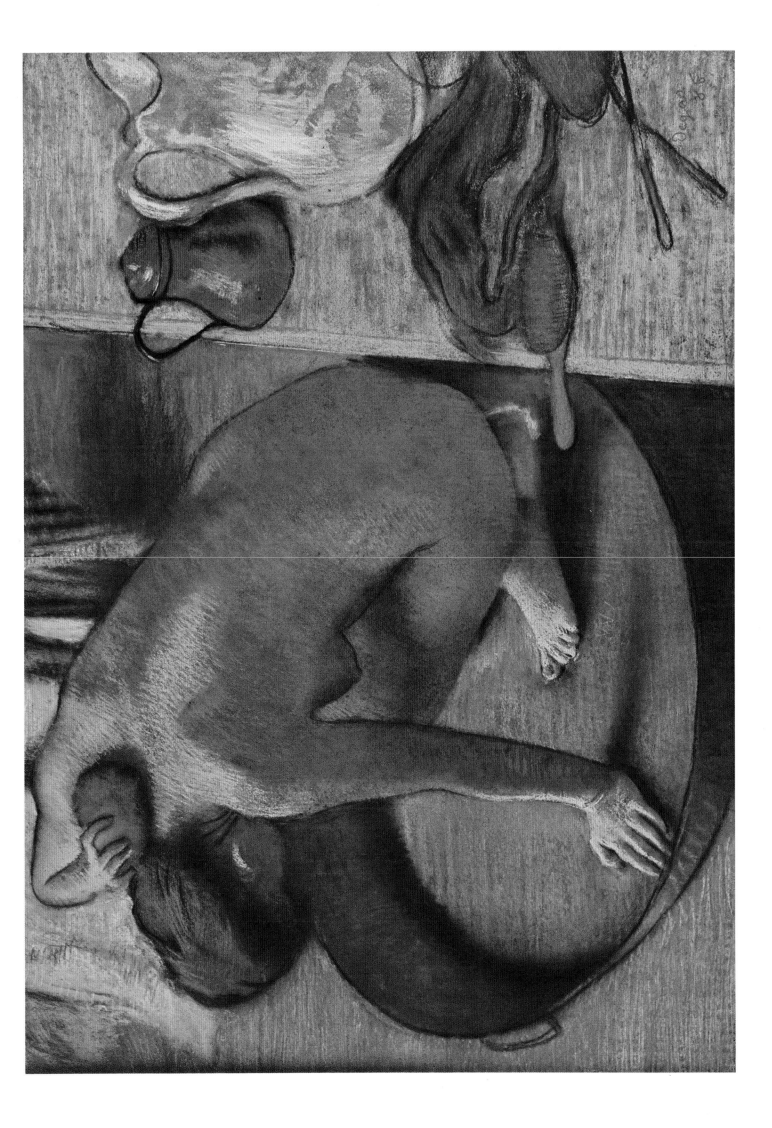

28
GEORGES SEURAT: Study for
the black dog in: *La Grande
Jatte.* 1884–5. Conté crayon
on paper, 16⅝ × 24¾ in
(42.2 × 62.8 cm). London,
British Museum

impersonality of the pointillist technique. But the unmistakable centre of attention was Seurat's enormous *Sunday Afternoon on the Island of la Grande-Jatte* (fig. 29). It stood apart from the rest in terms of scale and execution and occupied by far the greatest space in the reviews. Several critics grouped Gauguin and Guillaumin together and judged them to be representing a more conventional brand of landscape Impressionism. Gauguin's entry, which was almost devoid of figure work, was dominated by a series of rural motifs studied in the countryside around Rouen. Degas's group of ten nudes in pastel (fig. 27) was widely admired, but they were seen as the work of an idiosyncratic individual bearing little relevance to the rest of the show.

If one word cropped up consistently in the reviews it was 'naturalism'. Using this yard-stick, critics such as Fénéon and Jean Ajalbert found the vulgarity of Degas's nudes, as expressed in gestures and bodily imperfections, totally convincing; they could place his models in their true social milieu—namely the cheap brothels. For another young critic,

Paul Adam, Impressionist naturalism was evinced in the artists' concern to record their first-hand experiences, their pure appercep-tions of the world through colour; he also noted the new tendency to draw on scientific knowledge and to apply a more synthetic approach to the forms of nature, an approach derived from a study of the so-called 'primi-tives'. Seurat's treatment of nature in *La Grande-Jatte* was censured by many as being too caricatural and deliberately artful, but Adam found much to praise in it. The unwillingness to fudge, to utilize the accus-tomed pictorial conventions for giving a sense of recession in the trees for instance, was a sign, for Adam, of Seurat's integrity. The odd stiffness of the figures, which disconcerted so many viewers, for Adam added to their telling modernity. It evoked the constrictions on movement imposed by the fashions of the day and the current vogue for adopting an unbending 'British' de-meanour. For Ajalbert too, Seurat's tend-ency to simplify contours and unify colours was a mark of the picture's success. It was a truly 'synthetic work which does not stoop to

29
GEORGES SEURAT: *Sunday
Afternoon on the Island of La
Grande-Jatte.* 1883–6. Oil on
canvas, 81 × 120 in
(207 × 308 cm). Chicago,
The Art Institute of Chicago

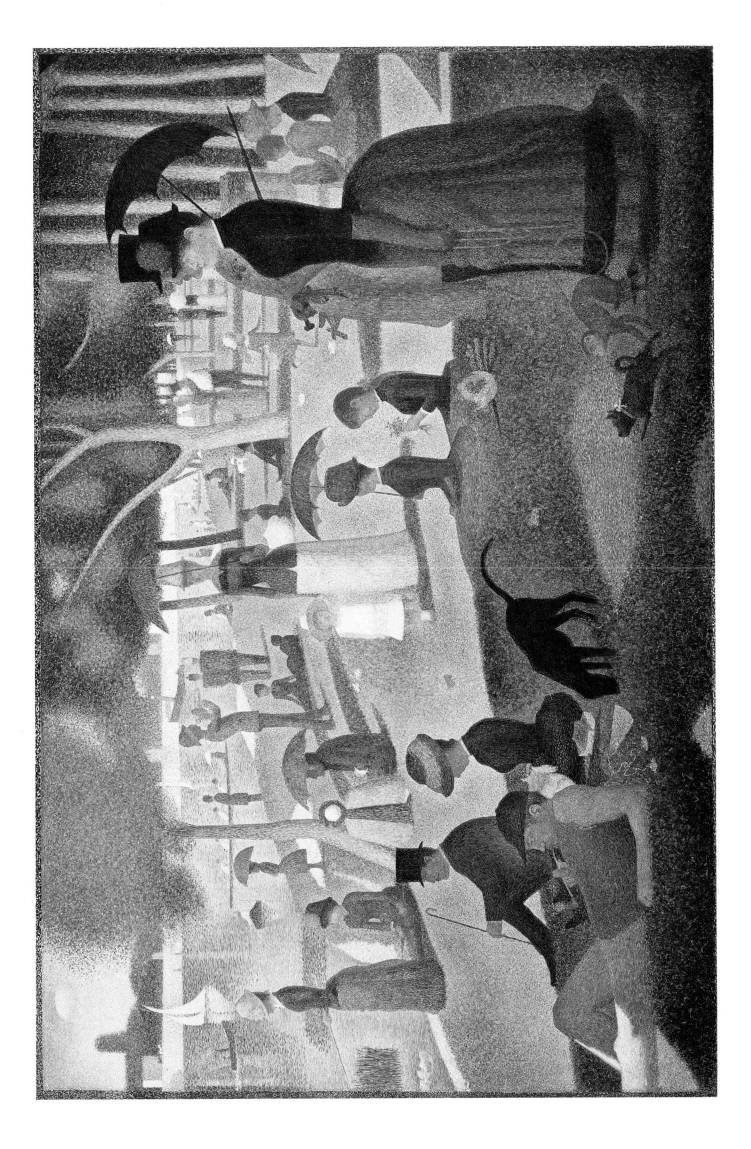

the facile subterfuges of an enumerative art but produces a contour that is synoptic, robust and telling'.

There was a limited amount of critical discussion, albeit oblique, of the artists' approach to their subjects. It was recognized that Seurat and Signac were saying something new about modern suburban life and leisure—that *La Grande-Jatte* in some way poked fun at the pomposity and inanity of the crowds that habitually gathered in this suburban spot on a Sunday afternoon. By the same token Pissarro was seen to have a true sensitivity to nature and an honest, earthy understanding of the life of the peasant. Apart from his recent *pointillé* paintings, his entry included a group of etchings, among them *The Potato Harvest* (fig. 30), whose impressive sturdy central figure could well have prompted Ajalbert's comment, 'And these country women with their square-set build and well-rounded hips! they aren't Batignolles girls, they breathe the soil!' Batignolles was the working-class quarter of Paris, where many artists had studios and hired their models. Ajalbert was alluding to the fact that for most contemporary painters, peasants were just one of a number of possible pictorial motifs that could be worked up in the studio. By contrast, Pissarro understood rural life and went directly out into the fields to observe peasants at work. But remarks such as this tended to be accorded second place to discussions of the pointillist technique and of Pissarro's courage in taking up a new style so late in his career. The best-documented and most coherent account of this technique was given by Fénéon in *La Vogue*, an account which he republished in the form of a pamphlet later in the year. Fénéon's explanation gave ready access to the new system of colour division for all interested young artists. It argued that Seurat's 'conscientious and scientific' tonal division had grown out of the tonal division of the Impressionists, that it was essentially a refinement and systematization of a previously haphazard and arbitrary procedure. Herein lay the future of Impressionism, was the clear mess-

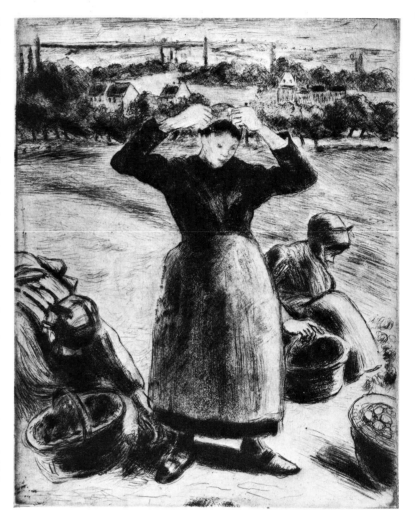

age, and it was echoed by Adam, who rounded off his review of the 1886 Impressionist show with the conclusion, 'this exhibition initiates [us] into a new art...'

One is led to ask what the artists taking part in the 1886 Impressionist show felt about its critical reception and how it affected their subsequent attitudes to one another. In some cases one can only conjecture. It is probable, for instance, that Pissarro felt pleased with his own performance and vindicated in having supported the younger Neo-Impressionists (fig. 32). If their paintings had been met with some predictable incomprehension and hilarity, they had also aroused considerable attention and interest. It is equally probable that

30
CAMILLE PISSARRO: *The Potato Harvest*. 1882. Etching and aquatint on paper, 7th state, 11 × 8⅝ in (28 × 22 cm). New York Public Library

31
PAUL GAUGUIN: *Still-Life with Profile of Laval*. 1886. Oil on canvas, 18⅛ × 15 in (46 × 38 cm). Switzerland, Josefowitz Collection

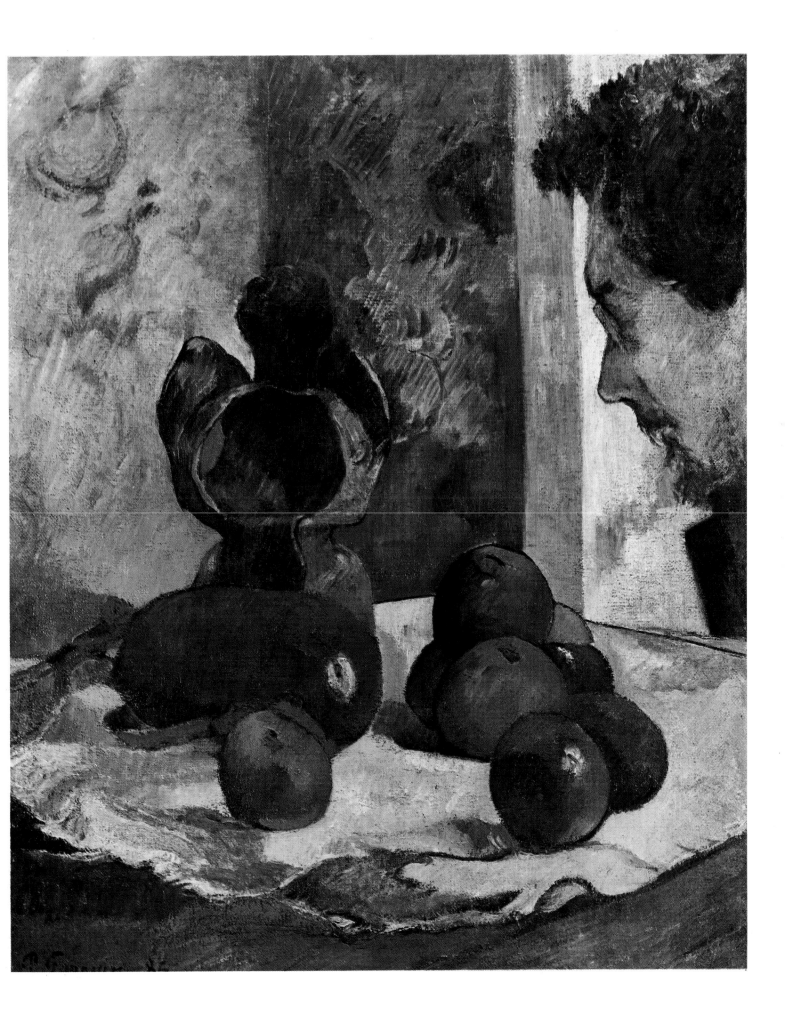

Gauguin felt disappointment at the lukewarm reception of his own works. His handling and colour had been judged conscientious but heavy, his subjects had been pronounced 'monotonous', even unhealthy. Symptomatic of his feelings was the petty personal misunderstanding between himself and Seurat that occurred shortly afterwards. Signac had apparently offered Gauguin the use of his Paris studio during the summer months, but when Ganguin tried to take up the offer he found Seurat, perhaps over-officiously, withholding the key. Gauguin complained somewhat petulantly to Signac, 'I may be a hesitant and unlearned artist, but as a man of the world I will allow no one to mess me about.' The incident sparked off seemingly unnecessary hostilities between the different groups of artists: Gauguin and Guillaumin refused to acknowledge the presence of Seurat and Signac when they chanced to meet in the same café, and in the autumn of 1886, as Pissarro noted with scepticism, Gauguin patched up his differences with Degas after a period of estrangement. Degas had come almost as well out of the 1886 show as Seurat, and Pissarro clearly regarded this reconciliation as hypocritical and self-interested on Gauguin's part. Among themselves the Neo-Impressionists became more united (figs. 14, 26, 32, 33), gained recruits and increasingly made their presence felt at the annual *Salon des Indépendants*. They also regularly appeared at the *Vingt* shows in Brussels, where a Belgian branch of Neo-Impressionism took root and thrived, led by such artists as Théo Van Rysselberghe, Willy Finch, and Georges Lemmen.

Looked at as the final attempt to rally the radical painters of the 1870s and to reanimate some common spirit of pugnacity, the 1886 show was a disappointing failure. In the years that followed Berthe Morisot, Degas, Monet, and Renoir maintained friendly but no longer professional contacts with one another, continuing to pursue their individual careers and holding periodic shows of their own work at the invitation of a dealer. No one had been keener than Gauguin to rally the dispersing Impressionist talents, but he had sought in vain to persuade them that their strength lay in their unity and that the move towards one-man shows at dealers' galleries was a dangerous one. In retrospect we can see that the 1886 exhibition and Seurat's success forced Gauguin to turn to new ways of finding a distinctive style and establishing an independent name for himself (fig. 31). It also forced him to search for new artists outside the Impressionist circle with whom to revive that idea of a 'phalanx of painters committed to a movement and protesting against commercialism', an idea of which he had spoken enthusiastically as early as 1883.

32
CAMILLE PISSARRO: *Woman in an Orchard*. 1887. Oil on canvas, 21½ × 25⅝ in (54.5 × 65 cm). Paris, Musée d'Orsay

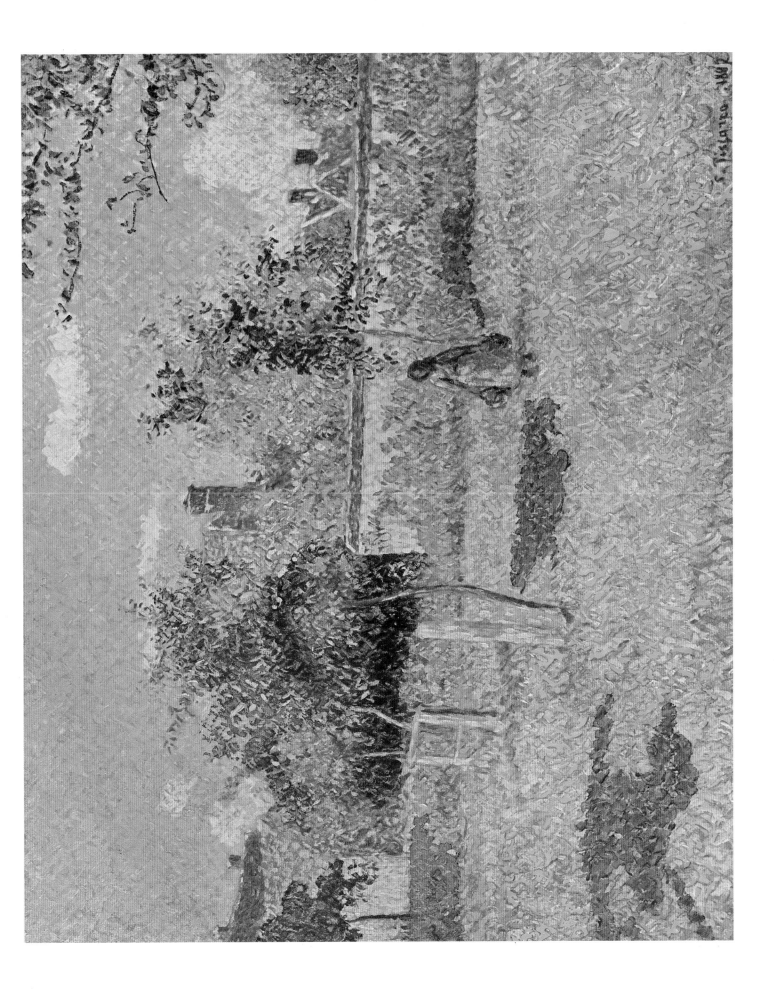

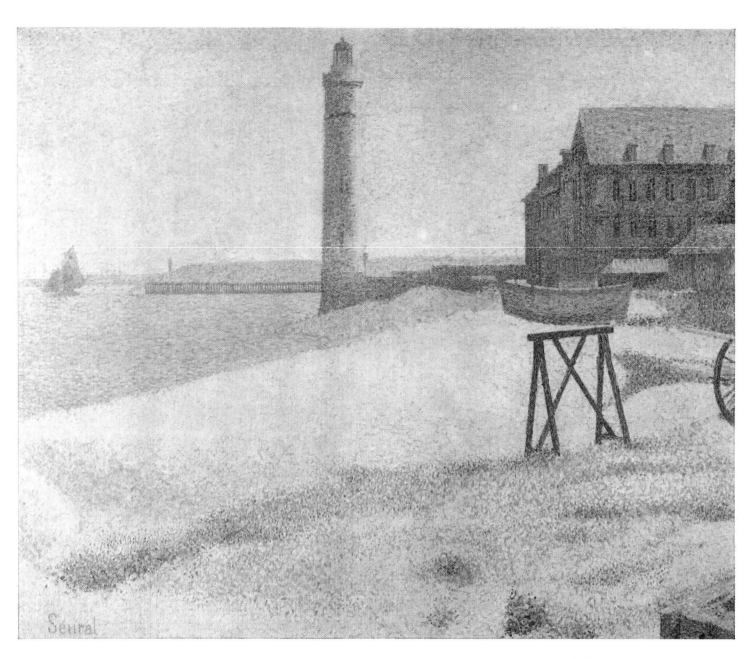

33
GEORGES SEURAT:
Lighthouse at Honfleur. 1886.
Oil on canvas,
25⅝ × 31⅞ in
(65 × 81.5 cm). Washington,
National Gallery of
Art. Paul Mellon
Collection

3 The Volpini Exhibition—1889

Three years after the last Impressionist show the centenary of the French Revolution was celebrated in an orgy of commercialism as Paris held its fourth Universal Exhibition. The star attraction was the newly inaugurated Eiffel Tower, situated next to the exhibition site on the Champ de Mars (fig. 34). Throughout the summer of 1889 Paris was filled with provincials and foreigners—in all 33 million people are estimated to have visited the Exhibition. The Beaux-Arts section was divided into three and claimed to constitute a retrospective of a century of French art. Not surprisingly, given the official bias of the selection committee, contemporary progressive painters felt they had been sold short. Most of the Impressionists were represented, but by their earlier work. Apart from the *Indépendants* Salon, destined to be held later than usual that year, in September, the visitor was offered little chance to familiarize himself with more recent trends in painting. It was doubtless for this reason, and to steal a march on the Neo-Impressionists, that Gauguin, together with his new friends Bernard, Laval, Schuffenecker and others, decided to mount a rival display in June at the Café Volpini, conveniently located on the Champ de Mars itself (fig. 35).

The critic Albert Aurier publicized the show in his new magazine *Le Moderniste* in these terms: 'Happily, I have learnt that individual initiative has just attempted something that administrative imbecility ... would never have allowed to happen. A small group of artists has succeeded in forcing an entrance not to the Palais des Beaux-Arts but to the Exhibition and in creating a small-scale rivalry to the official show ...' He proceeded to outline the main stylistic characteristics of the new group: 'I thought I observed in the majority of the works on show, and more particularly in those of P. Gauguin, Émile Bernard, Anquetin, etc., a marked tendency towards synthetism of drawing, composition and colour, as well as a search for simplification of means which I found extremely interesting in this era of skill and unashamed trickery.'

Apart from the artists mentioned by Aurier, the other exhibitors were all friends and acolytes of Gauguin: Émile Schuffenecker, like Gauguin, a former *agent de change* on the Bourse, had introduced him to Daniel de Monfreid, Charles Laval, Léon Fauché, and Louis Roy who were all artists with whom Gauguin had recently worked in Brittany. Later accounts of the Volpini show speak of it as launching the 'Pont-Aven style' and suggest that it displayed united aims and stylistic cohesion. But on closer inspection one finds very little unity in the character of the works included. Gauguin and Bernard dominated the show numerically—Bernard exhibiting 25 works (two under an assumed name) and Gauguin 17. Given Aurier's declared recognition of 'a marked tendency towards synthetism' it is puzzling that the two pictures that have subsequently come to be regarded by art historians as crucial to the development of a synthetist, anti-naturalist style—Bernard's *Breton Women in the Meadow* and Gauguin's *Vision after the Sermon* (figs. 99, 100)—were not in fact included. Gauguin's entries displayed a re-

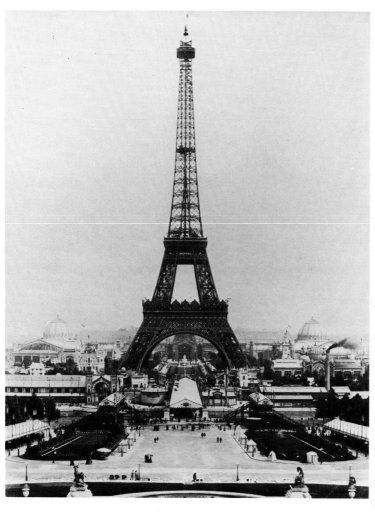

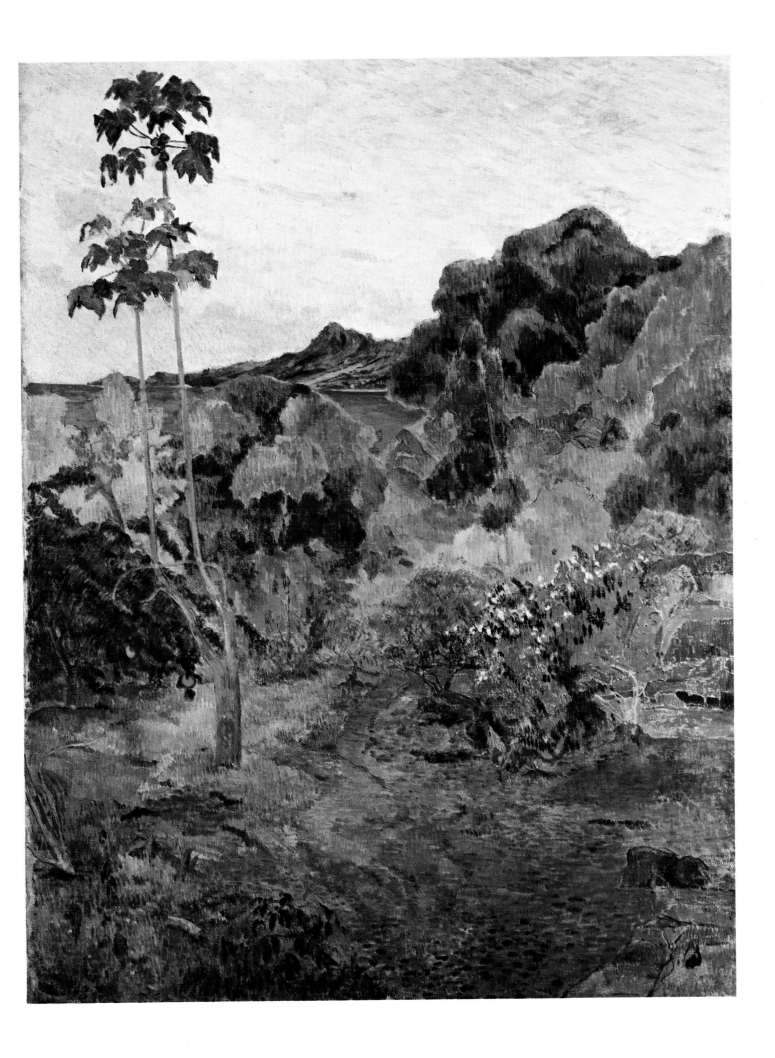

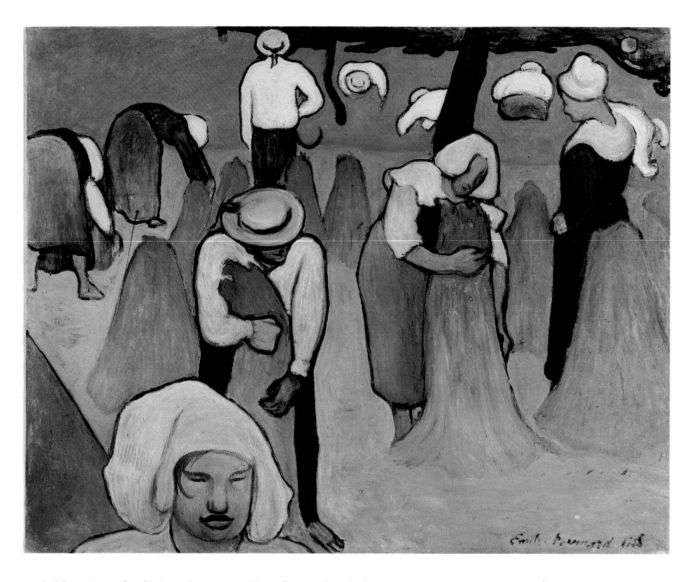

markable variety of stylistic and iconographic tendencies, ranging from the broken and variegated colour and brushwork of his early Breton and Martinique landscapes (fig. 36) to the more abstract treatment and brooding, unnaturalistic themes of his recent canvases painted in Arles. Bernard's style likewise veered from the bold simplifications of *The Buckwheat Harvest* (fig. 37) to a looser, more Impressionistic handling in some of his landscapes. His subjects ranged from Parisian industrial suburbs (*Bridge at Asnières*, (fig. 38) to Breton rural scenes. Where a certain stylistic and iconographic unity was to be found was in the albums of zincographs

Bernard and Gauguin were exhibiting, the *Bretonneries*. Drawn in bold, simplified outlines (figs. 39, 40), these cheaply produced hand-tinted images dealt with picturesque aspects of Breton life and were clearly intended as a joint commercial venture.

Although Gauguin seems to have been absent from Paris and content to leave the organization of the exhibition to Schuffenecker ('le bon Schouff' as he patronizingly called him), he had from the outset clear views about the purpose of the show and about which artists were to be represented. Apart from Bernard, Schuffenecker and the Breton artists Roy and Fauché,

37
ÉMILE BERNARD: *The Buckwheat Harvest* 1888. Oil on canvas, 28' × 35½ in (72 × 92 cm). Switzerland, Josefowitz Collection

38
ÉMILE BERNARD: *Bridge at Asnières*. 1887. Oil on canvas, 18 × 21¾ in (46 × 54 cm). New York, Museum of Modern Art, Grace Rainy Rogers Fund

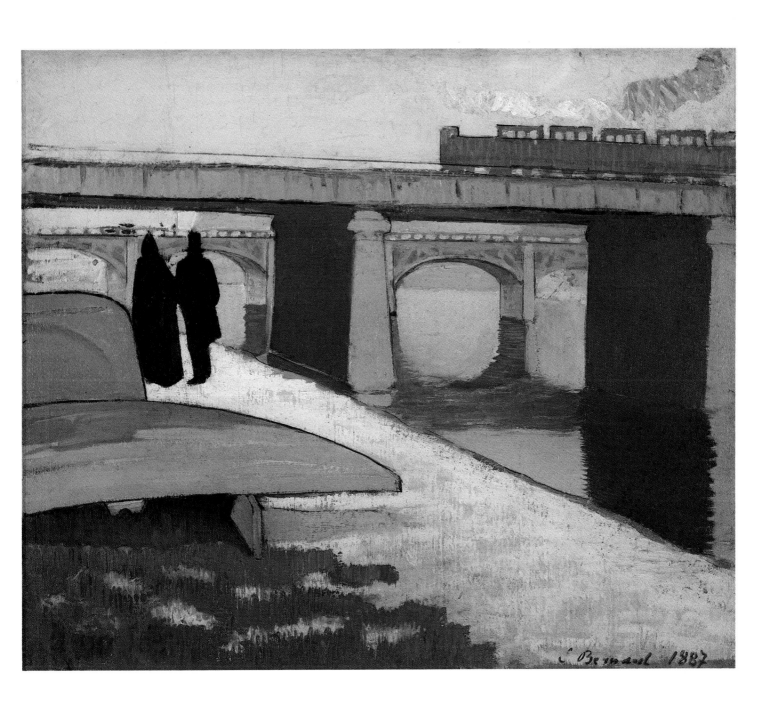

Guillaumin and Vincent Van Gogh were to be invited while Pissarro, Seurat and their associates were definitely not. There was also a question of inviting Toulouse-Lautrec but he was eventually debarred because he had previously shown with the fashionable private exhibiting club, the Cercle Volney. Louis Anquetin (fig. 41), a friend of Bernard's, was presumably included in the later stages but Guillaumin and Van Gogh defaulted, the latter because his brother Theo effectively prevented him from taking part. Theo had custody of the majority of Vincent's paintings, and he decided not to submit any to the Volpini show on the grounds that it looked like 'going to the Exhibition by the back stairs'.

If Gauguin was dismayed at the dealer's negative reaction, Vincent too was clearly disappointed. It may well have been he who inspired the initial idea of exhibiting the new works in a café, as he had mounted several shows of this kind in Montmartre during his stay in Paris between 1886 and 1888 (fig. 42). Indeed the last of these shows, held in late 1887 at the Restaurant du Châlet, had involved some of the same artists, Bernard, Anquetin and Lautrec, a group he referred to as the artists of the 'petit boulevard' to distinguish them from the original Impressionists. During Gauguin's two-month stay in Arles at the end of 1888, it is certain that he and Vincent discussed the practicalities not only of running a communal artists' studio and finding buyers but also of mounting joint exhibitions of this kind. So his exclusion must have compounded Vincent's feelings of disappointment at the failure of his own attempt to form an avant-garde exhibiting group or a harmonious working partnership in the Arles studio. From a distance, Gauguin, Bernard and their friends must have seemed to be succeeding where he had failed. But the impression would have been a falsely rosy one. The unity of aim that Gauguin and Bernard seemed to share in early 1889 was fragile, and soon to be destroyed by bitter arguments about which artist could rightly claim stylistic precedence. The seeds of its destruction lay

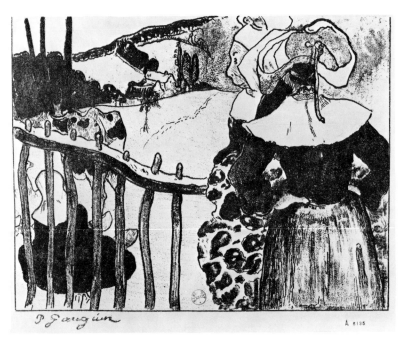

39
PAUL GAUGUIN: *Breton Women at a Fence Gate*, from *Bretonneries*. 1889. Zincograph on paper, 6¾ × 8½ in (17 × 21.5 cm). Paris, Bibliothèque Nationale

40
ÉMILE BERNARD: *Bretonneries*, cover of album. 1889. Zincograph on paper, 9¾ × 12½ in (33 × 25 cm). Quimper, Musée des Beaux-Arts

in the critical responses to the Volpini show.

For most of the critics who devoted any space to it, the title of the Volpini exhibition, 'Groupe Impressionniste et Synthétiste', proved to be a useful talking point, if not a

41
LOUIS ANQUETIN: *Avenue de Clichy, Five O'Clock in the Evening.* 1887. Oil on canvas, 27¼ × 21 in (69 × 53 cm). Hartford, Connecticut, Wadsworth Atheneum

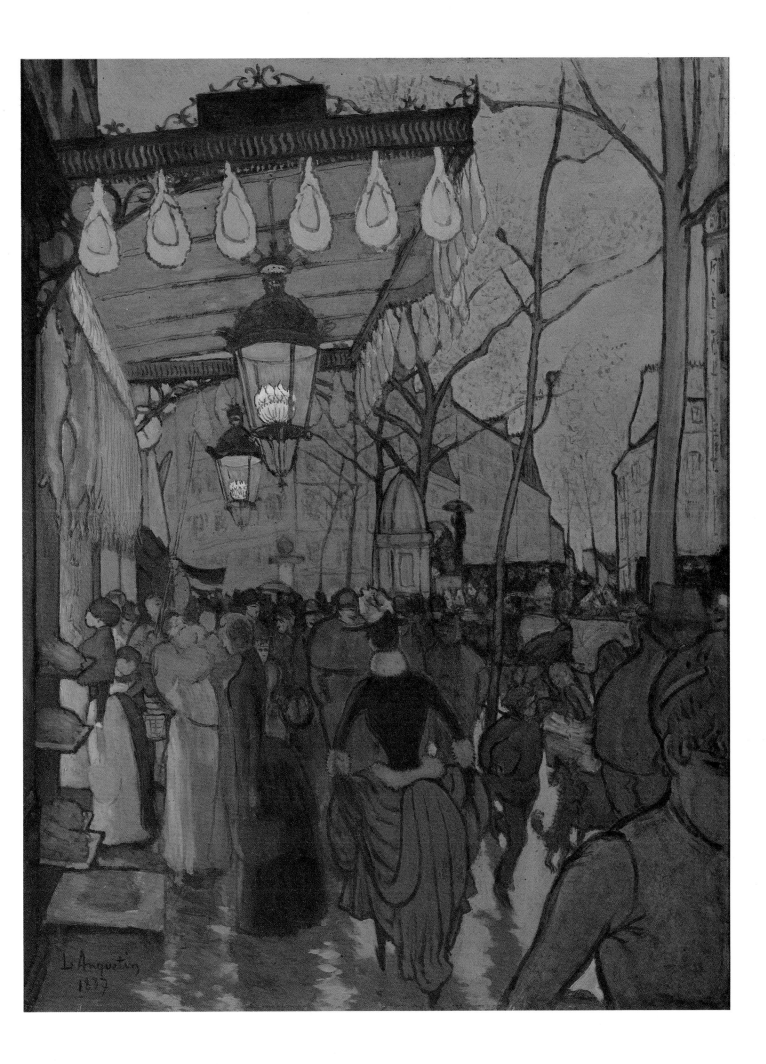

stumbling block. The decision to re-employ the term 'Impressionist' was curious. It seemed to apply mainly to Gauguin, the dominant personality of the show, who continued to call and think of himself as an Impressionist. For him, however, the term seems to have been synonymous with avantgarde and carried no specific stylistic connotations. For example, in the conservative company of academic artists in Pont-Aven, where he had been working in 1886 and 1888, his known association with the Parisian Impressionists had cast him automatically in the role of 'revolutionary', and this by no means displeased him. The topical term 'Synthetist', which looked more to the future, was assumed by several critics to apply to Bernard and Anquetin alone and to describe their new manner of working, a manner which had already earned the label 'Cloisonnism'. This involved the combination of heavy dark outlines and flat areas of colour, as in *cloisonné* enamelling, a combination that is clearly visible in Bernard's *Bridge at Asnières* and Anquetin's *Avenue de Clichy* (figs. 38, 41). Jules Antoine, writing in *Art et Critique*, found that their technique had affinities to Japanese art but was inferior. Posing as the ordinary spectator, he complained that only with difficulty was he able to make out the natural forms represented in these pictures, and objected that the artists' supposedly synthetic approach was really a matter of exaggerating rare oddities. Although not considered a synthetist by Antoine, Gauguin too was judged to be guilty of distortions of form in his drawing: 'There exists no aesthetic to justify arms that are too long, torsos that are too narrow, and a woman's head resembling the head of a mouse.' Fénéon, a much more sophisticated reviewer, was not so easily distracted into these age-old arguments about competence. He drew a direct parallel between what he saw as Gauguin's new stylistic departure and that of Seurat three years before. In both cases, he argued, the artists had been prompted by a sense of dissatisfaction with the limitations of Impressionism to search for an art 'of synthesis and premeditation'.

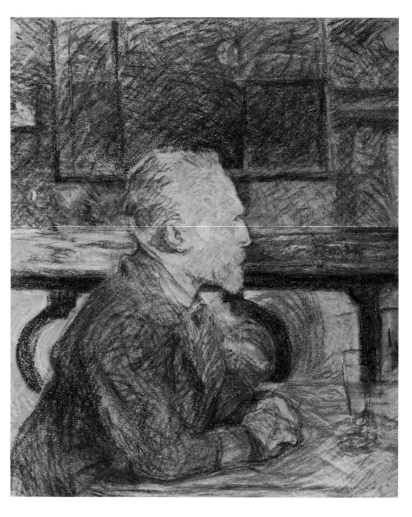

And while Seurat's search had led him to the pointillist technique and to a deliberate suppression of all arbitrary use of colour and individuality of handling, Gauguin's had led him to re-order the material presented by reality. He 'rejects all illusionistic effects, even atmospheric ones, simplifies and exaggerates lines, hieratizes them; and within each of the spacious zones formed by their intersections an opulent, heavy yet muted colour blazes, not threatening the adjacent colours but fully retaining its own identity.' Interestingly, Fénéon saw this development as consistent with tendencies he had already observed in Gauguin's earlier work, for example his leaning towards heavily foliated landscape motifs that demanded saturated colours and airless, dense handling (fig. 36).

42
HENRI DE TOULOUSE-LAUTREC: *Portrait of Vincent Van Gogh.* 1887. Pastel on paper, 21¼ × 17¾ in (54 × 45 cm). Amsterdam, Stedelijk Museum

43
JACOB MEYER DE HAAN: *Farmyard at Le Pouldu.* 1889. Oil on canvas, 29 × 36½ in (73.7 × 93.3 cm). Otterlo, Rijksmuseum Kröller-Müller

Given that Gauguin complained vociferously about Antoine's article, calling it sheer 'idiocy', one might imagine him to have welcomed Fénéon's so much more perceptive analysis. Certainly Fénéon had latched onto what we now know was one of the key motives behind the organization of the exhibition: to mount a counter-attack on the 'little dot' (as Gauguin referred to the pointillist technique). Unfortunately all such perspicacity was undermined because Fénéon also ventured to suggest that Anquetin had had some stylistic influence on Gauguin, a suggestion that infuriated Gauguin, who claimed, not entirely truthfully, not to know who Anquetin was. The modernistic impetus to be first in all stylistic innovation, such a characteristic of twentieth-century avant-garde art movements, was already quickening in the 1880s. Indeed it was responsible for many of the misjudgements, misunderstandings and bitternesses between artists and critics that beset the Post-Impressionist era.

The reason why the Volpini show made more impact than the café exhibitions previously held by Vincent Van Gogh and his friends must lie partly in its timing and location, partly in the inclusion of Gauguin, who, compared to the other exhibitors, had already achieved something of a reputation. Certainly his age and experience counted in his favour, and he was assumed not only by the critics but also by several younger artists who visited the show to be the leader of the new young school, an assumption which must have annoyed the ambitious Émile Bernard as much as it gratified Gauguin.

In a very short time Gauguin's band of recruits began to grow. In the summer of 1889 Jacob Meyer de Haan and Paul Sérusier, two artists who were impressed by the Volpini show, made their way to Brittany to join Gauguin (figs. 43, 44). During the winter of 1888–9 Sérusier had already gathered together a group of like-minded students at the Académie Julian who opposed the photographic naturalism they were being taught by such academicians as Jules Lefevre and Adolphe Bouguereau. Privately calling

themselves 'Nabis' or prophets, they had taken as their figurehead Paul Gauguin, whose very different artistic approach had been communicated to them by Sérusier. Sérusier's *Landscape in the Bois d'Amour* (fig. 44), which they treated as a talismanic symbol of the new artistic possibilities, had been painted under Gauguin's direct instructions in Pont-Aven in the late summer of 1888. The Volpini show offered the other young Nabis—Maurice Denis, Pierre Bonnard, Henri-Gabriel Ibels, Paul Ranson, Ker-Xavier Roussel, and Édouard Vuillard—their first real opportunity to study a sizeable body of Gauguin's work, although they were already familiar with some of his

44
PAUL SÉRUSIER: *Landscape in the Bois d'Amour, The Talisman.* 1888. Oil on panel, 10¾ × 8¾ in (27 × 22 cm). Paris, Musée d'Orsay

45
PAUL GAUGUIN: *Breton Calvary, The Green Christ.* 1889. Oil on canvas, 36 × 28¾ in (92 × 73 cm). Brussels, Musées Royaux des Beaux-Arts

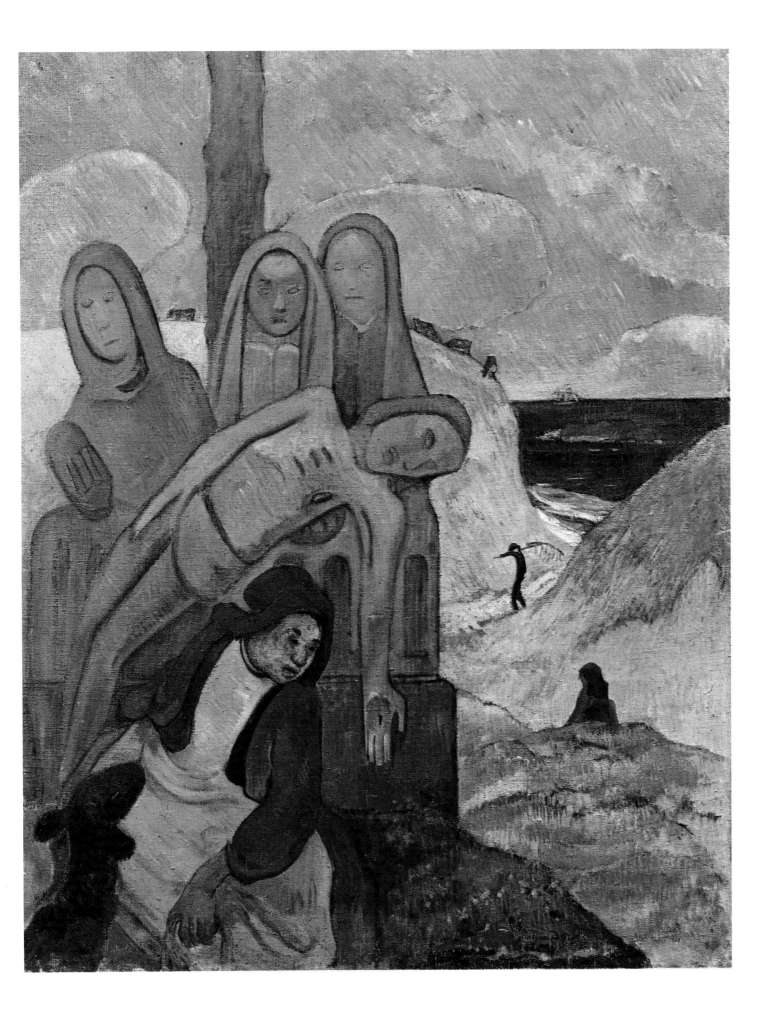

paintings from Theo Van Gogh's gallery. It was there rather than at the Volpini show that they had been able to admire Gauguin's *Vision after the Sermon* (fig. 99), and later in 1889 they could see new consignments such as the *Breton Calvary* and the bas-relief carving *Soyez Amoureuses* (figs. 45, 46).

Sérusier remained the essential link between Gauguin and the Paris-based Nabis, and his letters to Maurice Denis from Brittany in 1889 and 1890 reveal his initial disappointment, then his growing admiration for Gauguin as a man, craftsman, and thinker. Sérusier perhaps flattered Gauguin here, for it was essentially his own and Maurice Denis's theoretical frame of mind that managed to construct some kind of an aesthetic coherence from the *ad hoc* practice of the older artist, to turn his casual remarks into suitable material for an artistic manifesto. Denis's 'Definition of Neo-Traditionism' appeared in two instalments in the small review *Art et Critique* in the summer of 1890. It was not just a matter of 'shouting out loud' that Gauguin was 'quite simply a master', as its author claimed. It was also a conscious rejoinder to the reasoned defence of Neo-Impressionism published four years earlier by Fénéon, and was similarly written with a view to explaining and persuading others to adopt a new art. The three main thrusts of Denis's argument were, firstly, to urge artists to be mindful of their formal means before their representational ends ('Remember that a painting, before it is a war-horse, a nude or some anecdote or other, is essentially a flat surface covered with colours assembled in a certain order'); secondly, to decry illusionistic naturalism, which was the dominant aesthetic creed taught in the academic studios at the time; and thirdly, to demonstrate that Gauguin, and a few other contemporary painters such as Puvis de Chavannes

and Anquetin, belonged within a decorative tradition. In fact they had succeeded in reviving a lost tradition of decorative art which ran from the Egyptians to the Italian fresco painters of the Quattrocento, and which had only been broken by the obsession with illusionism and modelling that had taken hold since the high Renaissance. Whereas these 'primitive' artists had, Denis felt, been true to the essential decorative function of painting, Western artists since the Renaissance had neglected beauty for the illusory goal of truth to nature.

All in all, the repercussions from the Volpini show were probably as significant as those from the 1886 Impressionist show. The immediate outcome was to set up Gauguin as a leader of an avant-garde group, based in Brittany, to rival the Parisian Neo-Impressionists. Admittedly this was a role he was quick to abandon, but it was a necessary stage in his bid for artistic recognition on his own terms. The less immediate outcome was the conversion of a number of conventionally trained young artists to advanced painting. The example of the Volpini show prised Sérusier, Denis and their colleagues from their art school training and pitched them into a synthetic, anti-naturalist manner, more or less without any intermediate phase of naturalism or Impressionism.

These two exhibitions and their consequences demonstrate the pace of advanced painting in the 1880s, a pace given energy by each grouping's demands for autonomous avant-garde identity and by the promptings of critics eager for the kudos of supporting innovation. It was perhaps inevitable that the following decade would see a slackening off and a dissipation of this energy, as stylistic innovation and experimentation became more readily accepted and dealers began to trade on their young artists' 'audacity'.

46
PAUL GAUGUIN: *Soyez Amoureuses vous serez heureuses, Be in love and you will be happy*. 1889. Bas-relief carving in limewood, 38¼ × 28¾ in (97 × 75 cm). Boston, Museum of Fine Arts

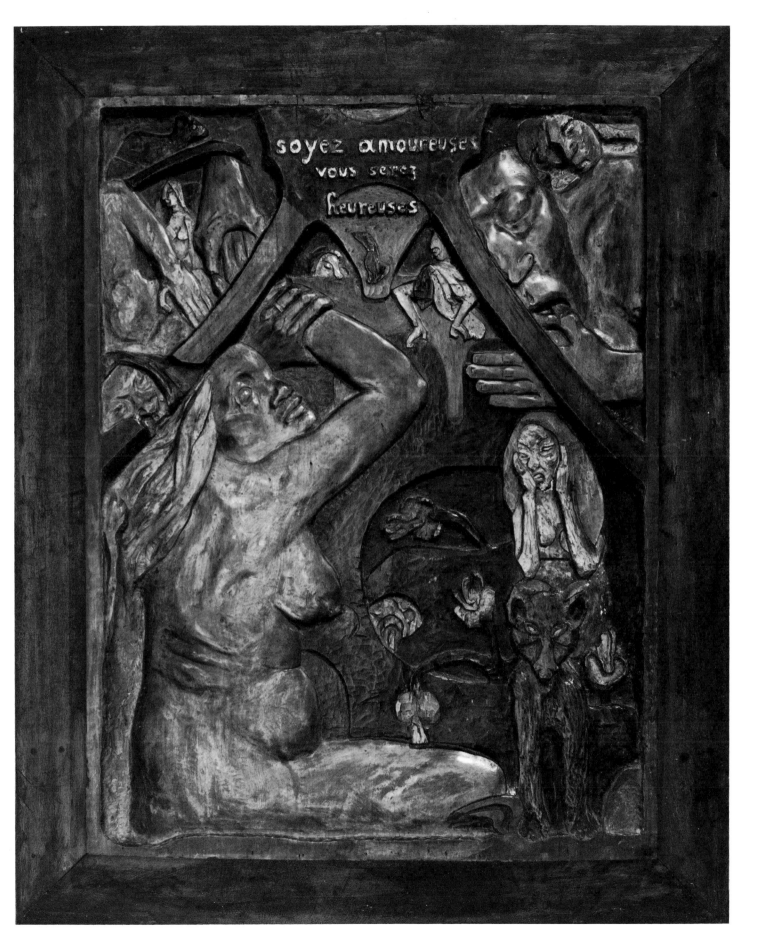

4 The Fourth Le Barc de Boutteville Exhibition—1893

In April 1893, the catalogue of the fourth exhibition of a group called the 'Impressionist and Symbolist Painters' (fig. 47) was prefaced by these lofty-sounding words about the role of artists: 'They ... are prophets. They proclaim the power of the human faculties ... They have no relations with society, except insignificant ones: they are a society unto themselves. They have no right to any material reward: their honour lies in the esteem in which they hold themselves in their isolation...' Having established these essential principles of the myth of the avant-garde, the author of the preface, Camille Mauclair, a Symbolist writer and critic, proceeded to comment upon the success of the current exhibition in bringing together two different strands of contemporary artistic practice. '... here we find a brotherly union between the sharp vision of life [the Impressionists], and the idealist domination over that same life [the Symbolists] through the desire to take the plastic and visual laws that were given new life by masters twenty years ago and put them to the service of new expressions of the modern soul.'

The 24 artists involved in this apparently harmonious amalgamation of Impressionist vision and techniques with Symbolist expressive aims were a decidedly mixed group, ranging from Impressionists and Neo-Impressionists such as Guillaumin, Pissarro, Angrand and Signac and independent figures such as Toulouse-Lautrec to followers of Gauguin such as the Brittany-based artists Charles Filiger, Maxime Maufra and Louis Roy, and the

Nabis Bonnard, Denis, Ibels, Ranson, Roussel and Vuillard. The artists represented a considerable technical and stylistic diversity, which was echoed in the disparate subject-matter of the 146 works shown. These ranged from landscapes and rural scenes to domestic scenes and portraits (fig. 48), from religious and mythological subjects (figs. 49, 50) to raw aspects of modern Parisian low life.

On the surface, then, it would seem to have been possible by 1893 to reconcile the

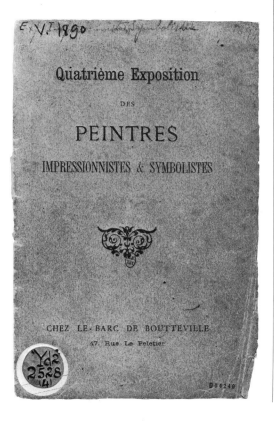

47
Cover of the catalogue of the Fourth Exhibition of Impressionist and Symbolist Painters, Le Barc de Boutteville Gallery. 1893. Paris, Bibliothèque Nationale

48
PIERRE BONNARD: *Madame Claude Terrasse (The Checkered Blouse)*. 1892. Oil on canvas, 24 × 13 in (61 × 33 cm). Paris, Musée d'Orsay

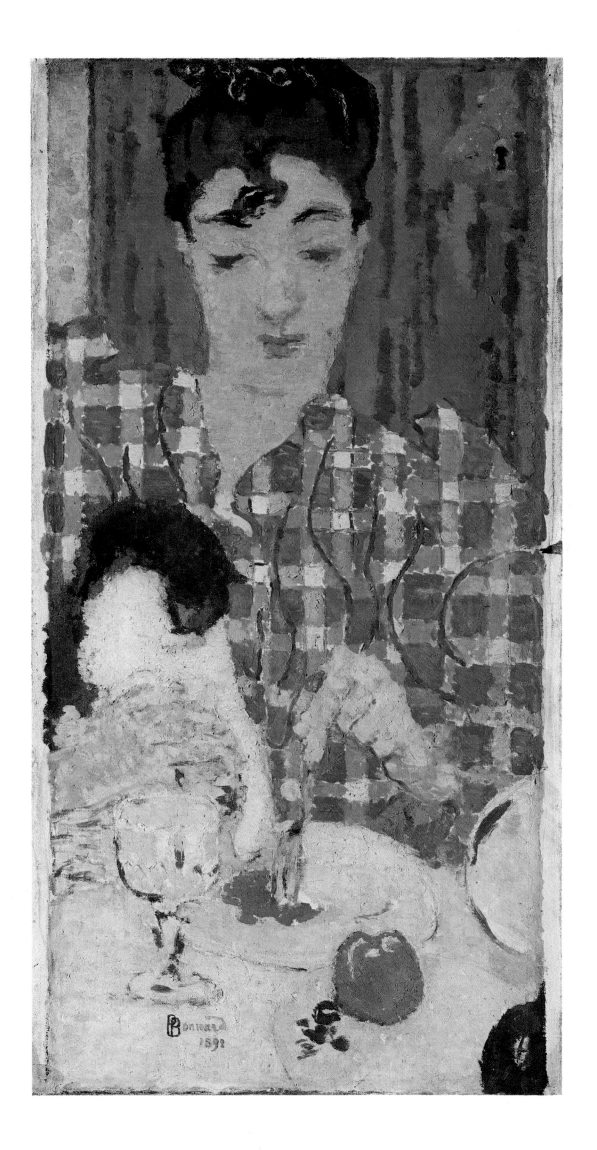

49
MAURICE DENIS: *Mystère
Catholique*. 1890. Oil on
canvas, 20 × 30¼ in
(57 × 77 cm). Alençon,
J.-F. Denis Collection

artistic factions that had been so opposed in the previous decade. A partial explanation for this lies in the nature of the exhibition. It was not a show put together by and for the artists concerned, as in essence the Volpini and the 1886 Impressionist shows had been. It was the fourth in an organized series of 15 shows selected and mounted by the dealer Le Barc de Boutteville. His arrival on the scene of modern art after a successful career dealing in Old Masters had come at an opportune time, particularly for the members of the Nabi group, who as yet had no commercial outlet. Le Barc, a somewhat flamboyant and garrulous figure, had a gallery on the rue Le Pelletier at the centre of the Paris art trade. Having been persuaded by Paul Vogler to turn his attention to the up-and-coming younger artists, he launched himself into the project with gusto, as Paul Ranson excitedly reported in December 1891: 'The big picture dealer who went to see Bonnard and Vuillard has been to see Sérusier. He is offering us favourable terms for exhibiting and selling our work.' And the minor Nabi Cazalis commented a year later:

'Le Barc de Boutteville's exhibition has a certain success, despite the disorder of his shop, the poor hanging arrangements and the annoying verbiage of Monsieur de Boutteville.' Approximately twice yearly Le Barc would organize a mixed show from his current stock of works, produce a catalogue and invite a sympathetic critic, poet or painter to write the preface. Le Barc's shows quickly achieved a certain notoriety, and were visited and patronized by 'le tout-Paris intellectuel'. The Nabis, or Symbolists as they were called in this context, were the main beneficiaries of the shows' success. They enjoyed active critical support from their earliest days in the many Symbolist reviews, and they largely avoided the material difficulties experienced by their Impressionist predecessors. In view of this, Mauclair's special pleading in his 1893 preface seems less than relevant.

What were the causes of the relative ease with which the Nabis gained acceptance? One factor was undoubtedly their bourgeois backgrounds—most of them were from well-off families and they had all enjoyed

50
PAUL RANSON: *Nabi
Landscape*. 1890. Oil on
canvas, 34⅝ × 44⅞ in
(88 × 114 cm). Switzerland,
Josefowitz Collection

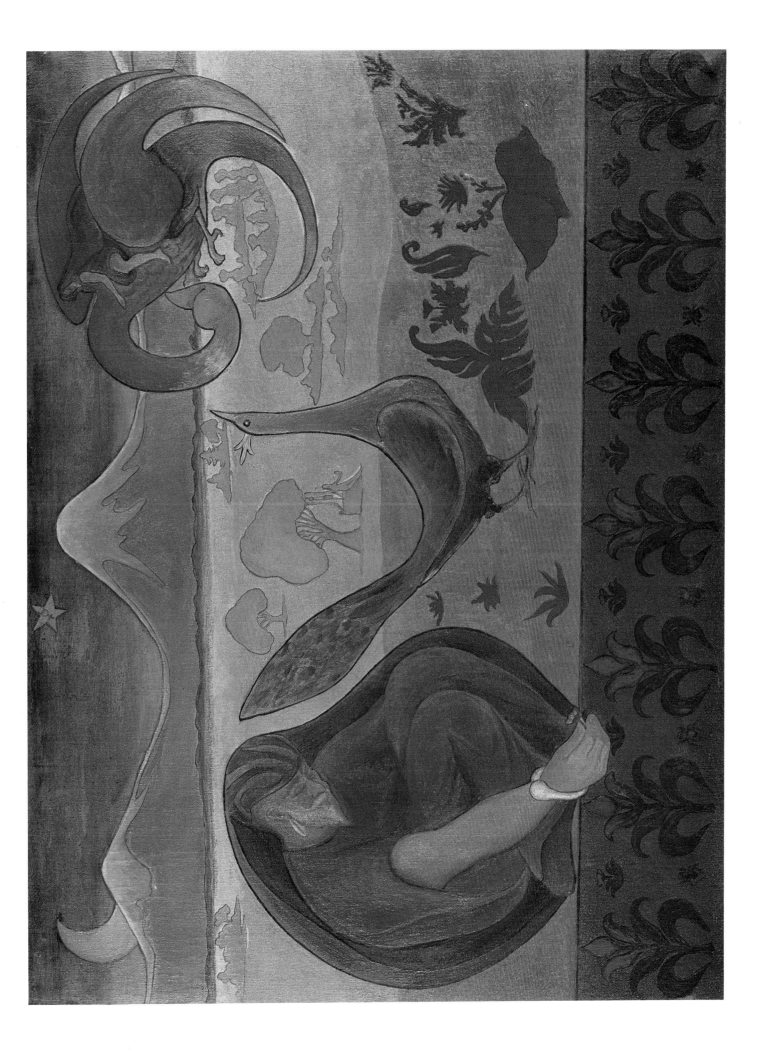

good education at the best Paris lycées. They shared the sophisticated outlook and tastes of their contemporaries among the poets. But a large measure of their success must be due to their having learnt from the experiences of their predecessors and being prepared to muster support from the right quarters. As we have seen, Maurice Denis was quick off the mark in publishing his own defence of Gauguin, and he was equally swift to drum up the necessary critical interest in his own and his friends' works. Early in 1891 he invoked the assistance of his friend the actor Lugné-Poë: 'I can't let this vogue for Gauguin slip by ... This will be the moment to introduce us to Geffroy and others if possible (call me calculating if you like). Bonnard's and my exhibits mustn't be allowed to pass unnoticed.' Lugné-Poe was able to arrange useful introductions not only to sympathetic critics, but also to buyers from the theatrical world such as the celebrated actor Coquelin Cadet and the director of the Comédie Française, Jules Claretie.

By the end of that first year's campaigning, Bonnard's and Denis's names were sufficiently well-known to justify their inclusion in an *Echo de Paris* interview with innovative young painters, alongside Anquetin, Bernard and Toulouse-Lautrec. Jacques Daurelle, the interviewer, invited each artist to comment on the artistic tendencies of the current young school, on such successful and highly-paid Salon artists as Meissonier, and on their preferred models among their contemporaries. The views expressed by Denis and Bonnard were evasive, and seem to have been calculated to avoid giving offence. Daurelle was struck by their tolerance and moderation, calling them 'likeable revolutionaries, intransigents with velvet palettes'. Only Émile Bernard was outspokenly hostile to the respected academics, and, significantly, when asked to name the contemporaries he most admired he was only prepared to mention Cézanne and Redon. Already he was anxious to quash the view that his work had been influenced by Gauguin's. Indeed the latter was not cited as a model by any of the artists interviewed,

an indication perhaps that his influence was on the wane.

The poets of the Symbolist movement were prompt to recognize in the artistic aims of the young Nabi painters similarities to their own struggle to free literature from its 'enslavement' to the Naturalist aesthetic. Probably the most important critic to come to their defence was Albert Aurier, who had already caused something of a stir with his article of March 1891, 'Symbolism in Painting—Paul Gauguin'. He wrote the preface for the second Le Barc de Boutteville show in 1892 as well as a lengthy defence of the Nabis in the prestigious *Revue Encyclopédique*. In Aurier's view Gauguin had incontestably been the Nabis' main guide to an art of symbol and synthesis, but their intelletual ideas and theories also had deeper roots and formed part of a many-fronted attack on an age of 'exclusive materialism'. Although theorizing was not generally regarded as falling within the domain of the painter, Aurier argued that Maurice Denis's initiatives in this direction had been well justified. As for their art, which was admittedly still at an experimental stage, it was characterized by an admirable concern for decorative qualities and had highly respectable origins in the various 'primitive' art forms already cited by Denis—the Egyptians, the Italian Quattrocentists and the more recent exemplars of a Symbolist approach—Puvis de Chavannes, Gustave Moreau and Odilon Redon.

The strength of the traditional element in their art was another cause of the Nabis' early success. Their stylistic daring, which manifested itself in a predilection for simplified arabesque-like lines and bold flat colour areas, was tempered by the frequent use of subtle, chalky matt effects—as in fresco painting—and by their subject-matter, which largely consisted of domestic interiors and updatings of conventional Catholic themes—the Annunciation for example (figs. 48, 49, 51, 52, 54). From this point of view their paintings, unlike those of Gauguin and Seurat, were inoffensive and readily accessible.

51
ÉDOUARD VUILLARD: *Two Young Girls*. 1893. Oil on panel, 32 × 25½ in (81 × 65 cm). Switzerland, Josefowitz Collection

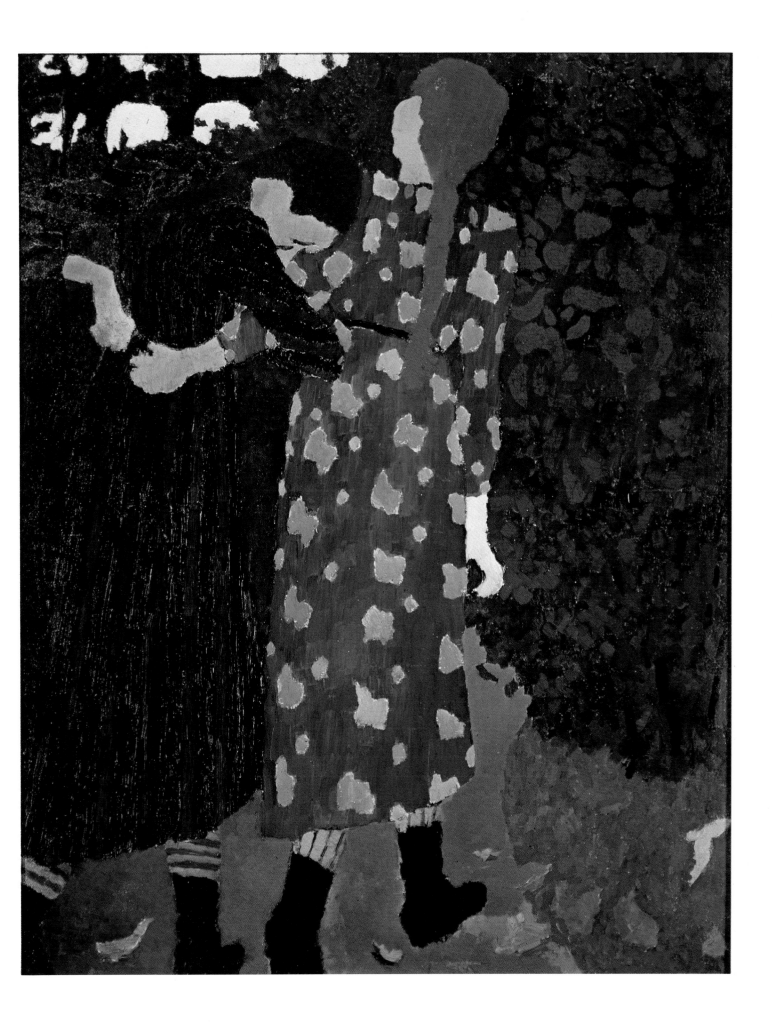

The works the Nabis showed at Le Barc's exhibitions were mainly oil studies on board of modest proportions (works such as Vuillard's *Little Girls Walking*, fig. 51). They also showed prints and posters, designs for theatre programmes and tapestries, even, in the case of Bonnard's *Le Peignoir* (fig. 52), paintings on velvet. This preparedness to experiment with a wide range of media was a characteristic feature of advanced art in the 1890s. And in stylistic terms too there was a willingness to make use of an eclectic range of sources, as the critic Émile Cousturier noted in the journal *Les Entretiens Politiques et Littéraires*: 'With not inconsiderable skill [they] transpose and rearrange the characteristics of ancient bygone schools, whether continental or exotic, or they adapt for easel paintings forms previously reserved for such disparate art forms as stained glass, manuscript illumination, old tarot cards or theatrical décors.' We have a good example of this in Pierre Bonnard, whose stylistic debt to the exotic East was such that he earned himself the nickname of '*Nabi très japonard*'. Using japonist silhouettes and arabesques, flat colour areas and playful distortions of outline, he was able to adapt his preferred motif, the elegant Parisienne, to the popular art form of the poster and the technical demands of colour lithography (figs. 53, 55).

It was almost certainly from the Japanese that Vuillard too learned how to contrast densely patterned materials as a means of enlivening the surface of his canvas. In *Mother and Sister of the Artist* (fig. 54) the checkered dress of the young woman seems to merge with the heavily patterned wallpaper, a sort of visual pun undoubtedly intended by Vuillard. In the design of such posters as *Au Divan Japonais* (fig. 56), Lautrec also made use of the stylistic devices of Japanese prints, which were collected by most advanced artists in this period (figs. 85, 158). Of course there were critics who found these stylizations excessive and signs of weakness, and who accused the painters of being content with sketchy and light-hearted ephemera when they should be attempting more substantial, serious work.

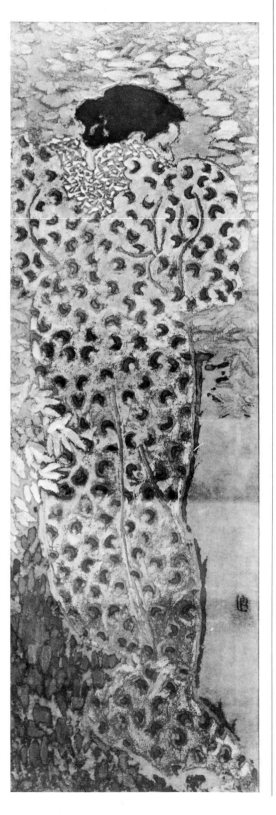

52
PIERRE BONNARD: *Le Peignoir*. 1892. Oil on velvet 60⅝ × 21¼ in (154 × 54 cm). Paris, Musée d'Orsay

53
PIERRE BONNARD: *France-Champagne*, poster. 1891. Colour lithograph, 30¾ × 19¾ in (78 × 50 cm). New York, Museum of Modern Art

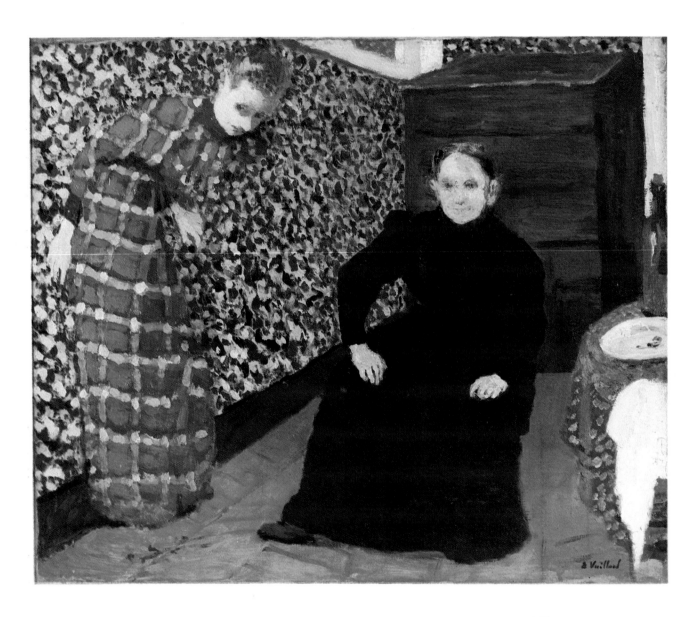

54
ÉDOUARD VUILLARD: *Mother and Sister of the Artist. c.* 1893. Oil on canvas, 18¼ × 22¼ in (46.4 × 56.5 cm). New York, Museum of Modern Art, gift of Mrs Saidie A. May

55
PIERRE BONNARD: *La Revue Blanche,* poster. 1894. Colour lithograph, 30¾ × 23⅞ in (62 × 80 cm). Paris, Bibliothèque Nationale

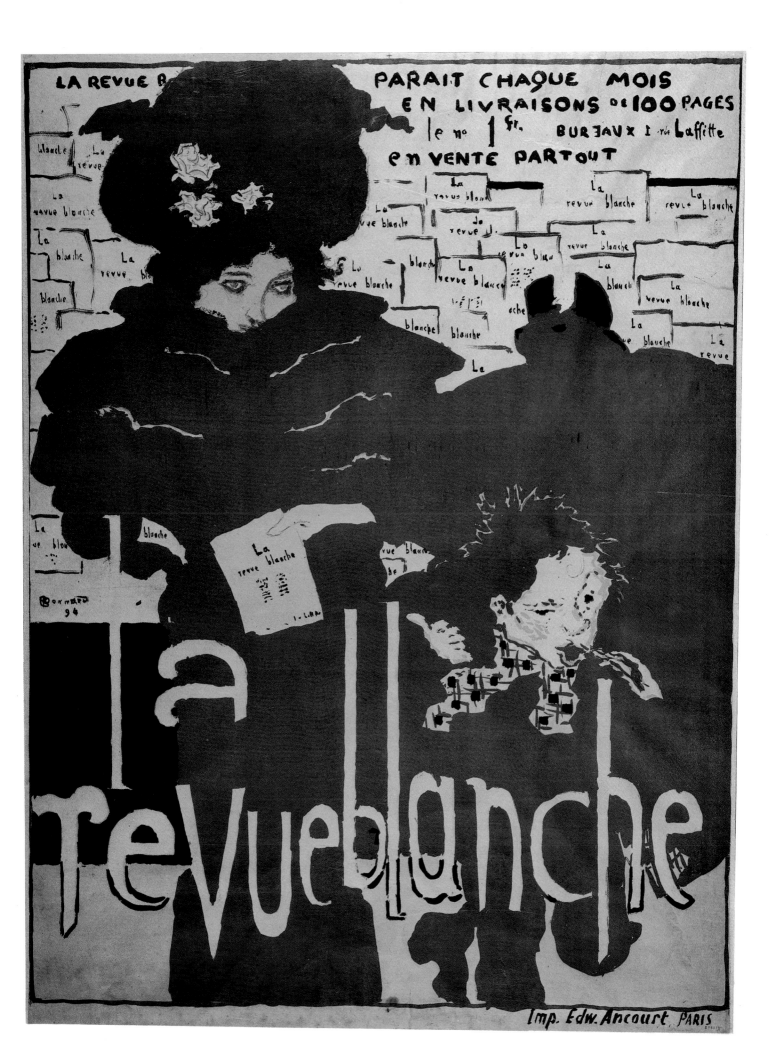

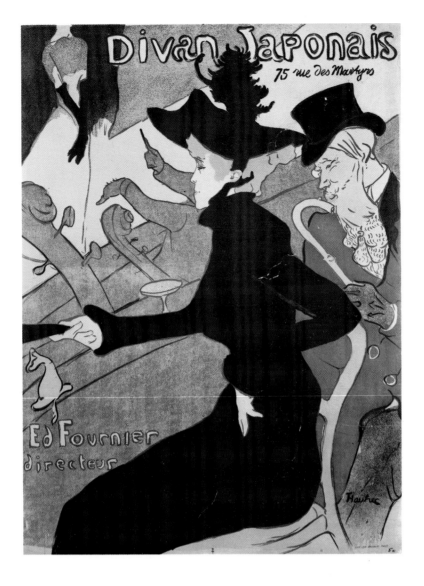

56
HENRI DE TOULOUSE-
LAUTREC: *Au Divan Japonais*,
poster. 1893. Colour
lithograph, 31¼ × 23⅝ in
(79.5 × 59.5 cm). Albi,
Musée Toulouse-Lautrec

Mauclair's preface to the fourth Le Barc show noted with approval a certain blurring of the stylistic edges between the so-called 'Impressionists' and 'Symbolists'. The pointillist dot had originally been employed in the 1880s as a means of achieving greater accuracy and objectivity in capturing the effects of sunlight. By the 1890s it had lost its pseudo-scientific pretensions and become essentially a decorative tool, a means of creating vibrant colour harmonies and surface patterns. In this purely decorative form the dot even appears in the works of the Nabis in the early 1890s. The tendency was unmistakable, but it was open to a variety of interpretation. The critics and artists who had aligned themselves with the Neo-Impressionists for ideological reasons—for most of those artists made no secret of their left-wing anarchist beliefs—were disappointed, in the 1890s, to see them adopt an increasingly mannered approach to the natural motif. Charles Saunier, for example, writing in the anarchist-orientated review *La*

Plume in 1893, advised Signac to leave off his current decorative experiments and to return to the study of 'living life'. And Camille Pissarro, another anarchist sympathizer, having abandoned the pointillist technique around 1890 because he found it too inflexible, was not impressed by the increasingly ornamental, unnaturalistic tendencies shown in the works of his former comrades. He disliked Signac's symbolistic *Portrait of Félix Fénéon* of 1891 (fig. 83), and pronounced Henri Edmond Cross's ambitious large-scale decoration *L'Air du Soir* 'frightful' when he saw it in 1894 (fig. 57). Signac, on the other hand, surveying the evolution of Neo-Impressionism, regarded its progression from a tough analytical period in the 1880s to a period of varied and personal creativity in the 1890s as altogether natural. What he saw in the development of Cross's work was not a falling-off of vigour but a greater logic of colour application and synthesis of form.

Where Mauclair (and we) might see no

57
HENRI-EDMOND CROSS:
L'Air du Soir. 1894. Oil on
canvas, 45⅝ × 64⅝ in
(116 × 164 cm). Paris,
Musée d'Orsay

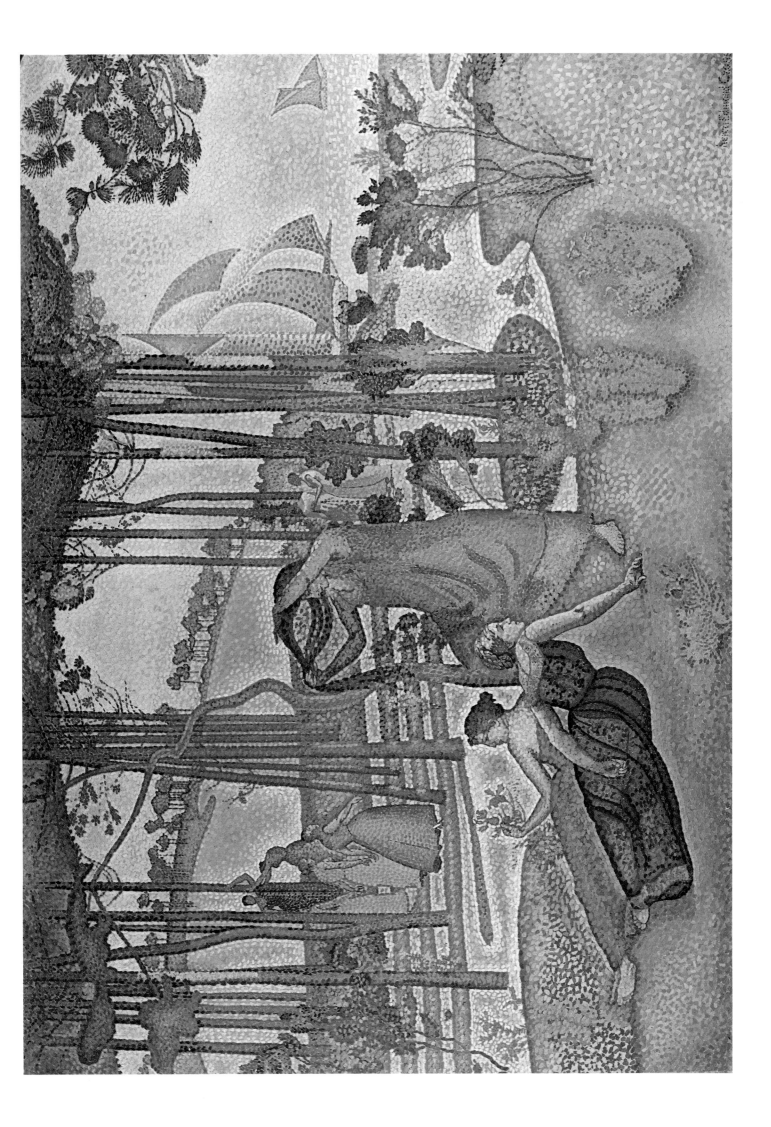

58
PAUL SÉRUSIER:
Melancholia or *Bretron Eve.*
c. 1890. Oil on canvas,
28 × 22½ in (71 × 57 cm).
Paris, Musée d'Orsay

great difference between the expressive aims and achievements of artists like Signac in *Au Temps d'Harmonie* (1895), Cross in *L'Air du Soir*, and Maurice Denis in *Avril* (fig. 104)—all three evoking a similar mood through the combination of graceful decorative figures and dream-like, Puvis-inspired setting—we would be mistaken to assume that all barriers between the Neo-Impressionists and the Symbolists had been broken down in the 1890s. The fact that they were prepared to exhibit in the same gallery was mainly for convenience's sake and there remained a large measure of suspicion—even outright hostility—between the two groups. Signac, like Pissarro, remained contemptuous of the Symbolist 'déformateurs', whose success, he felt, had come too easily. He was critical of their neglect of visual sensations and their indifference to the study of light and luminosity, a failing that he felt became all the more obvious when the Symbolists Sérusier and Lacombe (figs. 58, 59) hung their works in the well-lit galleries of the *Indépendants* Salon in 1895. 'They should have stayed in the obscurity of the Boutteville shop,' he commented somewhat caustically, 'where it was still possible to be taken in by their "merdes mystérieuses" [mysterious shit]!' The stylistic affinities that had been proposed as early as 1889 by Fénéon, and that appeared so markedly unifying an element of avant-garde art in 1893, disguised continuing and very real social and political antagonisms, antagonisms that were to divide groups and individuals within the spectrum of advanced painting throughout the 1890s.

59
GEORGES LACOMBE: *Cliffs near Camaret. c.* 1893. Tempera on canvas, 31⅞ × 24 in (81 × 61 cm). Brest, Musée Municipal

5 The Cézanne One-Man Show—1895

The mixed group show was one of the ways in which advanced art was presented to the public in the 1890s. But this was also a decade for taking stock of individual achievement. The original Impressionists were reaching the status of revered elder statesmen, and the 1890s saw a series of retrospective exhibitions of the work of Pissarro, Monet, Renoir, and Berthe Morisot. The most significant of these as far as the younger avant-garde artists were concerned was the one-man show of Paul Cézanne's work held in the gallery of Ambroise Vollard late in 1895. It was the first ever substantial showing of Cézanne's work in Paris, and the first showing of his recent work since 1877. The timing of the exhibition was propitious. Throughout the 1880s support for this veteran of Impressionism had been growing among progressive artists, and by the early 1890s advanced critics such as Fénéon and Lecomte were beginning to see Gauguin, Bernard and their associates as belonging to some sort of a 'Cézanne tradition'. Until 1895, however, their only opportunity of studying Cézanne's works was in the dark and confined back room of Père Tanguy's shop.

Cézanne himself rarely left his native Provence to visit the capital. The idea of this artist working in isolation in Aix had created something of a legend (figs. 60, 61). He was reputed to be taciturn and uncouth, and his reluctance to exhibit was generally put down to his exacting nature. Cézanne himself explained it in terms of his anxiety about the incomplete state of his researches, which he did not yet feel ready to defend against

criticism. 'I had resolved to work in silence,' he wrote to Octave Maus in 1890, 'until the day when I felt myself capable of defending the result of my efforts from a theoretical point of view.'

Cézanne was hypersensitive to criticism, a trait which had both caused and been exacerbated by his decision to distance himself from the Paris art world in the early 1880s. His reaction to *L'Oeuvre* in 1886, his former school friend Zola's novel about the artistic life of the capital back in the 1860s, might have been less violent had he been able to discuss and criticize the book with the rest of his former Impressionist colleagues. All of them complained that Zola had misrepresented their early struggles, but they were also laughingly able to agree that it was one of the weakest of the novels in the Rougon–Macquart series. The fact that Zola had presented his central character, Claude Lantier, as a tragically flawed artist, destined to failure and suicide, was taken by Cézanne to be a direct personal attack, and he broke off friendly relations with Zola. The author had indeed used Cézanne as one of the models for Lantier, but he had also used elements of Manet and Monet, so Cézanne's reaction was a trifle excessive. After 1886, however, Cézanne received increasingly encouraging treatment from the critics. A number of appreciative articles appeared in the early 1890s penned by Gustave Geffroy, and it may well have been the persuasive talents of Geffroy as much as those of the exuberant Vollard that finally made Cézanne agree to exhibit.

The show Vollard organized comprised

60
PAUL CÉZANNE: *Portrait of Cézanne.* 1896–7. Lithograph, 18½ × 13⅝ in (47 × 34½ cm). Ottawa, National Gallery of Canada

61
Cézanne painting near Aix-en-Provence. 1904. Paris, Sirot Collection

some 150 works, shown in rotation, 50 at a time. It covered all the stages of Cézanne's career and all aspects of his output. In particular, it included the works of his mature style, developed from the late 1870s on, in which he had begun to 'organize' his sensations before nature through regularized brush strokes, solidly structured compositions and carefully modulated colour patches. The regular parallel brush strokes are clearly visible in his *Still-Life, Fruit Dish, Glass and Apples* (fig. 63), and one finds the same diagonal hatchings in his drawings (fig. 62). His concern for solid structure can be seen in the balancing of verticals and horizontals—in the *Bay of Marseilles* (fig. 65) and in his figure paintings, *The Card Players* and *Woman with a Coffee Pot* (figs. 64, 67)—although, characteristically, these verticals and horizontals are never quite 'true'. The

paint application in his mature work, although varying from picture to picture, was generally lighter and less agitated than before, benefiting no doubt from his increasing activity as a watercolourist. Many of the oils he showed were in an unfinished state, an indication both of his self-critical temperament and of his relative freedom from economic constraint. Cézanne was not subject to the pressures to 'complete' his works that beset a Renoir, for instance.

The exhibition was greeted with enthusiasm both by the younger generation of artists and critics and by Cézanne's old Impressionist comrades Monet, Renoir, Degas and Pissarro, all of whom were eager to judge the progress he had made during his years of seclusion in the South. Cézanne himself kept away, and was thus deprived of hearing the glowing praise, praise in which

62
PAUL CÉZANNE: *Avenue of Jas.* 1885–7. Pencil on paper, 12⅛ × 18⅞ in (30.7 × 47.8 cm). Rotterdam, Boymans van Beuningen Museum

63
PAUL CÉZANNE: *Still-Life, Fruit Dish, Glass and Apples.* c. 1877–9. Oil on canvas, 19¼ × 21½ in (49 × 55 cm). Paris, private collection

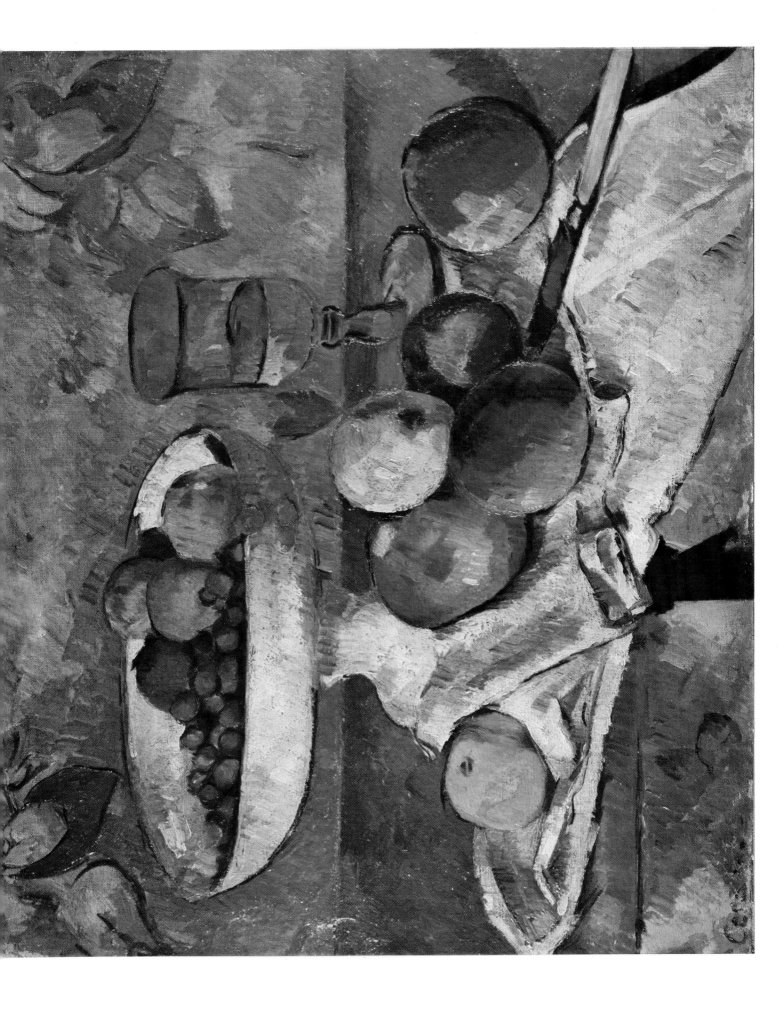

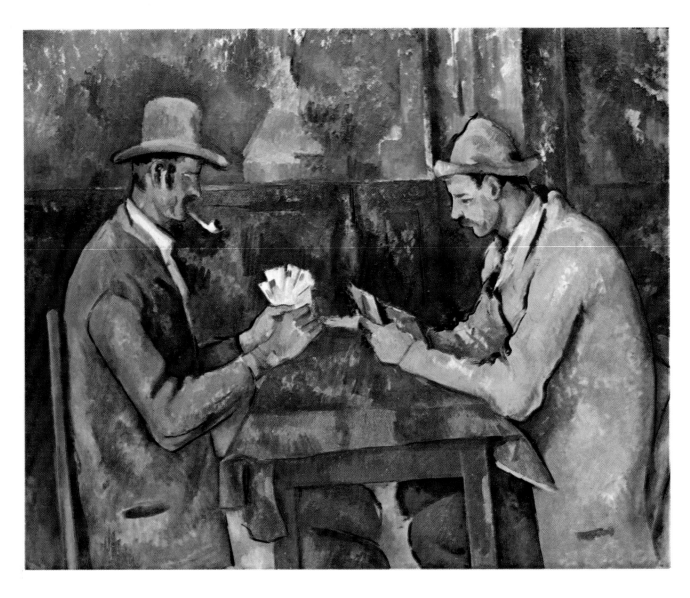

Pissarro found an ironic but satisfying vindication of his initial isolated support for Cézanne in the early 1870s. He wrote describing the show to his son Lucien, 'As Renoir put it so well, these paintings have I know not what quality: like the things of Pompeii, so crude and so admirable!' The old Impressionists all took this opportunity to buy work by Cézanne; even the 17-year-old Julie Manet, Berthe Morisot's daughter, much to the amusement of her prestigious guides and mentors Degas and Renoir, decided to make her début as a 'collectionneuse' at the Cézanne show. Cézanne's

patrons to date had been limited to a few enthusiasts, but this marked the beginning of an upturn in his commercial fortunes. Thus Vollard's bold entrepreneurial move slowly began to pay off. Among the more significant buyers to visit the Cézanne show was Auguste Pellerin, a margarine magnate, who over the next twenty years was to build up the most comprehensive private collection of Cézannes ever assembled (a collection which included figs. 3, 63, and 67). And the young Henri Matisse, who almost certainly visited the show, four years later paid Vollard 1,300 francs for Cézanne's *Three Bathers* (fig. 66), a

64
PAUL CÉZANNE: *The Card Players. c.* 1892. Oil on canvas, 23⅝ × 28¾ in (60 × 73 cm). London, Courtauld Institute Galleries

65
PAUL CÉZANNE: *Bay of Marseilles from L'Estaque. c.* 1885. 29⅞ × 38¼ in (75.9 × 97.2 cm). Chicago, The Art Institute of Chicago

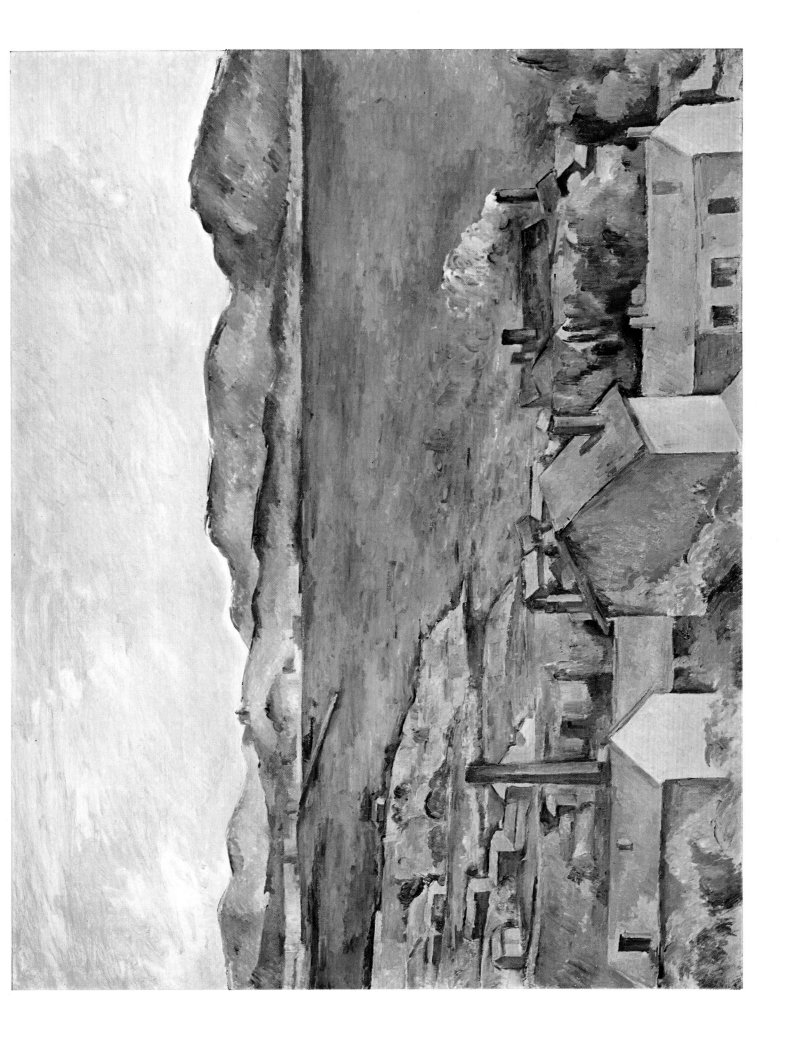

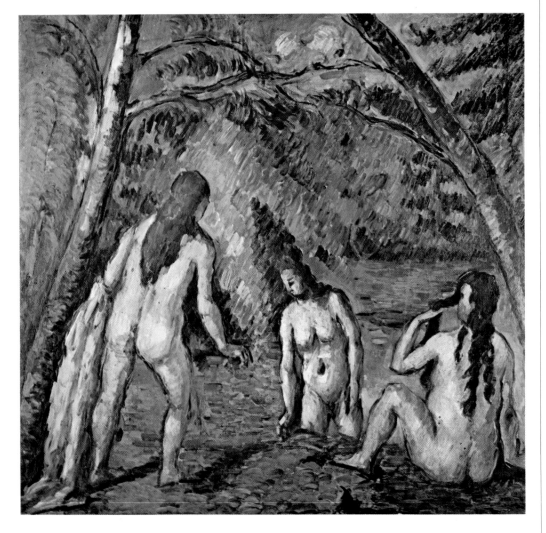

66
PAUL CÉZANNE: *Three Bathers. c.* 1879–82. Oil on canvas, 19⅝ × 19⅝ in (49.8 × 49.8 cm). Paris, Petit Palais

picture he would treasure and refer to for many years to come.

Despite the enthusiasm of artists and buyers, Pissarro predicted that the critics would fail to understand Cézanne's works, and he was confirmed in his view when he read Camille Mauclair's brief appraisal in the *Mercure de France* for January 1896. Mauclair's words were calculated to offend not only Cézanne, for whom his praise was far from unqualified, but also Pissarro and Gauguin (the latter was frequently the butt of Mauclair's witticisms). 'It is certainly late to be speaking of the Cézanne exhibition that Vollard held in rue Laffitte,' Mauclair began, 'and there's nothing I could say about it that is not already well-known here. Conscientious, simple, frank, but heavy and monochrome, exceptional in his still-lifes and certain landscapes, almost formless in his figures, rough and naïve, operating by guesswork rather than with knowledge, this solitary initiator of "late style" Impressionism has come to life again, leaving an impression of barbarism and distinctness. The peasant-like and singularly anti-intellectual aspects of some of these works [look] decidedly odd next to Whistler, Gustave Moreau and Monet. Gauguin derives entirely from Cézanne, and the Pissarros of 1885 likewise. But Gauguin added some toy-town philosophy to his Cézannes and Pissarro

67
PAUL CÉZANNE: *Woman with a Coffee Pot. c.* 1890–4. Oil on canvas, 51⅜ × 38 in (130.5 × 96.5 cm). Paris, Musée d'Orsay

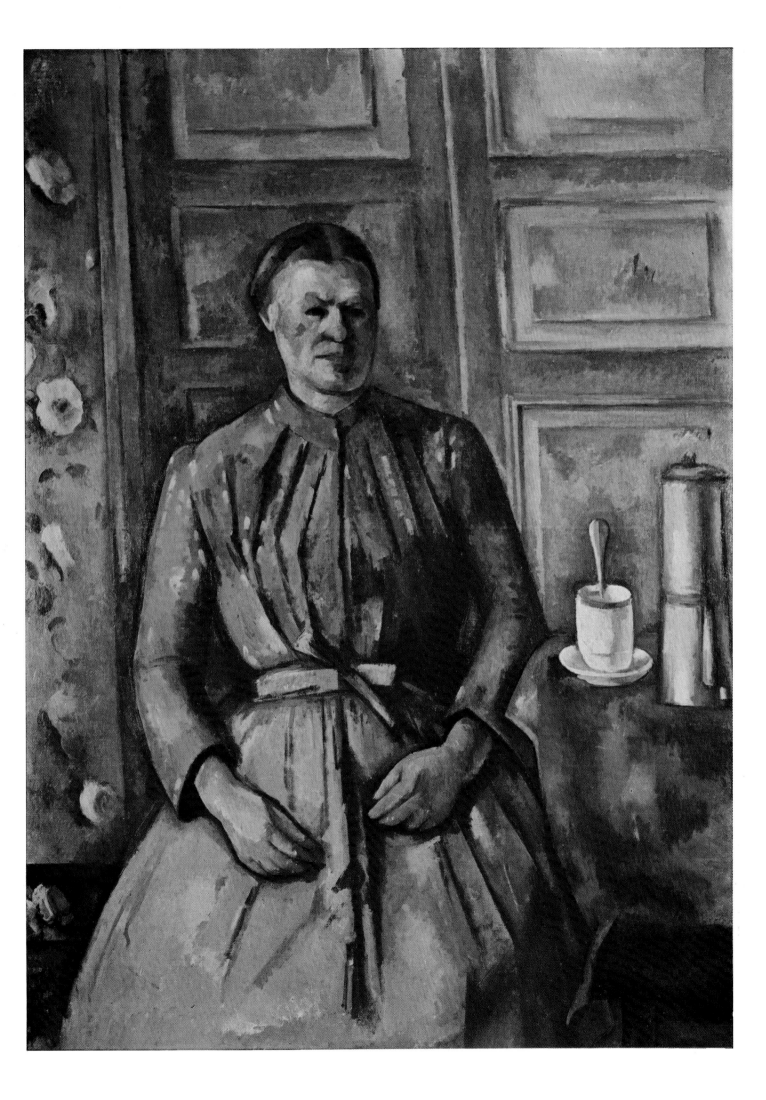

added the necessary attenuation to make his pictures saleable. Cézanne added nothing but Cézanne, and that's the way I prefer it.'

Even cut off in Tahiti, Gauguin was by no means indifferent to this sort of criticism, particularly when it was directed at the integrity of his Symbolist beliefs. And as a shareholder and regular recipient of free copies of the *Mercure de France*, a journal whose editorial line and breadth of interest he generally applauded, Gauguin was incensed to think that a literary upstart like Mauclair, with none of the requisite knowledge to judge art, should have reached the position of chief art correspondent. He wrote from Tahiti suggesting to the *Mercure*'s editor, Alfred Vallette, that Mauclair was out of place on his staff because he denigrated 'everything that has the courage of an idea, everything that isn't official, everything that isn't out of the Salon'.

Mauclair's snide remarks must also have been particularly wounding to Pissarro, who prided himself on never having sacrificed his artistic integrity, even in the most straitened of circumstances, and who in the early 1870s had himself guided Cézanne towards the direct response to nature on which his achievement so obviously rested. Pissarro complained to Lucien that Mauclair, coming fresh to Cézanne's work, like so many younger critics had completely failed to realize that 'Cézanne first of all underwent the influence of Delacroix, Courbet, Manet, even Legros, like the rest of us; he was influenced by me at Pontoise and I by him.' Like the Naturalists before them, the young Symbolist critics had fallen into the trap of assuming that painting had to be invented anew, from thin air as it were, and that one was failing to be 'original' if one's work resembled that of another painter.

Another critic who was new to Cézanne's work in 1895 was Thadée Natanson, editor of the eclectic but seminal journal *La Revue Blanche*. He sensibly adopted a more humble inquiring attitude to the work of a master he had never met. Surveying the broad range of Cézanne's subjects—still-lifes, portraits, bathers, landscapes—he observed that they in no way differed from the sorts of subjects one would find at the official Salon. What distinguished them was their sheer painterliness—'tout ce reste qui n'est que peinture'. The objects Cézanne chose to represent had no value in themselves, Natanson argued, they were simply pretexts for embroideries, festoons or arabesques. This view of Cézanne as an artist for whom subjects were irrelevant and formal concerns paramount—that is relationships between different parts of a composition and different colour patches, the boldness and purity of colours, the enamelled quality of surfaces and the arabesques of forms—although it had its roots in the Symbolist aesthetic of the 1890s, was to become the prevailing modernist view of Cézanne in the twentieth century. It was usually tempered, as here, by the reservation that there was something 'incomplete' about Cézanne's researches, a primitive clumsiness and hesitancy. Seeing him as a primitive carried the implicit, or occasionally explicit, assumption that he had begun a revolution that others would have to carry to completion. It is only relatively recently that this view of Cézanne as a painter for the eye alone has begun to be challenged.

Natanson could scarcely have failed to hear Cézanne's praises sung by the Nabis, artists with whom he had close personal as well as professional ties. And in fact as the 1890s wore on, the Nabis and their contemporaries increasingly came to see the influence of Gauguin as having less significance than that of Cézanne. Manifestations of this change of view took both written and pictorial form. For example, Émile Bernard wrote a naïvely laudatory profile of the artist for the *Hommes d'Aujourd'hui* series in 1891. And in 1895, when his anti-Gauguin campaign was well launched, he claimed in the *Mercure de France*, with some justification as well as a large measure of petulance, that he had learnt everything from the Aix artist. 'As for myself, I owe—and I'm happy to be able to record this here—almost all that is best in me to this master, to this true master, and not to Paul Gauguin as the ignorant have

68
PAUL CÉZANNE: *Portrait of Ambroise Vollard.* 1899. Oil on canvas, 39 × 31 in (99 × 78.7 cm). Paris, Petit Palais

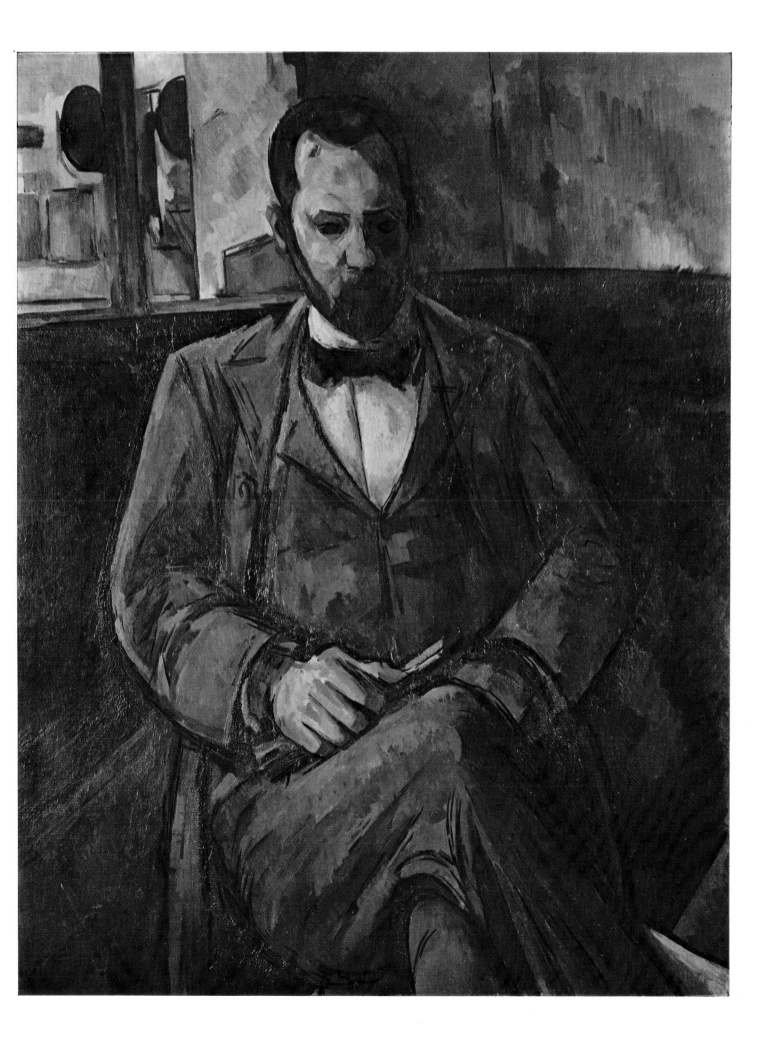

written...' Maurice Denis, who had come to Gauguin's defence in 1890, by the mid-decade was already gathering together what information he could find about Cézanne's working methods in preparation for a lengthy article eventually published in 1907, after the artist's death. In his journal for late 1899 he recorded Vollard's lively description of having his portrait painted by Cézanne (fig. 68), posing every morning and being obliged to sit extremely still as the artist applied his thin films of colour, waiting for each to dry before applying the next. At the least movement, Cézanne would complain that he had lost 'his line of concentration' and then bemoan his powerlessness to 'realize' work in the way that the Old Masters had done, citing as examples Veronese, Poussin, Le Nain, and, from the more recent past, Delacroix and Courbet.

In addition to assembling invaluable documentary evidence about Cézanne's secretive working methods, Denis embarked, in 1898, on a substantial painted homage. Although not as accomplished a group portrait as its notable antecedents by Fantin-Latour, (paintings which had paid homage to Manet and Delacroix), Denis's *Homage to Cézanne* (fig. 69) works well as a general statement about the former Impressionist's impact and influence on the avant-garde of the 1890s. It shows Redon (to the left of the composition), the critic Mellério (in the top hat), Vollard (behind the easel) and Marthe Denis, together with the Nabis Vuillard, Denis, Sérusier, Ranson, Roussel, and Bonnard. On the wall are paintings by Gauguin and Renoir, part of Vollard's stock. Just as he had been largely absent from Parisian art circles, Cézanne himself is absent from the painting, represented instead by a well-known still-life (fig. 63), which for many years had been the prized possession of Gauguin. The *Homage* thus records a specific set of economic circumstances, for there was a direct causal relationship between the help Vollard was beginning to be able to offer the Nabis (help they badly needed following the demise of Le Barc de Boutteville in 1896) and the success he was having in selling the work of Cézanne. That same year Vuillard had noted with pleasure his 'quite unlooked-for luck of selling some paintings, or rather clearing my debts to Vollard, who was suddenly enriched by the sale of a few Cézannes'. In more ways than one Denis's *Homage to Cézanne* can be seen as the outcome of the Cézanne one-man show of 1895.

The exhibitions of the 1880s and 1890s reveal different sets of attitudes and inter-relationships among advanced artists. The formation and fragmentation of rival avant-garde groups that had so marked the 1880s gave way to greater tolerance and individualism in the following decade, as the varied personnel of the Le Barc de Boutteville shows prove. Indeed the growing realization among artists of varied stylistic allegiances that Cézanne, who had made little effort to launch his work in Paris and no attempt to win followers (unlike Seurat and Gauguin), was an artist of great stature and importance, further supports the view of the 1890s as a decade of individual endeavour rather than of frantic jockeying for avant-garde status. Yet at the time of such grouping and re-grouping in the late 1880s, advanced artists formed no united front, as we have seen in the rivalry between Seurat's and Gauguin's groups. Even factions fragmented; witness Bernard's dissociation of his work from Gauguin's. Analysis of exhibitions does not reveal a logical or unified development from Impressionism, but rather a constantly shifting pattern of allegiances and rhetoric. If one can find no coherence in art politics or in matters of style at this period, a degree of consistency is to be found in artists' ideas and theoretical stances.

69
MAURICE DENIS: *Homage to Cézanne*. 1900. Oil on canvas, 71 × 95 in (180 × 240 cm). Paris, Musée d'Orsay

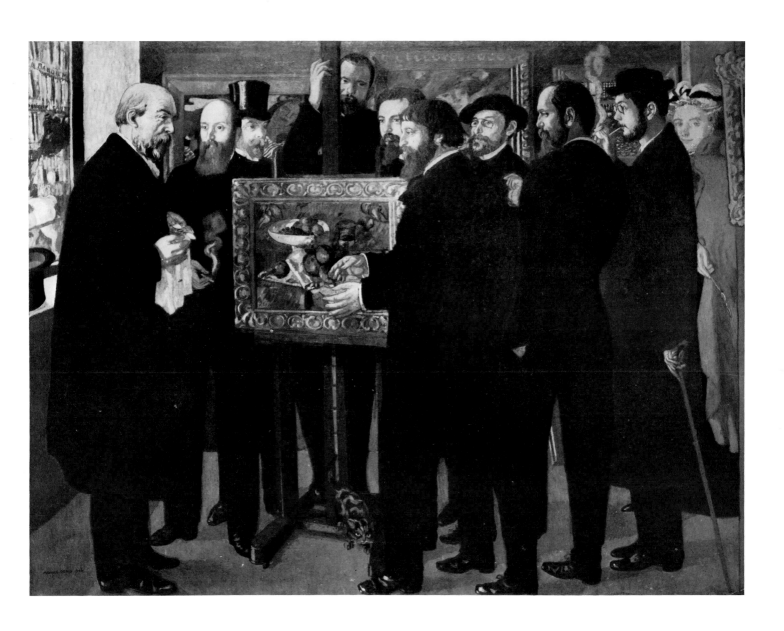

6 Ideas—From Naturalism to Symbolism

In the foregoing chapters we have had a taste of the variety and contradictions in the critical perceptions of new art in the 1880s and 1890s. The picture is a confusing one and a chronological approach to the events and life histories of this period would not really help to clarify it. What, then, were the main undercurrents, the received ideas, shared concerns and differences of opinion that formed the day-to-day experience of artists and critics at this time? A crucial factor was the broad shift that took place from the Naturalist aesthetic that had held sway in the 1870s and early 1880s to the Symbolist aesthetic that dominated the later 1880s and the 1890s. We can find an intriguing glimpse into the popular perception of this shift by comparing two illustrations that appeared in magazines of the period. *Le Monde Illustré* of 1879 published a drawing (fig. 70) of a recent costume ball at the Elysée-Montmartre dance hall. It was held to celebrate the 100th performance of the stage adaptation of *L'Assommoir*, Zola's immensely successful novel about working-class city life, and those attending were required to dress as types from the book, as workmen or as laundresses. The novel, first published in 1877, had sold 100,000 copies by 1881, shocking but fascinating its readers by its revelations of the more sordid aspects of Parisian life. The fact that in 1879 it could be turned into a society event is in itself indicative that Zola's reputation and the Naturalist doctrine as a whole had reached their apogee. A similar illustration dating from 1893 (fig. 71) shows another riotous Elysée-Montmartre ball, this time on a medieval theme. Again the date is significant. Ideas associated with the Symbolist movement, which had its formal inauguration in 1886 in the pages of exclusive reviews, by 1893 were on the verge of becoming common currency. Writers such as Octave Mirbeau and Maurice Denis were later to decry 'the fragile element of symbolism'—that is its encouragement of obscure medievalry and pseudo-mysticism, epitomized in the Pre-Raphaelite and primitive-inspired paintings of the Rose+Croix Salon.

It is often suggested that, just as Symbolism replaced Naturalism as the leading aesthetic in literature in the 1880s, so Post-Impressionism replaced Impressionism as the progressive idiom in painting. But for a number of reasons such a neat equation does not work. It suggests a complete change of scene and dramatis personae, and it raises again the difficulties and distortions involved in the term Post-Impressionism. The interrelations between ideas, writers and artists were far from clear-cut; it was more a question of evolution than of revolution.

On the one hand, many of the most significant figures in the visual arts during the 1880s had reached maturity within a broadly naturalist framework. They continued to work according to naturalist principles and yet increasingly found their work assessed in the language of Symbolism, a circumstance that neither Monet nor Pissarro, for example, seems to have found inappropriate. On the other hand, the Symbolist critical terminology developed during the 1880s was essentially oriented towards

70
H. MEYER: *Bal de l'Assommoir at l'Elysée-Montmartre.* 1879. Engraving from *Le Monde Illustré.* Paris, Bibliothèque Nationale

71
ANON: *Medieval Ball at l'Elysée-Montmartre.* 1893. Engraving from *Le Courrier Français.* Paris, Bibliothèque Nationale

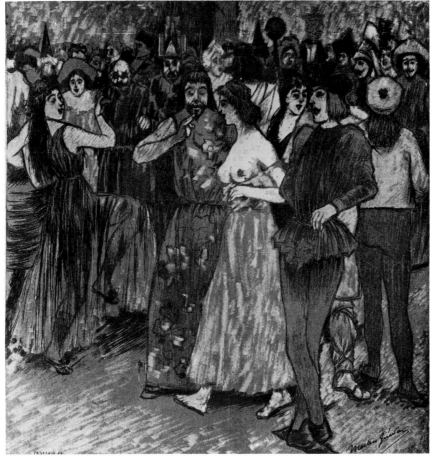

the art of a new generation. And indeed the work of such artists as Seurat and Gauguin was seen by the painters themselves, and by contemporary critics, as incorporating stylistic innovations commensurate with Symbolist ideas. We are faced here with complex and apparently contradictory problems. What could a Symbolist critic possibly find to commend in a painting produced by naturalist methods? What were the Symbolists' ideas about art? Were the innovative paintings of the young artists in the 1880s solely founded on Symbolist ideas or did they owe anything to their predecessors?

The importance artists attached to critical opinion and their awareness of its inevitable relativity are both well illustrated by Signac's somewhat wry observation in his journal for 1894: 'What the "advanced critics" most admired in *La Grande-Jatte* during the Naturalist period was the woman on the right, out walking with a young man and a monkey, because of her "look of an old harridan whom one doesn't keep waiting!" Nowadays the young Symbolists like the picture for "the hieratic stiffness of the figures that look as though they've come from an Egyptian bas-relief or a Benozzo Gozzoli fresco". Neither the critics of 1885 nor those of 1894 saw in it the superb purely *painterly* qualities of poor Seurat.' But in fact Signac himself paints a slightly false picture, for in 1886 Symbolist-oriented critics such as Fénéon were already talking of *La Grande-Jatte* in terms of 'primitive' art.

Another useful way of observing this shift in aesthetic outlook is to look at the ideas of a few individual critics and to assess how their expectations and demands for art subtly altered. What in fact did the Naturalist aesthetic consist of? Zola defined it succinctly by proclaiming that a work of art is equivalent to 'a corner of nature seen through a temperament'. It is worth remembering that this definition had a double edge which gave it considerably more breadth as an artistic approach than Zola's later detractors would have one believe. The Rougon–Macquart novels of course offer plenty of evidence of his conscientious documentary approach to nature. For example, when preparing himself in 1884 to write *Germinal*, his novel about the miners' strike, Zola carefully studied various reports of strikes, as well as every aspect of the lives and working conditions of the miners. And yet the personal element, the author's individual temperament, was also allowed to creep into the novel. Throughout, he used the potent but fanciful image of a subterranean monster for the mine itself, a lyrical element which he recognized but justified on the grounds that it was merely an exaggeration of the truth.

Zola's début as an art critic owed much to his close friendship with Cézanne. Like Cézanne, in the 1860s he had found common cause with Manet and the young Impressionists and had taken it upon himself to defend their stylistic innovations and their overturning of the traditional hierarchy of genres. But he soon tired of the sketchiness and unresolved aspect of Impressionist art in the 1870s. By 1880 he was already preparing to retreat, claiming that although the Impressionists would undoubtedly be of the greatest significance for the future development of modern art, they were still struggling. 'The great misfortune is that not one artist of this group has powerfully and definitively realized the formula that lies scattered throughout their works. The formula is there, infinitely divided; but nowhere, in none of them, does one find it applied by a master.' And of course in 1886 his novel *L'Oeuvre* seemed to many his final denunciation of the shortcomings of Impressionism.

In view of Zola's gradual withdrawal from his earlier position and from art criticism as a whole, probably the most important advanced art critic of the Naturalist school in the early 1880s was Joris-Karl Huysmans (fig. 73). He wrote a series of articles dealing with the annual Salons and the Impressionist shows between 1879 and 1882, which were published as a collective volume, *L'Art Moderne*, in 1883. As a novelist Huysmans had been a close disciple of Zola, producing such studies of the raw aspects of modern life as *Marthe, Story of a Prostitute* in 1876. Simil-

72
EDGAR DEGAS: *Ballet Dancers.* 1899. Pastel on paper, 24³/₄ × 23⁵/₈ in (63 × 60 cm). Paris, private collection

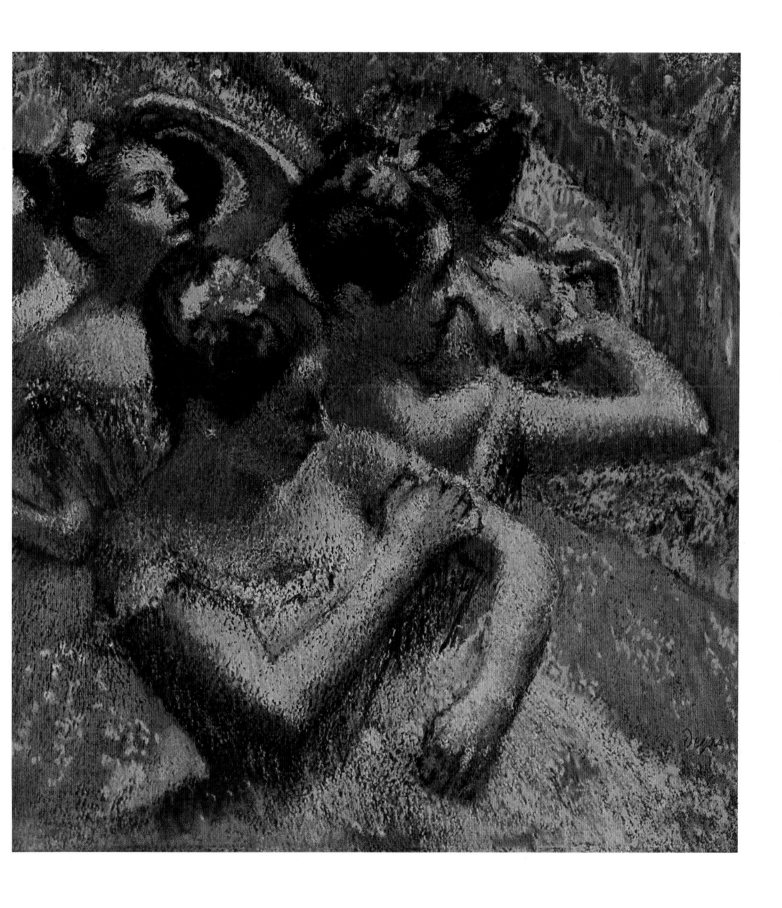

arly, his first writings on art followed the basic aesthetic tenets that Zola had laid down. Huysmans, however, was less shy about declaring his interests in the particular 'corners of nature' that artists chose to represent. His sympathies were all with the painters of modern life, and more especially of the city. This might have had the immediate effect of alienating the landscapists, but because he tried to couple his enthusiasm for novel subjects with discussion of novel technical means, all the Impressionist painters were at first prepared to listen to his criticism. His memorable cry, 'à temps nouveaux, procédés neufs' ('new times demand new techniques'), was one that accorded with their views. And certainly it was in the Impressionist exhibitions that Huysmans found his demands for 'modern truth' best satisfied. He hailed the Impressionists as the artistic equivalents of the Naturalist school in literature, something Zola had never been prepared to do. And whereas Zola felt that the tragedy of Impressionism was that it lacked a true master, for Huysmans there was little doubt that a master already existed in the shape of Edgar Degas. In his review of the Impressionist show of 1880, he eulogized Degas mainly from the point of view of his daringly broad choice of subjects which, he noted, went far beyond the ballet scenes for which the artist was most renowned to include washerwomen, race-horses, café-concert singers, women washing, and so on—all subjects that conventional academic standards deemed unacceptable but which Naturalist writers had in a sense opened up. He also praised Degas's technique, in particular the fact that he had abandoned the traditional but artificial chiaroscuro processes and methods of colour preparation and was prepared to apply pure colours according to the rules of optical mixture. His drawing style admirably combined precision and breadth (figs. 27, 72). Significantly, the only equivalent Huysmans could find for the revolution Degas had achieved in the technical sphere was in literature. Degas was likened to the Goncourt brothers—they too had 'had to forge a

73
Joris-Karl Huysmans.
Paris, Caisse Nationale des
Monuments Historiques,
archives photographiques

cutting and powerful tool, create a new palette of colours, an original vocabulary and a new language in order to make visible, almost tangible, the external visual form of the "human animal" in its natural habitat...' There was a world of difference in Huysmans's view between the sincere concept of modernity found in Degas and the 'false modernity' bandied about at the Salon by such artists as Bastien-Lepage and Gervex. Huysmans showed considerably less understanding of recent technical innovations in the domain of landscape painting: at one stage he declared Monet to be suffering from an eye defect because of his 'indigo mania' (passion for blue), and Cézanne to be a 'courageous fighter' whose works were prime examples of 'unresolved Impressionism'.

Gauguin was one of those who began to suspect that the critic had no eye for painterly qualities. In 1881 Huysmans warmly commended his *Nude* (fig. 74), but two years later Gauguin complained that it was on the basis of the subject alone—a frank everyday scene of a woman darning. Huysmans was guilty of a further lapse of taste in *L'Art Moderne*, at least in the view of Gauguin and

74
PAUL GAUGUIN: *Nude* or
Suzanne Sewing. 1880. Oil on
canvas, 45¾ × 31½ in
(115 × 80 cm). Copenhagen,
Ny Carlsberg Glyptotek

75
JEAN-FRANÇOIS RAFFAËLLI:
La Bièvre. 1880. Etching, 3rd
state, from Huysmans's
Croquis Parisiens.
3⅝ × 5½ in (9.2 × 14.1 cm).
New York Public Library

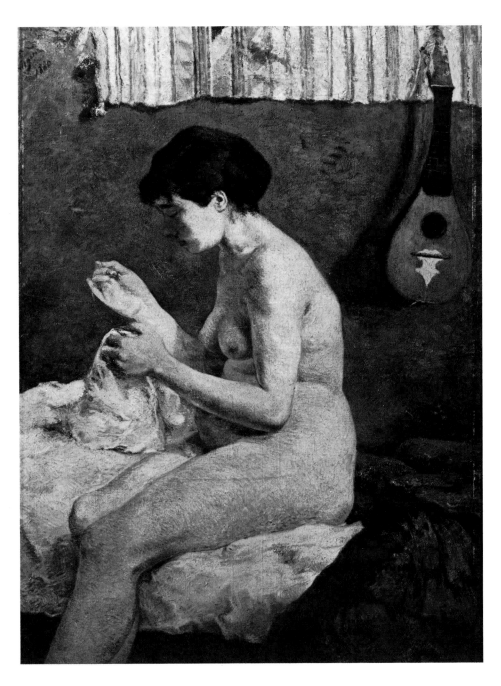

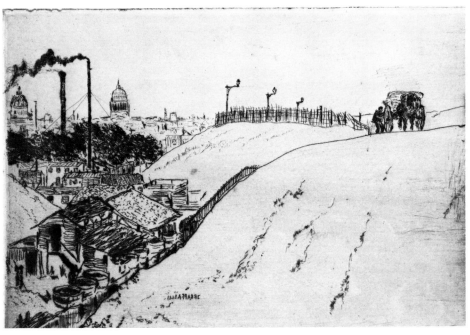

Pissarro, because he championed Jean-François Raffaëlli, an artist who had been briefly introduced to the Impressionist exhibiting group in 1880 by Degas. In the view of most of the landscape Impressionists, Raffaëlli was nothing but an opportunist upstart, and they felt that he appealed to Huysmans simply because he dealt with the subjects closest to the critic's heart—the wastelands and rag-pickers of Paris's industrial suburbs. In fact Raffaëlli was engaged by Huysmans in 1880 to illustrate his series of prose poems, *Croquis Parisiens*, and *La Bièvre* is one of the etchings from this collaborative venture (fig. 75).

Huysmans's review of the 1880 Impressionist show set out a full list of the subjects that he felt modern painters should be tackling. 'Everything remains to be done,' he wrote, 'official galas, salons, balls, corners of family life, of artisan and bourgeois life, shops, markets, restaurants, cafés, bars, in other words the whole of humanity, whichever social class it belongs to or whatever function it performs, at home, in hospitals, dance-halls, theatres, gardens, in poor streets or in those large boulevards whose American aspect is the necessary frame for the needs of our era.' Here laid out in full is the Naturalist canon of subject-matter, and these themes of modern life would be exploited in full by many painters of the generation then coming to maturity, by artists such as Seurat, Signac, Van Gogh, Anquetin, Toulouse-Lautrec, Bonnard and Vuillard (see, for example, figs. 76, 77). But they would not, ironically, find their staunchest supporter in Huysmans, whose tastes by 1883 were already beginning to veer away from this kind of modernistic Naturalism towards a very different kind of art—the fantasy art created by Moreau, Redon and Rops, all of whom he celebrated in his novel *A Rebours (Against the Grain)*, published in 1884. Although paradoxically *A Rebours* was still written according to Naturalistic principles, the tastes of its archetypal decadent hero, Des Esseintes, anticipated those of the up-and-coming generation of Symbolist writers. Prominent among the

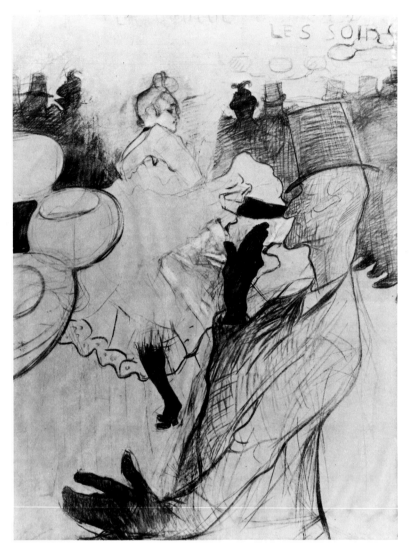

works of art in Des Esseintes's bizarre private collection were the paintings of Gustave Moreau and the drawings of Odilon Redon, with their obsessive nightmare imagery and frequent allusions to Romantic art and literature (figs. 78, 79). In 1884, when Redon's art was still virtually unknown, Huysmans's support was greatly appreciated—indeed the artist and the critic were to become close friends. Huysmans's new artistic tastes found expression in a fresh volume of criticism, published in 1889 under the title *Certains*. As the title suggested, the book dealt with individuals rather than groups.

76
HENRI DE TOULOUSE-LAUTREC: Study for the poster *Le Moulin Rouge*. 1891. Charcoal and coloured chalk on paper, 60⅝ × 46½ in (154 × 118 cm). Albi, Musée Toulouse-Lautrec

77
VINCENT VAN GOGH: *Restaurant de la Sirène*. 1887. Oil on canvas, 22½ × 26¾ in (57 × 68 cm). Paris, Musée d'Orsay

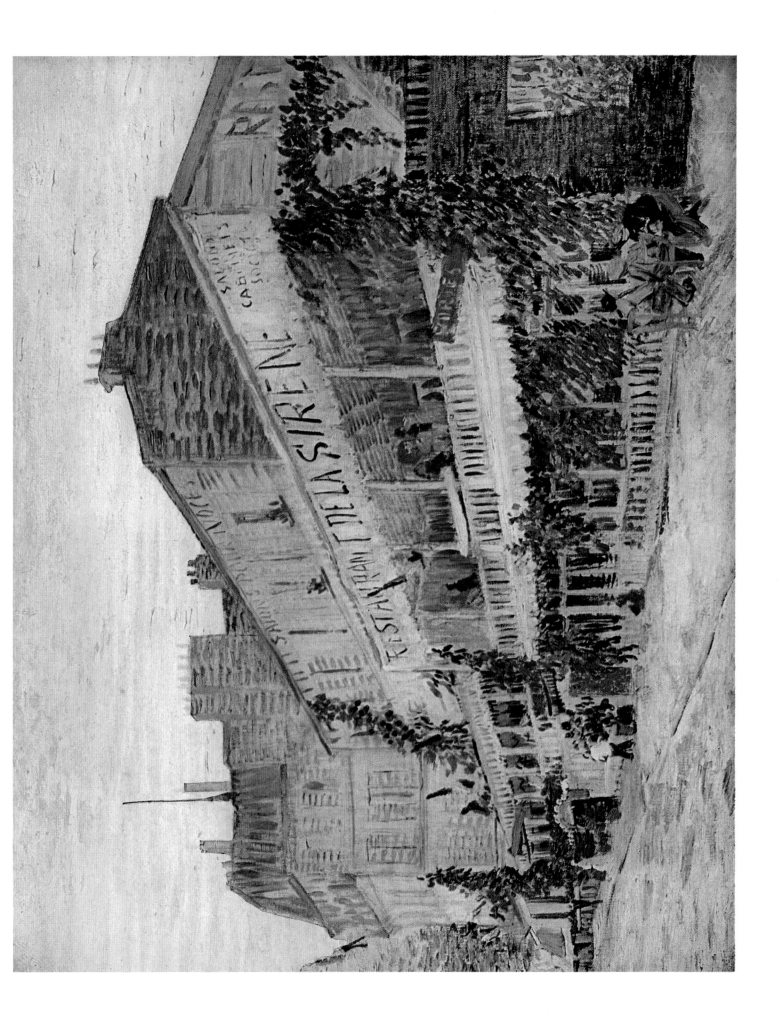

Reactions to *Certains* were mixed. Some readers who had applauded Huysmans's earlier commitment to *modernité* were disappointed. The critic Fénéon, for example, pointed out in a review of *Certains* that while Huysmans had rightly diagnosed several shortcomings in Impressionism, he had singularly failed to recognize a solution to those shortcomings in the achievements of Seurat: in other words, the critic whose taste had been formed in the 1870s could not keep pace with new trends. Because Huysmans had so curiously defaulted, Fénéon argued, and failed to recognize in the Neo-Impressionists a significant analogy to the Symbolist tendency in literature, it had been left to other younger writers to draw the Neo-Impressionists to the attention of the public, writers such as Gustave Kahn, Paul Adam—and he might well have added his own name.

The Neo-Impressionists themselves, having manifestly adopted so many of the subjects that Huysmans had listed, had clearly expected to have his whole-hearted support. In 1887 Pissarro, who had received a number of warm tributes from the critic for his down-to-earth kitchen garden and market scenes, clearly felt that Huysmans was basically sympathetic to their aims if temporarily a little discountenanced by their novel technique. He confidently predicted to his son, 'You'll see in a few years he'll adore the dot...' But Huysmans, although he wrote well of Seurat's seascapes, was not to be converted to the major figure works of pointillism. Paradoxically perhaps, the key to these failures to keep abreast of avant-garde ideas would seem to lie in Huysmans's basic commitment to Naturalism as a critical approach. For all his wallowing in the decadent and the fantastic in his later novels, he retained a deep respect for concrete detail, for the observation of material substances, for the precision with which an actual environment could be conjured up. And this was the legacy of his apprenticeship as a Naturalist author. Thus Gustave Moreau's richly jewelled ornate settings appealed to him more than Puvis de Chavannes's spare com-

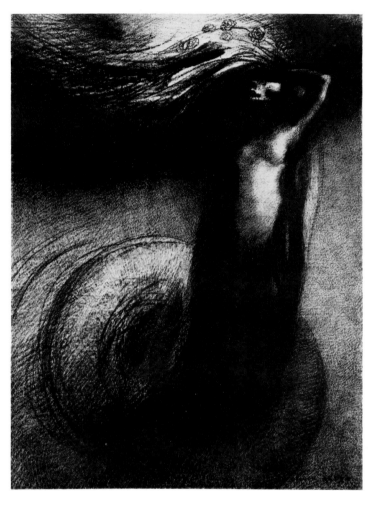

positions, simple contours and muted harmonies, just as a few years earlier he had been drawn to Caillebotte's and Degas's works not because of their simplicity of line or synthetic qualities, but because for him their accuracy evoked specific and identifiable milieux.

Although there were obvious divergences between the painters and the writers, the original Impressionists essentially belonged within a Naturalist aesthetic such as Zola and Huysmans had represented in their earlier writings on art. They shared the Naturalists' respectful attitude to nature and their belief in sensory rather than spiritual experience. Like them they were convinced that originality in art was a matter of 'temperament'. The letters of Monet, Pissarro

78
ODILON REDON: *Death: My Irony Surpasses all Others!* 1889. Lithograph from 'La Tentation de Saint Antoine', 10½ × 7¾ in (26 × 19.7 cm). London, British Museum

79
GUSTAVE MOREAU: *The Apparition.* 1876. Watercolour on paper, 41⅜ × 28⅜ in (105 × 72 cm). Paris, Musée d'Orsay

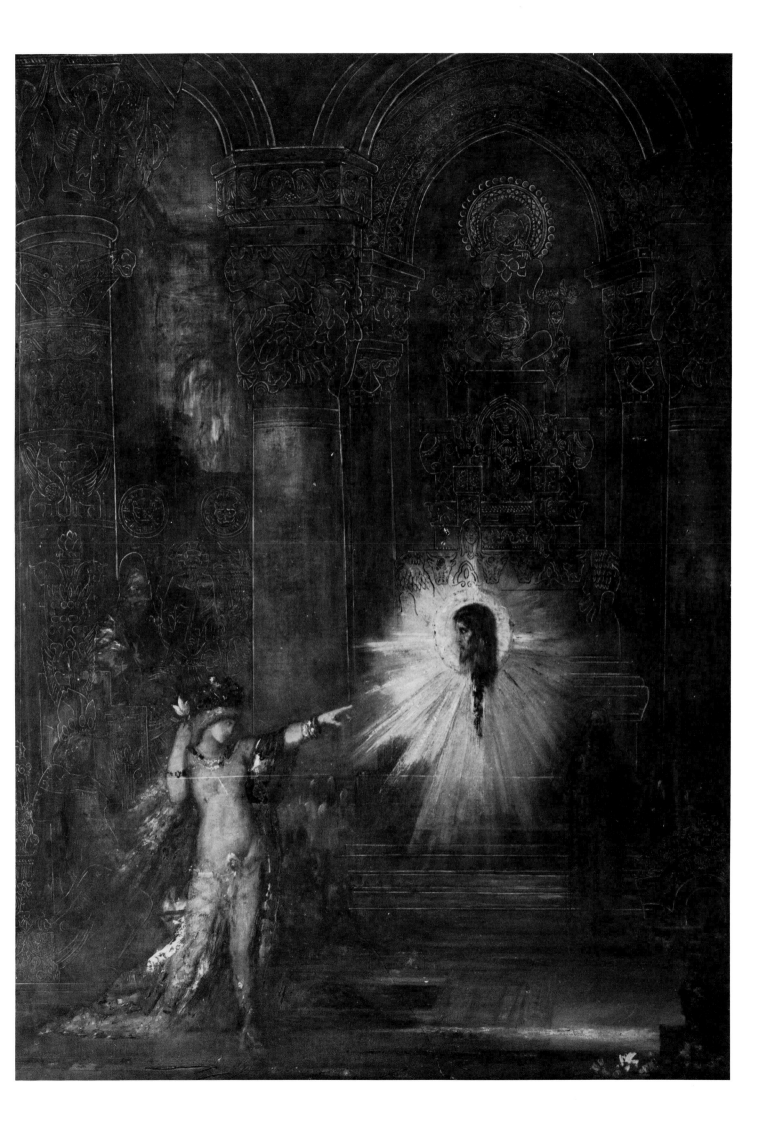

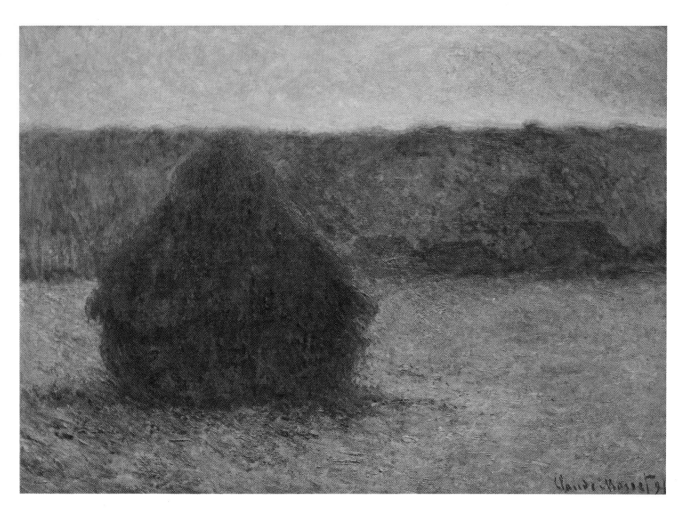

and Cézanne abound in references to the need to capture their 'sensations', in other words their initial sensory impressions, before a landscape. Monet particularly was convinced that the direct confrontation of nature was the right approach, despite the attendant difficulties of changing weather and light conditions. As he set about painting his series of *Haystacks* in 1890 (fig. 80), he wrote of his difficulties to his friend the critic Gustave Geffroy: 'I am working away: I am set on a series of different effects, but at this time of year, the sun goes down so quickly that I cannot follow it... I am working at a desperately slow pace... I am more and more maddened by the need to convey what I experience.' To the very end of his life and despite the attempts of younger artists and critics to appropriate his work and to inter-

pret his words to suit their own Symbolist ideas, Cézanne too emphasized his dependence upon the natural motif: 'The strong feeling for nature—and certainly I have that vividly—is the necessary basis for all artistic conception...', he told his friend the young poet Louis Aurenche. To Émile Bernard, who was responsible for eliciting from the aging Cézanne some of his most revealing artistic statements, he wrote: 'Now the theme to remember is that—whatever our temperament or strengths face to face with nature may be—we must render the image of what we see, forgetting everything that existed before us. Which, I believe, must permit the artist to give his entire personality, whether great or small.' This expression of faith in the Naturalist aesthetic might have been penned by his former friend Zola.

80
CLAUDE MONET: *Haystack at Sunset, Frosty Weather.* 1891. Oil on canvas, 25⅝ × 37¾ in (65 × 96 cm). Private collection

81
CLAUDE MONET: *Waterlilies.* c. 1916–22. Oil on canvas, 78¾ × 167¾ in (200 × 426 cm). Cleveland Museum of Art

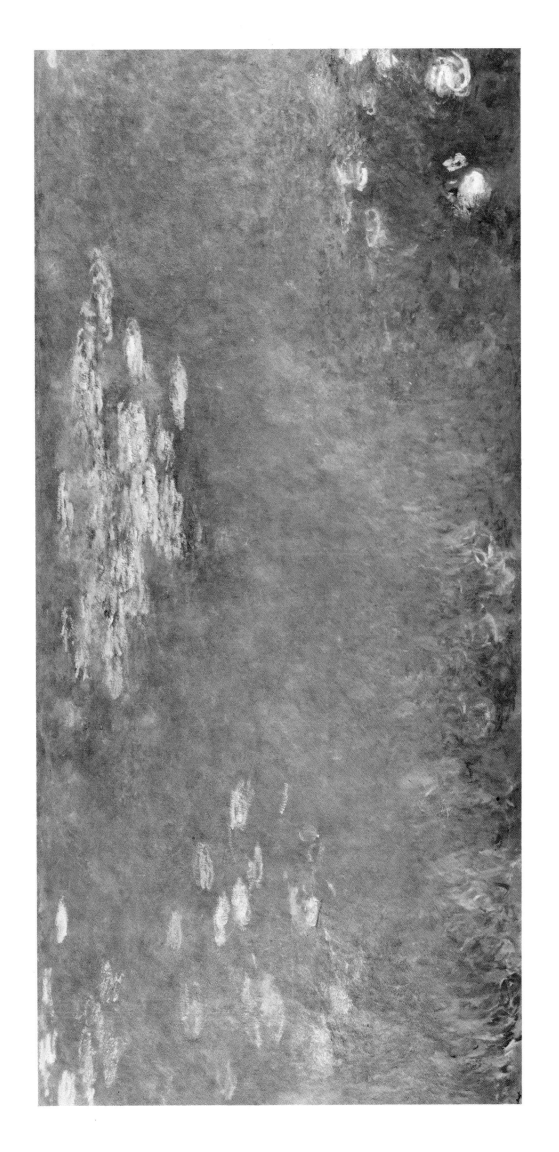

Like Monet, Cézanne put himself to considerable physical inconvenience in order to achieve the direct confrontation with the motif that he desired. He too braved inclement weather; and just as Monet in the latter part of his life was able to accommodate his uncompromising naturalism by investing capital, time and effort in his gardens at Giverny (figs. 81, 82), so Cézanne took out a stake in the countryside he loved; in 1901 he had a studio built for himself on the Chemin des Lauves, deep in the Provençal hills, the better to be able to paint his favourite landscape motif, the Mont Ste-Victoire (figs. 61, 164, 166). It was a romantic but fitting end to his career that one October day in 1906 he should have been carried home from his *plein-air* motif to his death-bed.

Naturalists in practice and inclination though they were, when we come to examine the complex encrusted paintwork of the later canvases of Monet, or the subtle interplay of abstract colour modulations in a late Cézanne, we are faced with the problem of relating their claims and stated aims to their achievements. Despite his faith in the naturalistic outlook, from the later 1880s onwards Monet spent more and more of his time 'completing' his canvases in the studio under conditions that by his standards were artificial, and the results can be seen in his more unified and integrated textures and colour harmonies. When we consider how these works were perceived by contemporary critics the sense of conflict becomes more acute. In 1891 Monet's *Haystacks* series was exhibited as a group at Durand-Ruel's gallery, and Gustave Geffroy praised them in glowing terms, not only for the subtle shifts in light effects and enveloping atmospheres that Monet had spoken of capturing, but also for their propensity to evoke particular moods: 'From all these aspects of the same place, expressions are transmitted that are similar to smiles, slow darkenings, deepnesses and silent stupors, certainties of strength and passion, violent intoxications.' Like Monet's, Geffroy's aesthetic attitudes had matured in a Naturalist climate, but by 1891 it had become more appropriate for him to

talk of such pictures as Monet's *Haystacks*— ostensibly painted with the most scrupulous attention to minute changes of light—in Symbolist terminology. Praised in such terms, Monet's paintings could have meaning for a younger generation, and the idea that Impressionism was considered *retardataire* or irrelevant to the 1890s is given the lie. Geffroy also extolled Cézanne's paintings three years later, seeing them essentially as exercises in decorative pattern-making. 'His painting takes on the muted beauty of tapestry, arrays itself in a strong harmonious weft, or else coagulated and luminous it assumes the aspect of the picture of a piece of richly decorated pottery' (see figs.. 63, 66). The relevance of Cézanne's choice of motif and his commitment to realizing its appearance were persistently denied by critics of the 1890s. Émile Bernard, for example, asserted, 'Where others, to express themselves, are concerned with creating a subject, he [Cézanne] is content with certain harmonies of lines and tones taken from any old objects, without troubling himself about these objects in themselves.'

There was, then, an uneasy relationship between what critics saw in and claimed for Monet's and Cézanne's works in the 1890s and what the artists themselves thought they were achieving. It forces us to question just what the new generation of critics now expected from painting. We need to ask how their criteria for making judgements of quality differed from those of their predecessors, and on what philosophical bases their aesthetic criteria rested.

Among the innumerable attempted definitions of Symbolism that one finds scattered through the writings of the 1880s, one or two stand out for their memorable brevity. In 1886, the year in which Symbolism was formally launched, Gustave Kahn, for example, reduced the Symbolists' overall aims to the slogan: 'The essential aim of our art is to objectify the subjective in place of subjectifying the objective.' But for all its conciseness it is a statement that needs to be analysed and set in a context before its meaning becomes clear. As we have seen,

82
Monet painting in his garden at Giverny. Paris, Bibliothèque Nationale

the Naturalists took nature as their starting-point and represented it through the filter of a temperament—in other words it was a question of 'subjectifying the objective'. The Symbolists, on the other hand, regarded 'nature' as unstable, illusory, no more than a collection of external appearances. For them, only ideas had any substance. But they accepted that in order to convey these ideas, certain external signs or symbols were necessary. Thus art was said to consist of 'objectifying the subjective'. This is how the poet Jean Moréas explained the objectives and methods of Symbolist poetry in his historic manifesto of 1886: 'Symbolist poetry, which is the enemy of didacticism, declamation, false sensibility and objective description, aims to clothe the Idea in a tangible form which would not, however, be an end in itself, but would remain subsidiary, while serving to express the Idea... Thus it would be unthinkable in this art for pictures of nature, the actions of human beings, or any concrete phenomena to manifest themselves in their own right: they are simply tangible appearances intended to represent their esoteric affinities with certain primordial ideas.'

A number of factors played their part in bringing about this aesthetic revolution. Firstly, there was a general impatience for change. Naturalism had run its course, as all manifestations of art must, and the time was ripe for another movement to take its place. 'For almost twenty years', he complained, 'we have had an art which has systematically denied the ideal, which has taken material description as its immediate aim, has substituted the "sensation" for the study of the soul, hardening itself in detail and anecdote, and becoming intoxicated with platitude and vulgarity.' Another factor, indicated by the objections Moréas raised to Naturalism, was the rise of a new spirit of anti-Positivist Idealism. The Positivism of the philosophers and writers Auguste Comte, Hippolyte Taine and Émile Littré,

which had held sway since the mid-nineteenth century and which formed the essential philosophical basis for the Naturalist aesthetic, was now under threat from various forms of Idealism. The newly translated writings of Schopenhauer were much in vogue, and there was a resurgence of interest in Neoplatonist ideas in general. In aesthetic terms the result of these Idealist influences was to restore primacy to the individual creativity and to the imagination. It would no longer do for the artist to observe and catalogue the banalities and minutiae of detail in the natural world: his role would once again be much more elevated. He would be required to initiate his viewer into a higher realm of experience, using signs and symbols that were generally intelligible. Thus it was that the typical Symbolist critic, instead of seeking qualities of truth, fidelity to nature, or accuracy of detail, was on the look-out for works of art that made synthetic or symbolic use of the forms of nature in order to express a more definitive meaning, a state of mind or an abstract idea beyond the concrete, material world.

The term 'synthesis' crops up as frequently during the later 1880s in the discourse of Symbolist critics and painters as did the term 'sensation' a generation earlier. A vital component of the Symbolist aesthetic creed, it was intoned by critics who were in other respects (for instance politically, socially and in religious terms) fundamentally opposed—critics such as Félix Fénéon and Albert Aurier (figs. 83, 84). Indeed, although they shared some common ground, and admired some of the same artists, they had very different theories as to why those artists were significant. By examining some of the uses made of this term 'synthesis' we can get some way towards understanding what critics looked for in the avant-garde art of the 1880s and 1890s, and what the artists themselves aimed for via apparently disparate stylistic routes.

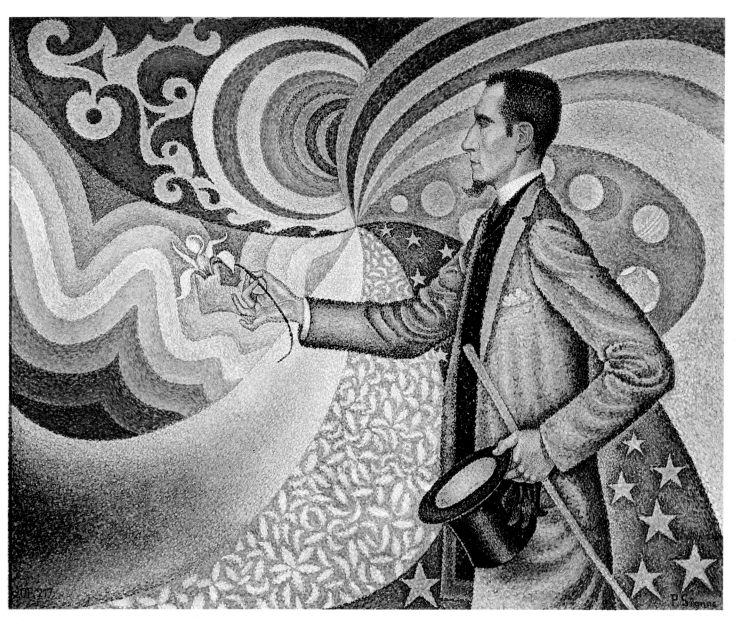

7 Synthesis

Broadly speaking, the term 'synthesis' was used to denote an artistic unity achieved through the conscious simplification of drawing, of composition and of the harmonization of colours. Maurice Denis wrote that to 'synthesize is to simplify in the sense of *rendering intelligible*', and indeed there is an implicit intellectualism in the concept as well as the idea of reality seen at one remove. But because 'synthesis' was such a central term in the art criticism of the 1880s it has become customary to make a distinction between the 'analytical' Impressionists and the 'synthetic' approach of Post-Impressionists. This view is ill-founded. We have already seen how Signac recognized analytical and synthetic phases within the development of Neo-Impressionism. And in the first half of the 1880s several artists of established reputation—among them some exhibitors at Impressionist exhibitions—were seen to be producing work that evinced pronounced synthetic tendencies. Pissarro's 1882 etching of *The Potato Harvest* (fig. 30) and Puvis's *Poor Fisherman* (fig. 94), quite as much as the nudes Degas showed in 1886, preferred to explore the essential form rather than to detail accessories, and such images achieved successful simplification by the telling appropriateness of their bounding line; what these three apparently disparate artists had in common was the quality of their draughtsmanship. Here, then, were contemporary examples from which young artists could learn, but the hieratic qualities of Ancient Egyptian art, the 'primitives' of the Italian and Northern European quattrocento, the Japanese wood-block of the eight-

eenth and early nineteenth centuries and the caricatures of Daumier (figs. 85, 86, 87) also served to advance the 'synthetic' cause.

Let us then look at the ways in which two of the most ambitious artists of the decade achieved, and were seen to have achieved, possibilities for new kinds of visual expression.

Unlike Pissarro, Gauguin and Van Gogh, Georges Seurat (fig. 88) was not a prolific correspondent, nor was he given to making public his aesthetic aims. A study of his artistic development, however, reveals the

85
UTAGAWA KUNIYOSHI:
Courtesan Dressing.
1843–6. Colour woodcut,
14 × 9¾ in (35.7 × 25 cm).
University of Kansas,
Spencer Museum of Art,
May Finney Marcey
Collection

86
FRA ANGELICO: *The
Annunciation. c.* 1440. Fresco,
91½ × 127¼ in
(230 × 321 cm). Florence,
San Marco

87
HONORÉ DAUMIER: 'Comme
c'est heureux pour les gens
...' 1862. Lithograph from
Le Nouveau Paris.

VIRGINIS INTACTE CVM VENERIS ANTE FIGVRAM PRETEREVNDO CAVE NE SILEATVR. AVE

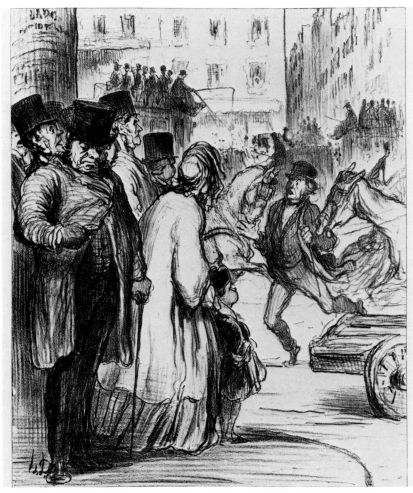

remarkable consistency of his approach. From his student days he made a practice of studying in his sketchbook, for future reference, particular facets of modern life. By the early 1880s he was working these individual notations into more substantial drawings or painted studies, exploring for instance the full range of chiaroscuro effects attainable with conté crayon on rough-textured paper (figs. 89, 91). Readable at one level as pure studies in light and shade, they are also emblematic images of contemporary life in the 1880s. They cut out all unnecessary detail and concentrate on strong, silhouetted shapes—be it of a female in profile with the typical 1880s bustle or the arch of a suburban railway bridge. In this way Seurat established for himself, committed to memory almost, a repertoire not only of urban and suburban (fig. 90) figural types—but also of compositional structures upon which to draw in his later career. If he was accused by critics, seeing *La Grande-Jatte* for the first time, of having a caricatural approach, this was not so much because he exaggerated what he saw—though this is to some extent true of his later images such as *The Circus* (fig. 140)—but rather because, when pared down to their essential forms and contours, contemporary fashions did appear ridiculous and wooden. As Fénéon pointed out, neither his landscapes nor his urban images were leavened with any of the accidental or anecdotal incidents that were habitually used by naturalistic painters of modern life.

The synthetic process is observable both in Seurat's preparatory drawings and in the final realization of his major compositions. When planning *Une Baignade* or *La Grande-Jatte* (figs. 11, 29) he not only made numerous drawings of the individual figures—of the bather seen in profile for instance—he also made a series of small-scale oil sketches in which he worked out the compositional scheme. Having settled on his stage set, as it were, rather like a choreographer or theatre director, he tried placing against it first one figure, then another, then a group, then a dog, before coordinating the final ensemble. Despite his calculated use of interlocking

and echoing shapes in *La Grande-Jatte* (the arcs formed by the parasols, the bustles, the sails and the monkey's tail), the figures retain a great isolation and seem not to interrelate. If the gestures and figures seem formalized and hieratic, as several critics noted, this is largely no doubt because they are presented either in profile or facing the spectator. They form horizontals and verticals like the trees and their shadows, rather than diagonals that would tend to break up the rigidity and suggest movement.

Seurat owed as much to other artists as he

88
ERNEST LAURENT: *Portrait of Georges Seurat.* 1883. Black chalk on paper, $15\frac{3}{8} \times 11\frac{3}{8}$ in (39 × 29 cm). Paris, Louvre — Cabinet des Dessins

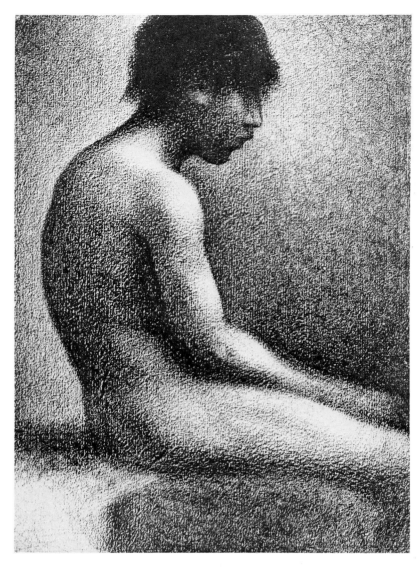

89
GEORGES SEURAT: *Bather,* study for *Une Baignade.* 1883–4. Conté crayon on paper, 12⅜ × 9½ in (31.5 × 24 cm). Edinburgh, National Gallery of Scotland

90
GEORGES SEURAT: *The Stonebreaker.* 1882. Oil on panel, 6⅜ × 10 in (16.2 × 25.4 cm). Washington, Phillips Collection

did to contemporary scientific and Symbolist theory. One of his main stylistic debts was to Puvis de Chavannes, as critics were quick to realize (fig. 95). In the early 1880s Seurat, together with his studio colleague Edmond Aman-Jean, had visited Puvis's studio and helped him square up the sketches for the vast mural *The Sacred Grove* (fig. 7). Both subsequently produced compositions that were closely modelled on Puvis. But whereas Seurat's modernization of a Puvis theme in *Une Baignade* proved too radical for the Salon jury of 1884, two years later the same jury accepted Aman-Jean's *Sainte Geneviève* (fig. 93), a much more straightforward plagiarism of the elder artist's subject and style. At the purely formal level Seurat too had adopted wholesale certain features of Puvis's mural compositions—their scale, their relation of figure to landscape, and their use of the broad horizontal sweep intersected by strong verticals and diagonals. Indeed, such was the similarity between their overall synthetic approach to nature and their compositional procedures that, when Vincent Van Gogh came to make a memory sketch of Puvis's *Inter Artes et Naturam* for the benefit of his sister Wilhelmina (he had just seen it at the 1890 Champ de Mars Salon), he unwittingly confused its overall appearance with Seurat's *La Grande-Jatte* (figs. 92, 17, 29).

Much of Seurat's career can be seen as an attempt to impose a system onto what was beginning to be seen as the far too arbitrary and romantic business of *plein-air* painting. He tried to reduce the previously haphazard colour use of the Impressionists to certain codifiable procedures following the laws of colour mixture and contrast set out by the chemist Chevreul. Later in his career he explored the theory that linear directions convey emotion as well as movement, a preoccupation with 'correspondences' that linked him to his contemporaries among the Symbolist poets, and to theoreticians like Charles Henry. If his experimentation with these theories in his later urban figure paintings—in the upward-tending flares in *La Parade*, for example (fig. 96)—now seems

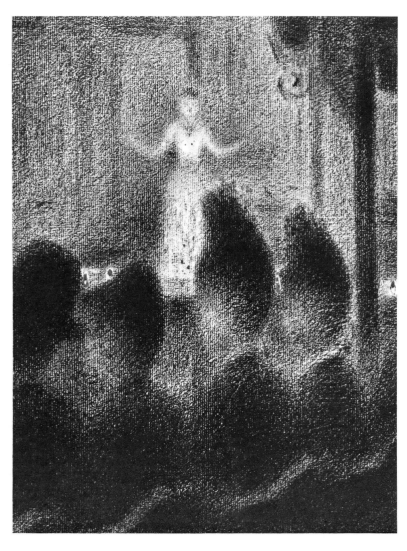

somewhat dry, academic and mechanical, his success in reducing his more neutral seascape subjects to harmonious arrangements of line and colour was then, and remains today, more immediately appealing.

As we have already seen, in the work of Seurat and the Neo-Impressionists the Symbolist critic Fénéon found the complete answer to his aesthetic demands. Although he saw them as organically linked to the Impressionists, they also represented for him a significant refinement and distillation of the earlier manner. In a review of 1887 he summarized the differences between them. Whereas the Impressionists in the 1870s had

91
GEORGES SEURAT: *Au Concert Européen*. 1887–8. Conté crayon on paper, 12¼ × 9⅜ in (31.1 × 23.9 cm). New York, Museum of Modern Art, Lillie P. Bliss Collection

92
Letter from Vincent Van
Gogh to his sister
Wilhelmina with memory
sketch of *L'Arlésienne* and
Puvis de Chavannes's *Inter
Artes et Naturam*. June 1890.
Amsterdam, Rijksmuseum
Vincent Van Gogh

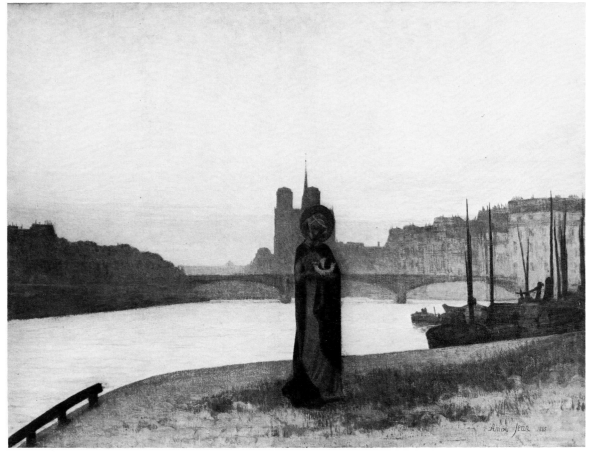

93
EDMOND AMAN-JEAN: *Sainte
Geneviève*. 1885. Oil on
canvas, 29⅛ × 41⅜ in
(74 × 105 cm). Brest, Musée
des Beaux-Arts

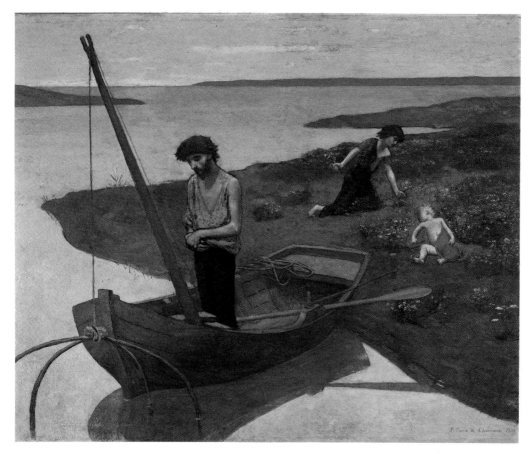

94
PIERRE PUVIS DE
CHAVANNES: *The Poor
Fisherman*. 1881. Oil on
canvas, 61¾ × 75¼ in
(157 × 191 cm). Paris,
Musée d'Orsay

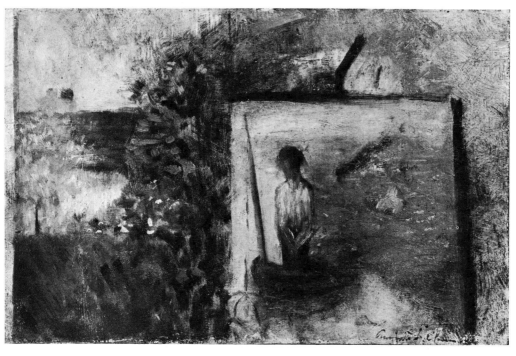

95
GEORGES SEURAT: *Landscape
with Puvis's Poor Fisherman*.
c. 1882. Oil on wood,
6⅝ × 10 in (16.8 × 25.4 cm).
Paris, Private
Collection

96
GEORGES SEURAT: *La
Parade*. 1887–8. Oil on
canvas, 39¾ × 59⅛ in
(99.7 × 150 cm). New York,
Metropolitan Museum of
Art

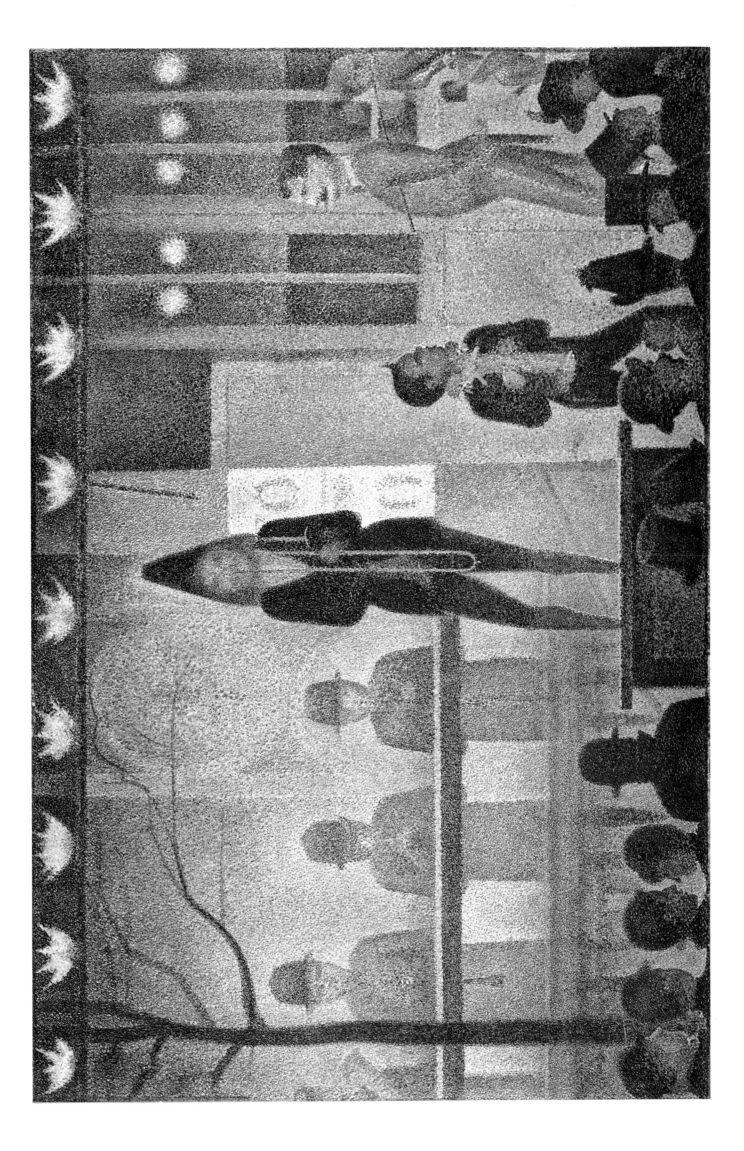

made it their aim to seize the fugitive aspects of nature and had reinforced the immediacy of the captured moments by completing their landscapes in one session, the aim of the Neo-Impressionists was, on the contrary, to 'synthetize a landscape in a definitive aspect which perpetuates the sensation [it produces]', an aim which, like their pointillist technique, involved a more measured studio-based working method. If they had recourse to science it was simply as a means towards the expression of subjective truths and not as an end in itself. The scientific aspect of their work did not conflict with what Fénéon saw as its basic anti-naturalistic orientation. The reason why their works stood out among the mass of mechanical copiers of exterior aspects of nature was, Fénéon claimed, that 'objective reality is to them a simple theme for the creation of a higher sublimated reality.'

From the mid-1880s on there are frequent references in Gauguin's writings to his conscious striving after synthesis. It was a goal he initially set himself in his draughtsmanship. One critic of the 1886 Impressionist show noted the return of the expressive use of line as a distinctive and forward-looking feature in the work of several exhibitors. Although Gauguin exhibited no drawings in that show, it was certainly through the development of his drawing, initially under the watchful eye of those prolific draughtsmen Degas and Pissarro, that he succeeded in freeing himself from Impressionist mannerisms and creating the more synthetic style that he had long spoken of, a style that was capable of expressing his ideas (fig. 98). His initial paintings of Brittany in 1886 were tentative naturalistic landscapes, but in his drawings of Breton figures done at the same time he was already achieving a more synthetic and simplified manner. Back in Paris he reworked and further reduced these sketched observations to their essentials in order to make ornamental use of them in his ceramics. The use of memory played a crucial part here. The most resolved figure painting resulting from his first stay in Brittany is the *The Four Breton*

Girls (fig. 97). The picture is innovative in its bold linear design rather than in its paint handling, and, like the ceramic pots, seems to have been a studio concoction made in Paris after Gauguin's return from Brittany.

From a letter to his friend Schuffenecker in 1885 it is clear that Gauguin's intellectual grasp of what needed to be done in order to achieve synthesis in his painting was way ahead of the ability of his hand to put these ideas into practice. He was convinced, for example, that there were properties in lines and colours suited to express every human emotion. And he was equally sure, as he advised Schuffenecker, of the need for simplification: 'Don't sweat over a canvas; a great emotion can be translated instantly, dream about it and seek for it the simplest form.' By 1888 he was stressing the need to get away from the close observation of nature, to abstract from reality. And at last he could claim with confidence to have achieved this synthesis in his own work. He had completed some studies of bathers, drawn in a manner that was no longer so indebted to Degas, as he himself remarked, and painted 'flatly'—that is, without the painterly facture that was so intrinsic to Impressionism.

Bernard's arrival in Pont-Aven in August 1888 and the stimulus of his Symbolist ideas and cloisonnist experiments provided an important additional impetus for Gauguin to abandon the naturalist approach. His ideas were confirmed by the younger artist's anti-naturalistic procedures. In the *Vision after the Sermon* (fig. 99), prompted by the example of Bernard's bold painting of *Breton Women in the Meadow* (fig. 100), Gauguin played up the decorative possibilities of the Bretonnes' white coiffes, and for the first time dared to abandon naturalistic colour and spatial treatment. But the picture was more complex and ambitious than Bernard's—it was Gauguin's bid to prove that lines and colours were capable of expressing intangible ideas. When Gauguin insisted that it was necessary not to paint too much after nature—and this was the main theme of the advice he offered Vincent Van Gogh in Arles in late 1888 (see

97
PAUL GAUGUIN: *The Four Breton Girls*. 1886. Oil on canvas, 28 × 35½ in (71 × 90 cm). Munich, Bayerische Staatsgemäldesammlungen

98
PAUL GAUGUIN: *Head of a Breton Peasant Girl. c.*1888–9. Graphite, crayon and watercolour on paper, 8¾ × 7⅞ in (22.4 × 20 cm). Cambridge, Mass., Fogg Art Museum

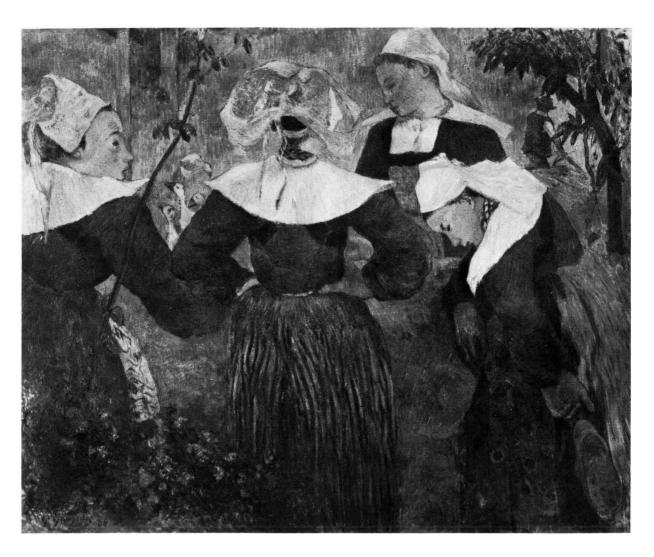

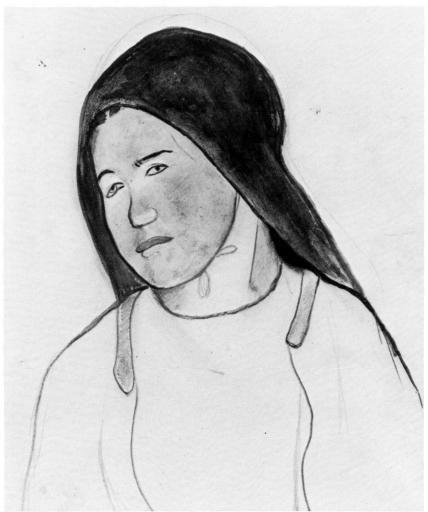

99 PAUL GAUGUIN: *Vision after the Sermon: Jacob Wrestling with the Angel*. 1888. Oil on canvas, 28¾ × 36½ in (74.4 × 93.1 cm). Edinburgh, National Gallery of Scotland

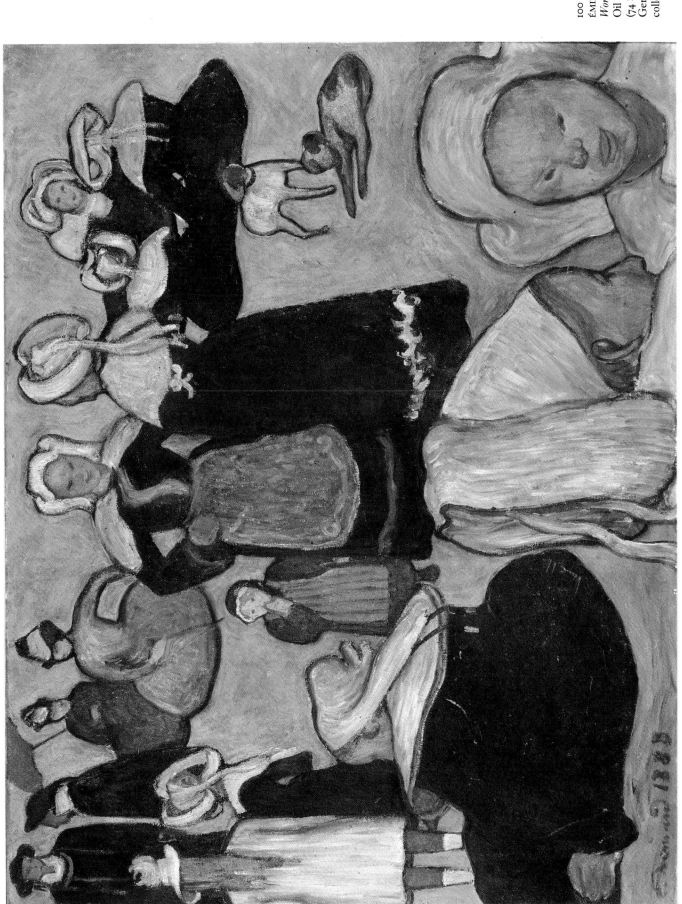

100
ÉMILE BERNARD: *Breton
Women in the Meadow.* 1888.
Oil on canvas. 29 × 36¼ in
(74 × 92 cm). Saint
Germain-en-Laye, private
collection

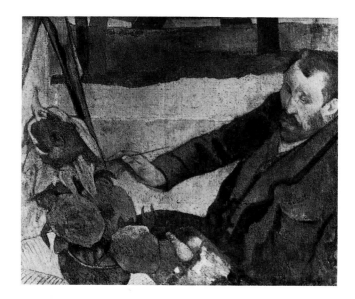

101
PAUL GAUGUIN: *Van Gogh Painting Sunflowers*. 1888. Oil on canvas, 28¾ × 35½ in (73 × 91 cm). Amsterdam, Rijksmuseum Vincent Van Gogh

fig. 101)—his concept was twofold. He meant that it was necessary to forget the trivial details of natural appearances and retrieve the essential forms (something Van Gogh was already successfully doing), and also that it was necessary to go beyond the experience of real life and to create a visionary world of thoughts and dreams.

Viewed cynically and from a historical perspective, there was more than a hint of opportunism about the use of the word 'Synthetist' in the title of the Volpini show in 1889. It was as though Gauguin, Bernard and their associates were attempting to claim some kind of spurious entitlement to the concept. While they could be certain that this topical term would serve to awaken the interest of the progressive critics of the day, all of whom by that stage were conversant with, if not actively employing, the Symbolist critical vocabulary, they must equally have been aware that the term had already been applied consistently to the art of Seurat, and occasionally to the art of Pissarro, Degas and Puvis de Chavannes.

The sort of claims made in 1891 for Gauguin's art by Aurier as a direct result of the Volpini show were similar though more extravagant than those made by Fénéon four years earlier for the art of Seurat. If Seurat's art, according to Fénéon, synthetized 'a landscape in a definitive aspect which perpetuates the sensation [it produces]', Gauguin's art, according to Aurier, was no longer confined to the expression of 'sensations'; it had achieved a higher aim—that of expressing ideas through a special language of lines and colours (figs. 2, 99, 117).

There was, then, in the 1880s a recognizable aesthetic shift from a broadly Naturalist to a broadly Symbolist outlook. Taking account of this shift enables us to make sense of the changes that took place in the art of the younger avant-gardes, and to appreciate the aspirations they had for their art, and the critical interpretations of that art. As we have noted, the latter part of the 1880s and the 1890s saw the dominance of the Symbolist aesthetic—but Symbolism was a broad church and its doctrines were decidedly nebulous. It could accommodate critics and artists of such different approaches as Fénéon and Aurier, Monet, Seurat and Gauguin. And we do wrong to assume that Naturalism had become obsolete. Both the *plein-air* aesthetic of Cézanne and Monet and the subjects of Toulouse-Lautrec testify to its continuing vigour. Only a preparedness to consider such a variety of concepts, paradoxes and contradictions enables us to appreciate the artistic and intellectual vitality of this era.

102
PAUL GAUGUIN: *Tahitian Women Bathing. c.* 1891–2. Oil on canvas, 43¼ × 35¼ in (110 × 89 cm). New York, Metropolitan Museum of Art, Lehman Collection

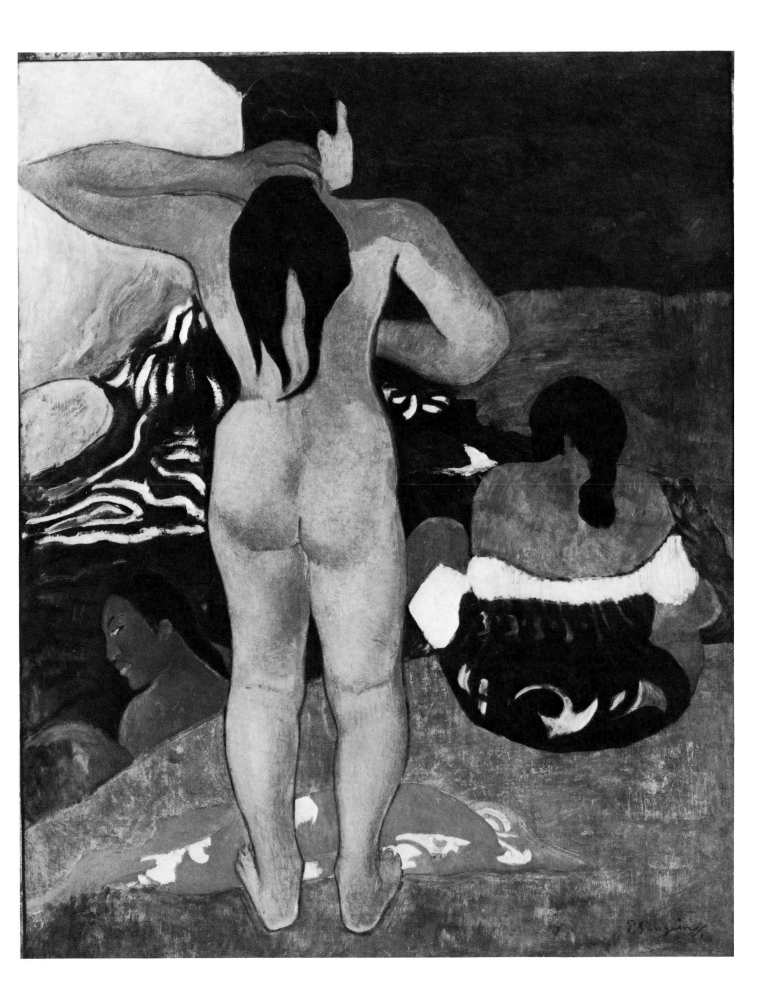

8 Subject versus Form

The standard modernist view of the 'Post-Impressionists' is that they were artists who, following on from the Impressionists, dealt a further blow to 'the subject' and carried art along an inexorable path towards non-representational abstraction. It is an account that distorts our understanding of art history and selects only those facts that suit its argument. Yet there are seemingly unimpeachable sources for this line of reasoning. In the private and public utterances of the artists with whom we are dealing many statements might lead one to believe that their paramount concern was to decorate a flat surface with lines and colours, and that subject-matter was to them of little or no importance. In 1884, for example, we come across Camille Pissarro advising his son Lucien, just then embarking upon his artistic career: 'Don't worry yourself too much about searching for *novelty*. The new is not something one finds in the subject, but rather in the means of expression.' In 1890, Maurice Denis opened the 'Definition of Neo-Traditionism' with these words: 'Remember that a painting, before it is a war-horse, a nude or some anecdote or other, is essentially a flat surface covered with colours assembled in a certain order.' In 1894 Signac, reflecting in his journal on the lack of understanding he and his associates had encountered, concluded: 'What pleasure can people who have no eye find [in our works], since we are simply seeking beautiful lines and beautiful colours, with no concern for fashion, anecdote or literature?'

Similar views abound in the writings of avant-garde artists of the late nineteenth century, and it would be dangerous to dismiss them as mere rhetoric. Understandably it frustrated them to be judged solely on the basis of their subjects, as usually happened, and to find their painterly qualities entirely overlooked. By so insisting on their formal innovations they may only have been pleading for this side of their work to be taken seriously, for the avant-garde artists of the late nineteenth century palpably did have views about and commitments to different types of subject-matter, as the most cursory study of their works and writings makes clear.

Questions are certainly raised by such pictures as Pissarro's *Women Gleaning* of 1889 (fig. 103) and Denis's *Avril* of 1892 (fig. 104). Both present harmonious, almost lyrical images of women set in landscapes, but whereas Pissarro's women are peasants engaged in a practical task, Denis's women seem deliberately mysterious, their presence in the landscape defying rational explanation. One is led to ask why peasants and peasant women in particular crop up so frequently in Pissarro's work. What meanings might they have held for him and for his spectators? What can such images tell us about contemporary perceptions of peasants? How does Pissarro's treatment of peasants differ from Gauguin's, in his drawing of a *Head of a Breton Peasant Girl* (fig. 98) for instance, or from Van Gogh's in his drawing of a *Peasant Woman Gleaning* (fig. 152)? Then again, one is intrigued by the presence of so many graceful young women in Denis's work and in the works of other Symbolist painters of the 1890s, Fernand Khnopff, for example (see fig. 13). Are Denis's women

103
CAMILLE PISSARRO: *Women Gleaning*. 1889. Oil on canvas, 25½ × 32 in (65.5 × 81 cm). Basel, Kunstmuseum, Dr H.C. Emile Dreyfus Foundation

104
MAURICE DENIS: *Avril*. 1892. Oil on canvas, 15 × 24 in (38 × 61 cm). Otterlo, Rijksmuseum Kröller-Müller

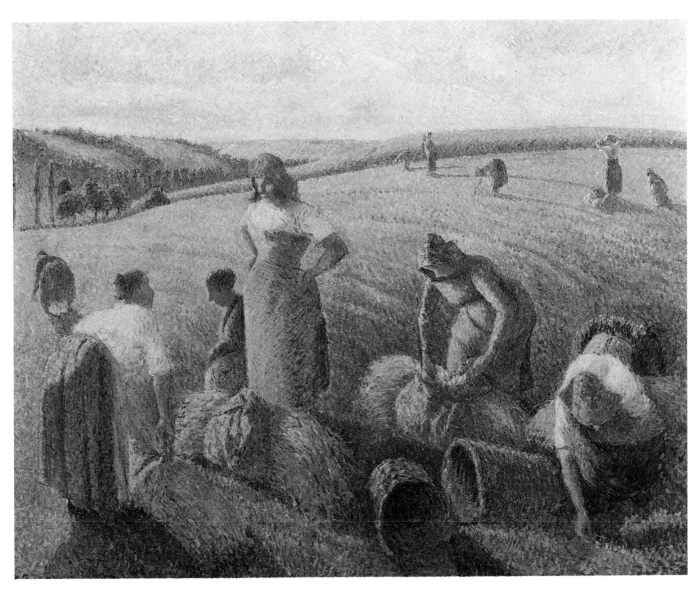

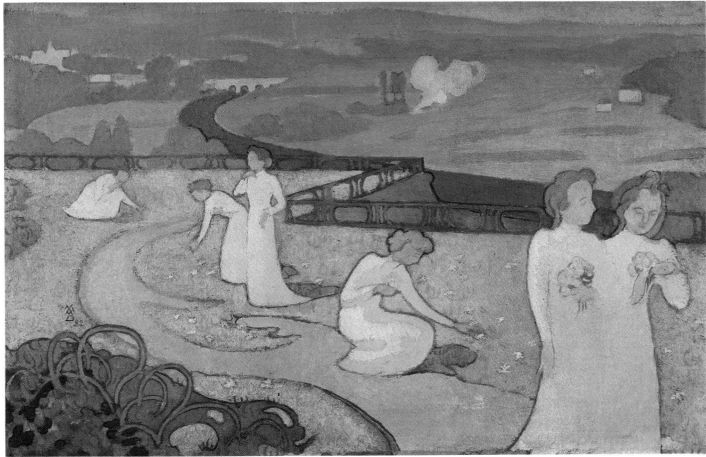

first communicants or brides-to-be, as one critic suggested at the time? What are Khnopff's women waiting for, seemingly suspended in time in their incongruous tennis attire? Such questions are clearly meant to be raised by the subjects of these pictures, even if their authors meant the questions to remain unanswered.

For the Neo-Impressionists, weighing up the rival claims of form and subject-matter seems to have produced a certain intellectual confusion. On the one hand, their commitment to anarchist beliefs more or less forced them into the role of social critics and into producing art that could be understood by the masses. On the other hand, their commitment to modernistic formal experimentation led them to concentrate on harmonious arrangements of line and colour and to produce paintings that, so Signac maintained, could only be appreciated by spectators with an 'eye'. Their partial solution to the problem was to reserve their more blatant political messages for their drawings and prints. Yet their paintings were not devoid of meaning, despite Signac's claims, and in the case of a work such as *Le Clipper, Asnières* (fig. 14) we might justifiably be led to question the significance for the artist of the juxtaposition of yacht, that emblem of bourgeois leisure, with gasworks and factory chimneys, those images of industry.

We need, then, to find a balance between the artists' often explicit insistence on their works' formal qualities and the implicit meanings of the images they produced. And in seeking to retrieve this measured approach we have as our authority the statements of Félix Fénéon, whose criticism was widely admired by his contempories, and of Vincent Van Gogh. Fénéon clearly saw an intrinsic compatibility between the progressive painter's innovations of form and innovations of subject. It is notable that when he wrote, in 1889, of the limitations of Impressionism, which he felt had been experienced simultaneously but in different ways by both Seurat and Gauguin, he considered that they lay as much in its subject-matter as in its technique, or rather that the two were inseparable. The technical 'advances' of the Impressionists in terms of bright colour and spontaneous brushwork had been made with a view to performing a specific job. They were ideally suited to the capturing of fleeting weather or light effects. The corollary of this was that if their young successors wanted to paint different motifs—be they less transitory effects of nature, more complex figure compositions, images that were less dependent on reality—they would inevitably have to develop new techniques with which to express them. That same year much the same point was made by Vincent Van Gogh in a letter to his brother Theo: 'When the thing represented is, in point of character, absolutely in agreement and at one with the manner of representing it, isn't it just that which gives a work of art its quality?'

9 'The Simple Means of Portraiture'

Van Gogh, 1888

One way of attempting to assess the relative weight the 'Post-Impressionists' gave to subject and form is to look at the ways in which they approached two of the most traditional genres, the portrait and the still-life.

The very fact that portraiture continued to be an important preoccupation in the 1880s and 1890s in a sense gives the lie to the claim that this era saw the death of the subject. For the previous two centuries at least portraiture had been accorded a fairly lowly rank in the hierarchy of genres, and artists whose main interests lay elsewhere often regarded it as workaday drudgery, a sure way of earning one's daily bread. By the 1880s, however, this kind of production-line portraiture had become less widespread, largely no doubt because of the advent of photography. The camera had taken over the role of flattering the vanities of the bourgeoisie, and although its arrival deprived some artists of a useful source of income, it left others freer to make more imaginative use of the genre. It is significant that out of the considerable number of portraits produced by avant-garde artists at the end of the nineteenth century, only a very few were commissioned in the conventional way. For the most part it was a case of artists volunteering to portray their friends, relations or associates, sitters in whom they had a personal interest (fig. 106).

The two poles of aesthetic approach outlined in the preceding chapters are identifiable in the field of portraiture. On the one hand, there were the artists working in a naturalist vein, seeking to convey a sitter's personality not simply through facial expression but through the authenticity and informality of pose and setting—something Duranty, the Naturalist critic, had called for back in 1876. We find this approach carried on well into the 1890s by such artists as Théo Van Rysselberghe, Toulouse-Lautrec, and Vuillard. On the other hand, a new type of symbolic or emblematic portrait appeared, in which unreal settings were used to add a symbolic or decorative dimension, and to enrich the expressive power of the image. This new type of portraiture was explored by such different artists as Redon, Signac, Gauguin and Van Gogh.

While there are recognizable likenesses among both types of portrait, in most cases it is true to say that creating a close resemblance to the sitter was not the main aim—or rather that this objective was understood in new, rather broader terms and never allowed to outweigh the concerns of picture-making. The treatment of pose, setting and compositional arrangement was never formulaic, although inevitably the artists obeyed certain norms and conventions. One of the paradigms was a portrait from the previous generation, Cézanne's *Achille Emperaire* (fig. 8). Rejected from the Salon in the 1860s, two decades later it hung in Père Tanguy's shop and was regarded as some sort of a classic by Tanguy's regular customers, who included Gauguin, Van Gogh, Émile Bernard and Maurice Denis.

It has been plausibly argued that the *Emperaire* portrait's bold simplification of colour and contour played a part in the development of the cloisonnist technique. One finds reminiscences of its stark frontal

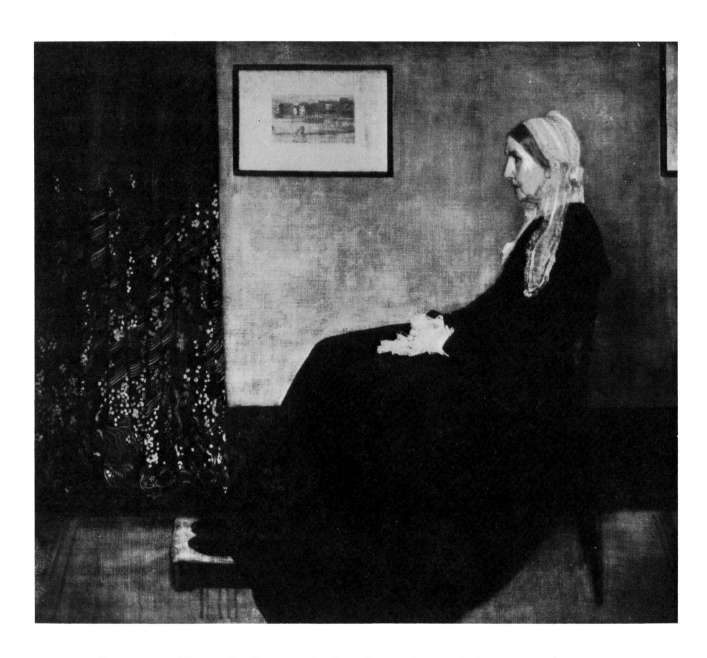

monumentality in some of Bernard's, Gau- to the flat colour application, bold contours
guin's and Van Gogh's portraits, not least and asymmetrical compositions of Gauguin
perhaps in the latter's *Portrait of Père Tanguy* and Bernard, or to the sinuous decorative
(fig. 23). The uncompromising square-cut arabesques of the Nabis. Another 'classic'
symmetry of this image sits oddly against the portrait type particularly beloved of the Sym-
fanciful backdrop of Japanese wood-block bolists was Whistler's *Portrait of the Artist's*
prints. But although the Japanese figure *Mother* (fig. 105). Shown at the Salon of
print also had an important influence on 1883, to the delight of its many admirers it
portraiture in this era, such influence is entered the State museum of modern art,
entirely absent from Van Gogh's *Tanguy* the Luxembourg, in 1891. Its success lay in
portrait. To find it, we have to look rather its combination of intimate realism with a

105
JAMES WHISTLER: *Portrait of the Artist's Mother. c.* 1870. Oil on canvas, 56 × 64 in (142.2 × 162.6 cm). Paris, Musée d'Orsay

106
ODILON REDON: *Portrait of Gauguin.* 1904. Oil on canvas, 26 × 21⅝ in (66 × 55 cm). Paris, Musée d'Orsay

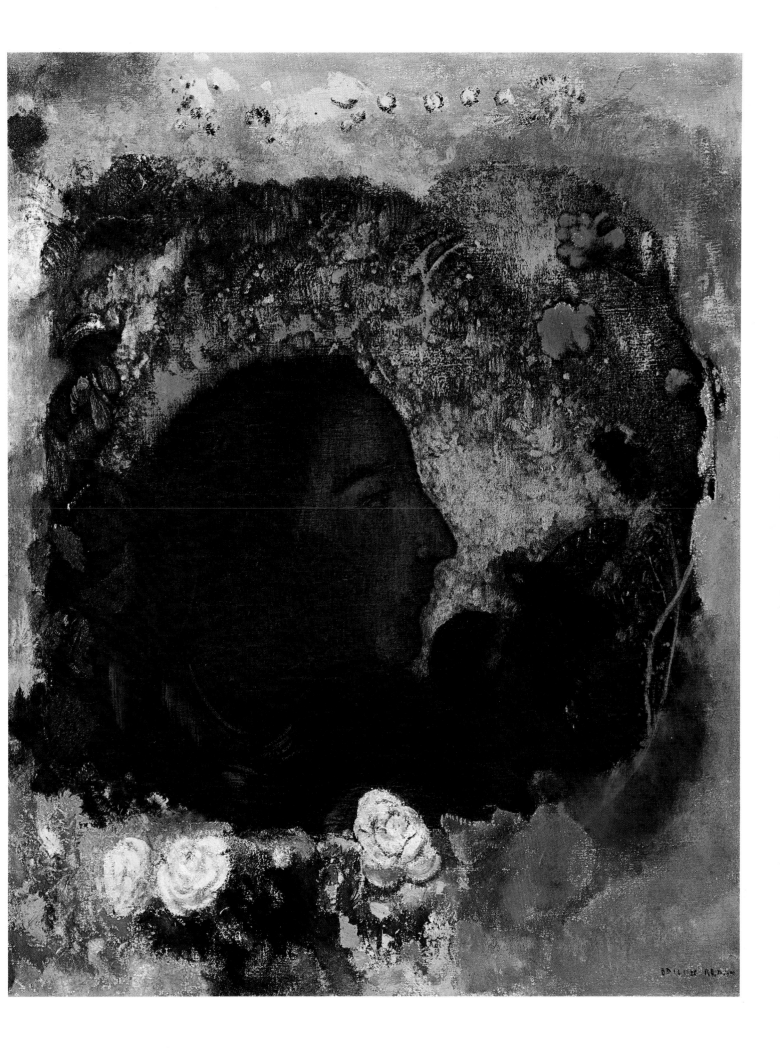

mood of other-worldly mystery, and its sombre colouring, contained composition and powerful use of the profile were echoed in the portraiture of such artists as Vuillard, Lautrec and Redon and of the Belgian Vingtists, Khnopff, Ensor and Van Rysselberghe (fig. 107).

Perhaps the most committed and prolific portraitist of all the artists working in this era was Vincent Van Gogh. At a particularly interesting juncture in his career, between 1888 and 1889, we can chart his general movement from a Naturalist to a Symbolist approach. He brought to the genre his characteristic zeal and enthusiasm, with which he seems to have succeeded in infecting others. Indeed it was probably his prompting that awakened Gauguin to the portrait's symbolic and expressive possibilities. It is of considerable interest to compare some of the portraits executed by these two artists before, during and shortly after their short period of collaboration in Arles.

Van Gogh's long-established ambitions as a portrait painter seem to have come to fruition in 1888 during his first year in Provence. Looking back to the great Dutch tradition embodied in such artists as Hals and Rembrandt, he was convinced that portraiture was the highest form of art and also, paradoxically, that it was the thing of the future. He planned at this time to paint a whole series of modern heads, and was always on the look-out for representative types. The artist was of course as representative a 'type' as any, and it was with a view to assembling a collection of portraits of artists that he wrote asking his friends in Brittany to paint images of each other and send them to him. His request was a reflection of his loneliness and desire to establish an avant-garde artistic community in Arles, where ideas, materials and day-to-day expenses would be shared. He had it in mind to invite several artists he had met in Paris to join him, and was even willing to extend his invitation to Gauguin's friends in Brittany, artists he had not met such as Laval and De Haan. But in the meantime, by having their

107
THÉO VAN RYSSELBERGHE:
Portrait of Mme Charles Maus.
1890. Oil on canvas,
38⅝ × 29½ in (98 × 75 cm).
Brussels, Musées Royaux des Beaux-Arts

portraits by him and corresponding regularly, it was as though he was seeking vicariously to become a part of the growing artists' colony in Brittany.

The self-portraits Van Gogh received from Gauguin and Laval both made interesting though very different statements about how the artists wished to be seen (figs. 108, 109). When Gauguin sent his he had just accepted Van Gogh's invitation to come to Arles. The canvas is inscribed at the bottom right *Les Misérables*, and it is a strong image, if somewhat perplexing in its juxtaposition of sombre brutish head and decorative floral background. Characteristically, he invested it with more complex and literary meanings than at first might appear. He explained in an accompanying letter that

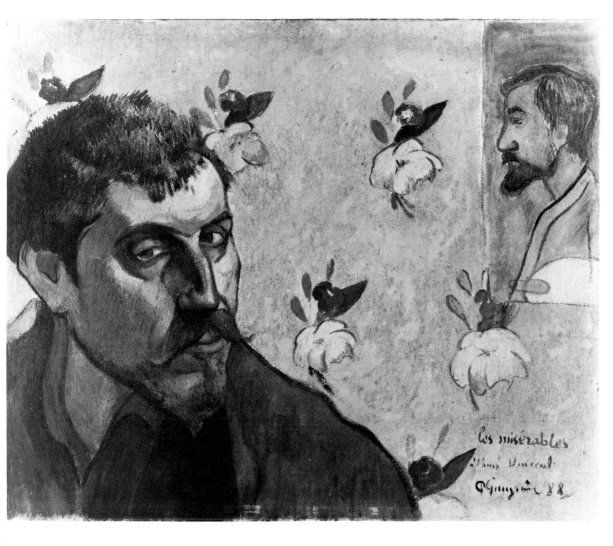

108
PAUL GAUGUIN: *Self-Portrait, Les Misérables.* 1888. Oil on canvas, 17¾ × 22 in (45 × 56 cm). Amsterdam, Rijksmuseum Vincent Van Gogh

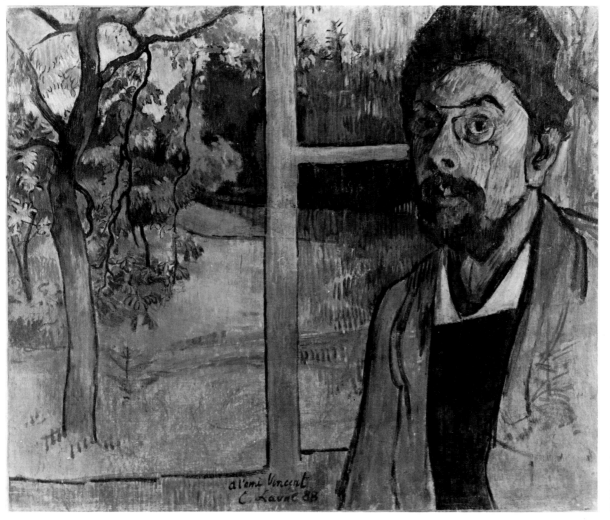

109
CHARLES LAVAL: *Self-Portrait dedicated to Vincent.* 1888. Oil on canvas, 19¾ × 23⅝ in (50 × 60 cm). Amsterdam, Rijksmuseum Vincent Van Gogh

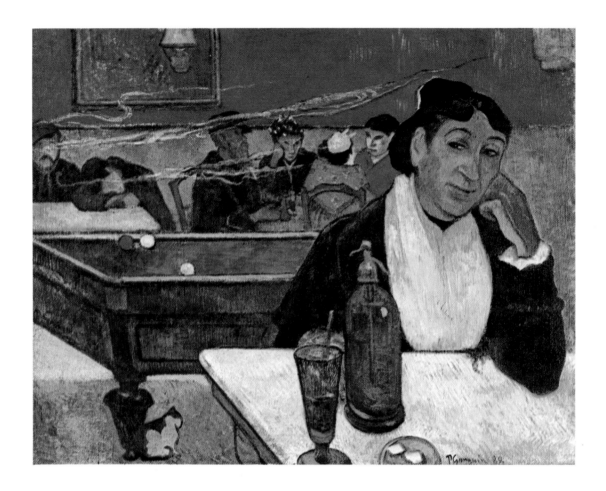

he had assumed the guise of Jean Valjean, the hero of Victor Hugo's novel, as a way of signifying his plight as an outcast and a misunderstood artist. Laval's *Self-Portrait* by comparison is an optimistic and straightforward representation of his lean, earnest, bespectacled figure. Although, like the Gauguin, it is characterized by synthetic, simplified drawing and an asymmetrical composition, the broken brushwork and the window open onto nature seem to present Laval as the *plein-air* landscape Impressionist.

Shortly after Gauguin's arrival in Arles in late 1888, he and Van Gogh undertook portraits of Mme Ginoux, the proprietress of the Café de la Gare, where they regularly drank. Van Gogh gave his portrait the title *L'Arlésienne* (fig. 111), and clearly intended it as his representative image of these re-nowned southern beauties. He completed it in less than an hour, starkly simplifying the model's characteristic black costume and head-dress and setting them off against a flat abstract background of pale lemon yellow. If Gauguin's portrait (fig. 110) was more pondered, it was also more naturalistic, incorporating in its setting the rough and ready modern café, with billiard table and soda siphon, which was the sitter's daily habitat. His *Arlésienne* is strangely Parisian in feeling, which could explain why Gauguin himself seems to have regarded the painting as something of a failure, choosing never to exhibit it. For his part Vincent complained in early 1889 that he had so far been 'powerless to paint the women of Arles as anything but poisonous', a reference perhaps to his somewhat witch-like representation of the sitter for *L'Arlésienne*.

110
PAUL GAUGUIN: *Mme Ginoux, Night Café at Arles*. 1888. Oil on canvas, 29 × 37 in (72 × 92 cm). Moscow, Museum of Western Art

111
VINCENT VAN GOGH: *L'Arlésienne*. 1888. Oil on canvas, 36 × 29 in (90 × 72 cm). New York, Metropolitan Museum of Art

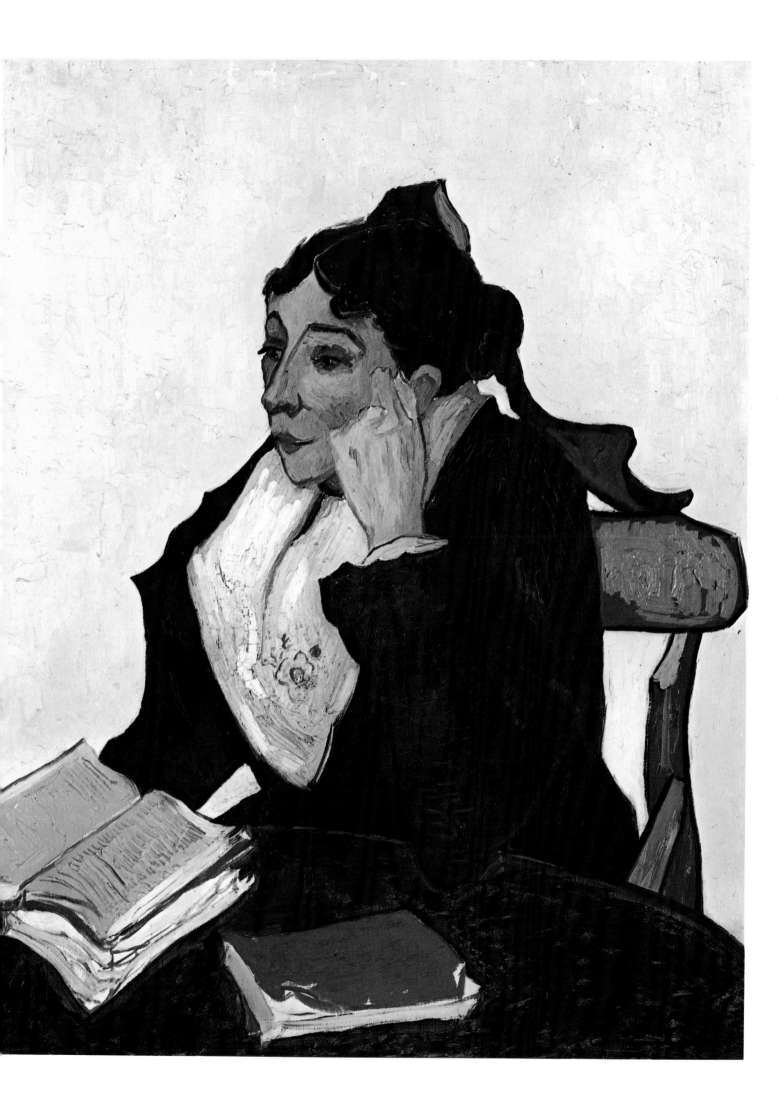

Van Gogh partially fulfilled his ambition to paint a series of representative types in his portraits of the various members of the postman Roulin's family; conveniently for us he has left accounts of the feelings he was trying to express through these images. In the case of *Mme Roulin—La Berceuse* (fig. 113), for example, painted shortly after Gauguin's departure, he was trying to convey a comforting maternal image, appropriate in view of the fact that the model was at the time still nursing a baby. However, he also wanted it to be the sort of image a sailor would wish to have on board ship to remind him of home, a romantic notion inspired by his recent reading of Pierre Loti's novel of 1886, *Pêcheur d'Islande*. Work began before and was completed after his first attack and admission to hospital, which might partially explain his obsessive repetition and reworking of the image. It was worked on from memory, a practice foreign to Van Gogh but one that had been strongly recommended by Gauguin. Indeed the image comes as close as Van Gogh ever came to Gauguin's cloisonnist style, with its relatively smooth and unemphatic paint application, its strong, curving contours and contrasting colour complementarities of red and green. Mme Roulin chose the best version to keep, according to Van Gogh, but he was also able to give one version of the painting to Gauguin and another to Bernard.

Gauguin too went on to paint several important portraits in 1889. *La Belle Angèle* (fig. 112), for instance, was in a sense a corrective to his *Mme Ginoux* in that it again represented a café proprietress, Mme Angèle Sâtre, but this time through an amalgam of incongruous artistic sources— Holbein's *Anne of Cleves* and the Japanese print. The portrait was considered an 'horreur' by the sitter herself, a reaction which in Gauguin's eyes would have helped to confirm its status as a successful synthetic image. Shared enthusiasm for the possibilities of modern portraiture can count as one positive outcome of Gauguin's stay in Arles. Paradoxically, though Van Gogh helped to direct Gauguin towards the pos-

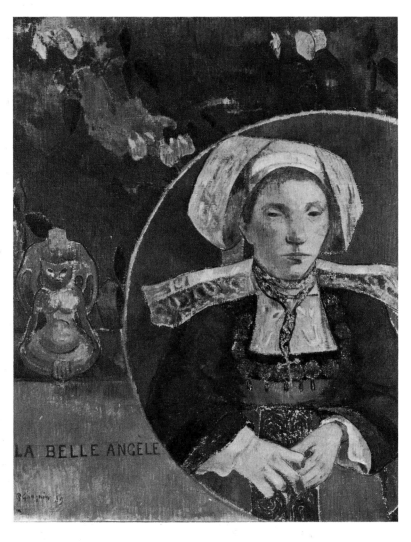

sibilities of symbolic portraiture, he himself fought shy of the synthetic procedures recommended by Gauguin and clung to the more naturalistic confrontation with the model.

The marked emphasis on self-portraiture which we find in the 'Post-Impressionist' era was, one might argue, only to be expected of an age that placed great stress on self-expression and individualism. It is of some significance that Gauguin, Van Gogh and Cézanne—all of whom devoted considerable time to the self-portrait—ultimately spent most of their careers working in isolation despite brief attempts at collaboration with other artists. In 1889 Gauguin

112
PAUL GAUGUIN: *La Belle Angèle*. 1889. Oil on canvas, 36 × 28¾ in (92 × 73 cm). Paris, Musée d'Orsay

113
VINCENT VAN GOGH: *Mme Roulin—La Berceuse*. 1889. Oil on canvas, 36 × 28¾ in (92 × 73 cm). Otterlo, Rijksmuseum Kröller-Müller

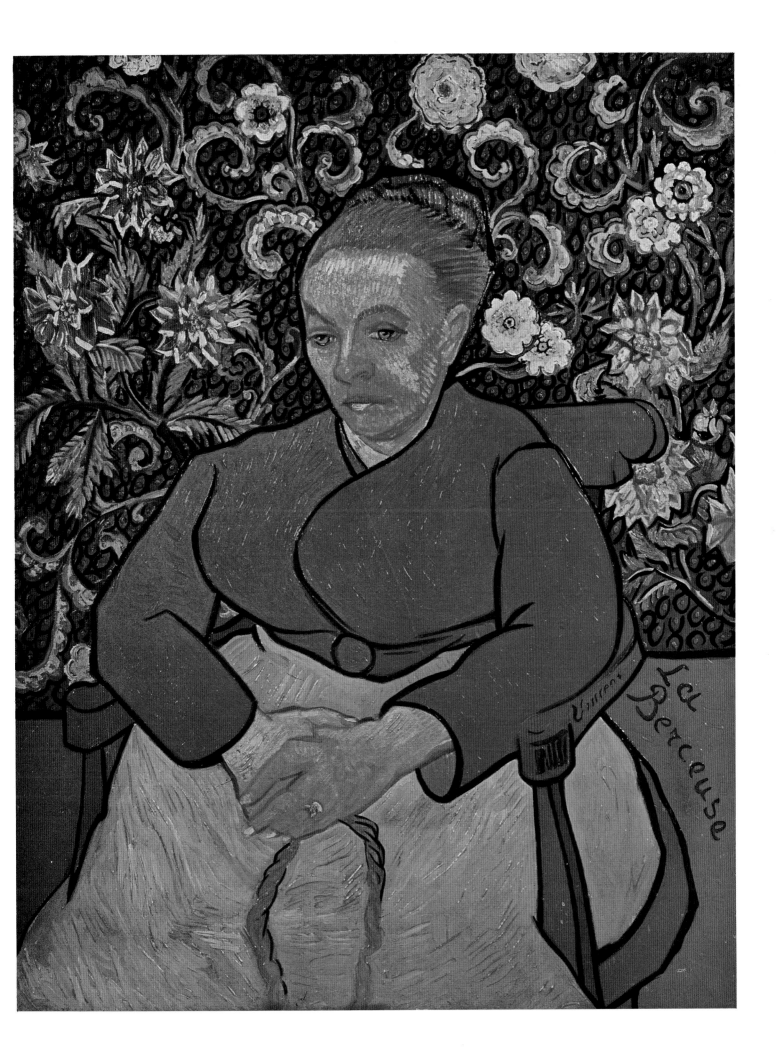

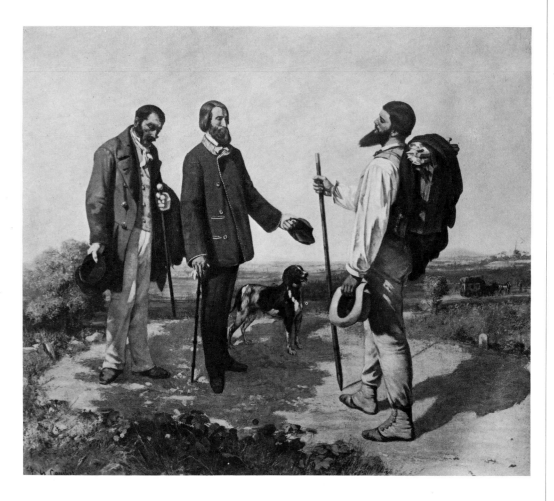

114
GUSTAVE COURBET: *Bonjour M. Courbet*. 1854. Oil on canvas, 50¾ × 58⅞ in (120 × 149 cm). Montpellier, Musée Fabre

seems to have become exceptionally pre-occupied by his self-image, both in his correspondence and in paintings such as *Bonjour M. Gauguin* (fig. 115). The concept and title of the painting hark back to Courbet's manifesto painting *Bonjour M. Courbet* (fig. 114), in which the Realist artist had presented himself in the guise of the Wandering Jew confidently striding forward to greet his patron Bruyas on equal terms, a painting Gauguin would have seen in 1888 when he and Van Gogh visited the Fabre museum in Montpellier. It is tempting to speculate on Gauguin's reasons for quoting Courbet at this particular stage in his career. Far from enjoying the same encouraging patronage as Courbet, he was beginning to despair of ever finding buyers. In the painting he again presents himself as an outsider,

cut off both physically and intellectually from the world he had chosen to paint, the world of the Breton peasant.

Gauguin carried his self-pity further still when he depicted himself in the guise of Christ in *Christ in the Garden of Olives* (fig. 117). The same somewhat blasphemous analogy had been drawn in a contemporary poem of Albert Aurier's, 'La Montagne du Doute', dated October 1889, where the poet as Christ cries out with frustration at having to fulfil a higher destiny, to pursue an impossible ideal, an illusory dream which keeps him apart from the rest of humanity. Yet again it seems likely that Gauguin read and was influenced by a literary source. With some circumspection he wrote to Vincent Van Gogh describing the painting and including a small sketch (fig. 116): 'I have at

115
PAUL GAUGUIN: *Bonjour M. Gauguin*. 1889. Oil on canvas, 29½ × 21⅝ in (75 × 55 cm). Prague, National Gallery

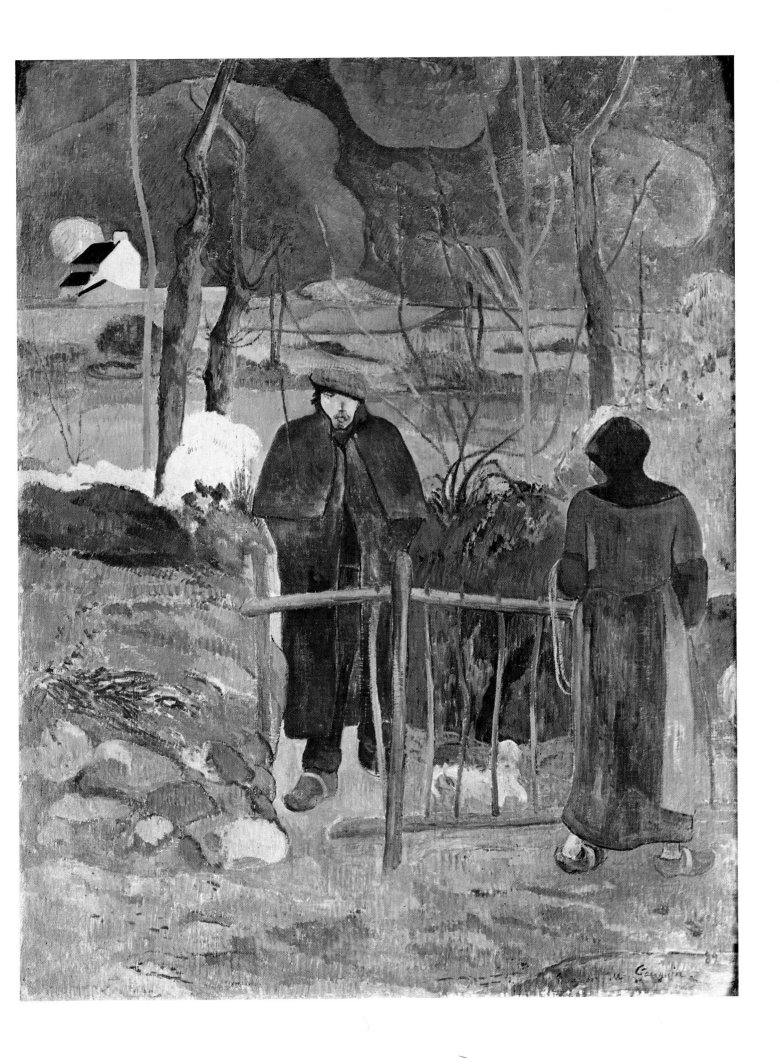

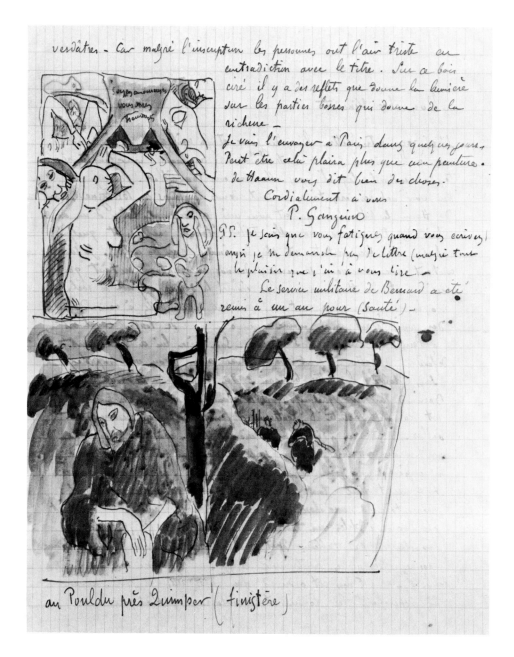

my residence a thing which I have not sent [to your brother] and which would irritate you I believe. It's a Christ in the Garden of Olives. This canvas is not intended to be understood. I shall keep it for a long while.' Vincent's reaction was indeed hostile; he felt that Gauguin had let his imagination run riot. Ironically, this literary emphasis that Van Gogh disliked in Gauguin's work—the product of his increasing involvement with the poetic Symbolist movement—was precisely the failing Gauguin had earlier pin-pointed in the paintings approved by Huysmans. The most enthusiastic reaction to Gauguin's painting came, as one might have expected, from Aurier, who described it in his 1891 article in high-flown Symbolist terms. Basing his interpretation, in part at least, on notes supplied by Gauguin, Aurier made no bones about identifying Gauguin's

Christ with the Symbolist artist: 'This sublime *Garden of Olives* in which Christ with incarnadine hair seems to bewail the ineffable pains of the dream, the agony of the chimera, the betrayal of contingencies, the vanity of the real, of life and perhaps of the beyond...'

The Symbolist approach to self-portraiture, in Gauguin's case, produced artfully contrived, somewhat literary images. In the case of Van Gogh, although there is a shift from a broadly naturalistic to a broadly Symbolist approach in the later 1880s, the self-portraits show a continuing and genuine search for self-knowledge. Self-portraiture also offered him a useful vehicle for technical experimentation. In his 1887 *Self-Portrait with Grey Felt Hat* (fig. 118), painted during his stay in Paris, we see him somewhat clumsily trying out new colour combinations

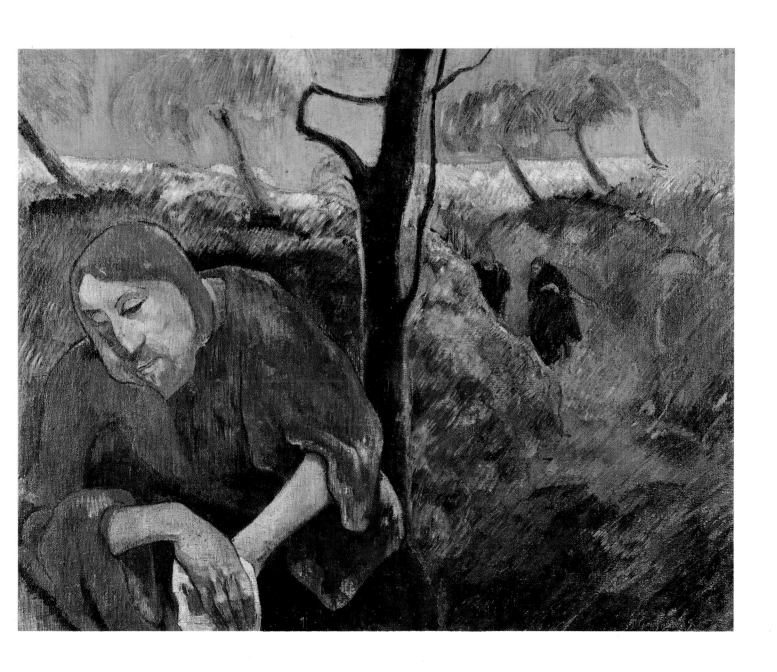

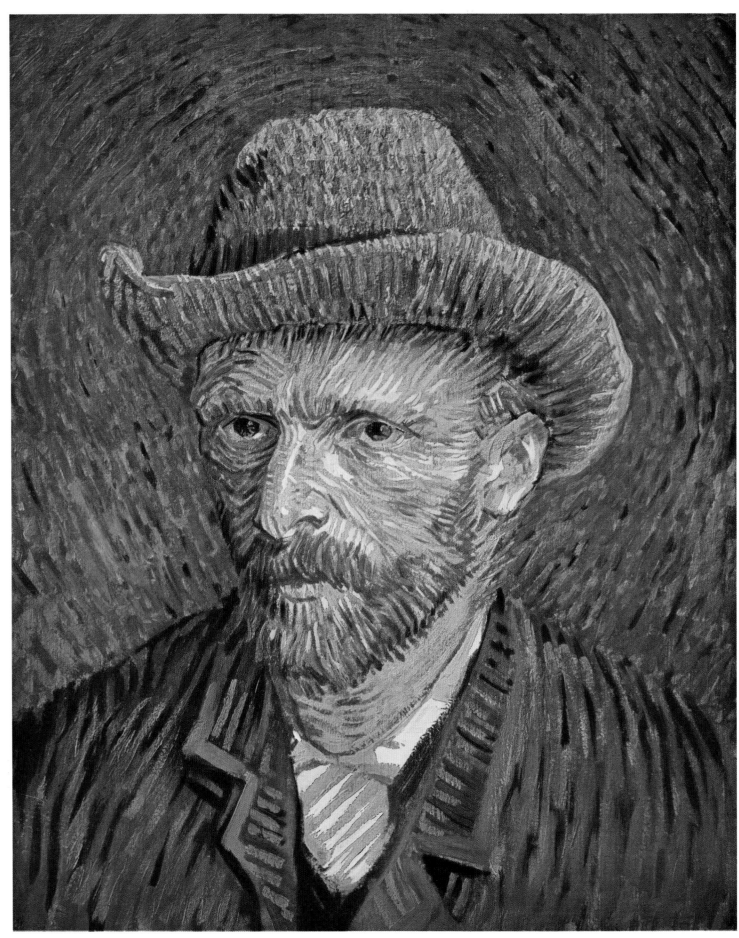

118 VINCENT VAN GOGH: *Self-Portrait with Grey Felt Hat.*
1887. Oil on canvas, 17³⁄₈ × 14³⁄₄ in (44 × 37.5 cm).
Amsterdam, Rijksmuseum Vincent Van Gogh

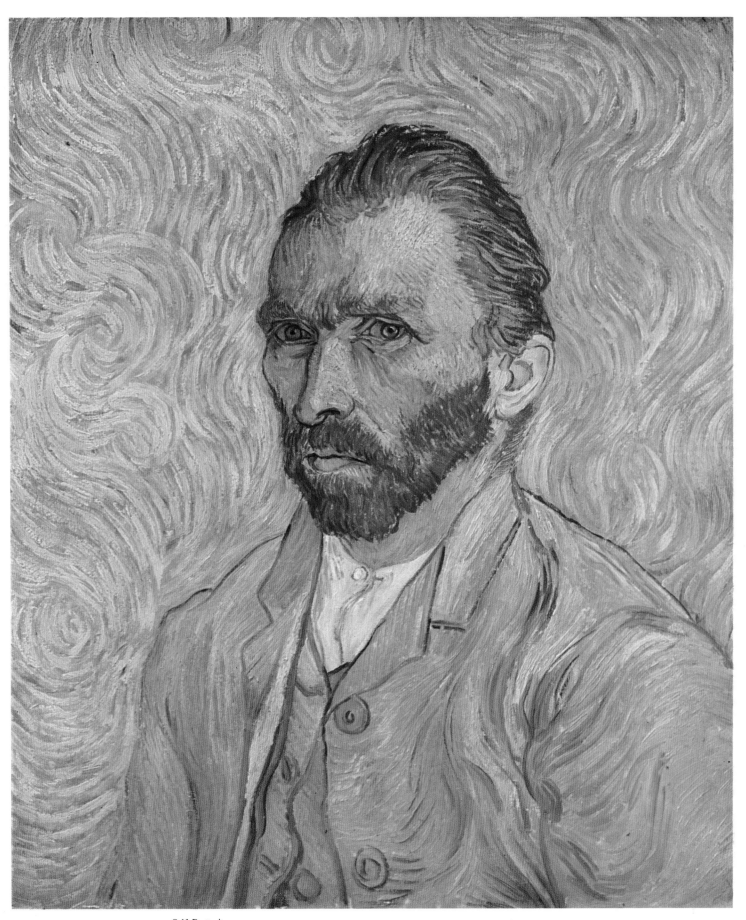

119 VINCENT VAN GOGH: *Self-Portrait*.
1889. Oil on canvas, 25⅝ × 21¼ in (65 × 54 cm).
Paris, Musée d'Orsay

and methods of paint application, prompted partly by his recent study of Delacroix and the colour theories of Charles Blanc, partly by his recent encounters with the Impressionists and the pointillists. The image remains essentially naturalistic, however, with its emphasis on the smart new hat, on the persona of the artist about town. The Musée d'Orsay *Self-Portrait* (fig. 119), dating from two years later, is rather more penetrating in its self-analysis, but also more Symbolist in its treatment of the background. Here the colour is subdued, dominated by shades of pale grey, but the brush strokes play a dynamic and expressive role, drawing the contours and textures of the face and hair and setting up flame-like rhythms behind the head. Vincent completed the painting during his convalescence at the St. Rémy asylum, and described it with some satisfaction to Theo; 'You will see, I hope, that my face is much calmer, though it seems to me that my look is vaguer than before . . . I have tried to make it simple.'

This broad division between the naturalistic and the Symbolist approach to portraiture applies to the works of the 1890s. The Neo-Impressionists took the portrait in both directions. Yet it is worth remembering that Seurat himself had not made much of an attempt to apply the pointillist technique to portraiture. The portraits he left were in the main early drawings of friends and family (fig. 9). It may well have been that portraiture was the next project in his so methodically organized career, had death not intervened. Signac's *Portrait of Félix Fénéon* of 1890 (fig. 83) combined a naturalistic, highly elaborated profile view of the critic with such unnaturalistic elements as the cyclamen and the background of abstract swirling lines and patterns. These were intended to represent the aesthetic theories of Charles Henry, which Fénéon had helped to promote. Even though it was a recognizable likeness, as a picture it was generally judged to be a bizarre failure because of the over-dominant background which, according to Pissarro, was 'neither explicable from the point of view of the sensation' nor

did it 'give the work a feeling of decorative beauty'. But it was the Belgian pointillist Van Rysselberghe who most consistently worked in the genre, exploiting the naturalistic approach for all it was worth. His images hark back to Whistler as well as to the seventeenth-century tradition of genre portraiture with their use of everyday domestic settings and appropriate props to suggest the sitter's personality and interests. The *Portrait of Maria Sèthe* (fig. 120) is a good example of his combination of new and traditional elements—the sitter's fashionable mutton-chop sleeves, her hairstyle and the harmonium firmly situate the image in the 1890s. On the other hand, the mood and motif as a whole, like Whistler's famous portrait of his mother, carry deliberate overtones of Vermeer.

One finds both naturalist and Symbolist portraits among the works of the Nabis. For Maurice Denis, for example, the Symbolist mode offered the necessary freedom to combine or synthetize three different views of the same model in a single image, as in his *Portrait of Yvonne Lerolle in Three Poses* (fig. 123). This is one of the rare instances of a commissioned portrait in which the artist was clearly given a free hand to represent the model as he chose. It is a measure of Denis's early success that he should have succeeded by this date in gaining the support of such a cultured patron as Henri Lerolle, a successful painter in the more academic sphere. In format, scale and conception, the painting is reminiscent of Puvis's *Girls by the Seashore* (fig. 121), and like his predecessor Denis managed to show the figure in three different moods. He evokes an almost medieval simplicity and calm in the schematic landscape setting and the enveloping mauve tonality. By contrast the Nabi Vuillard's figure paintings have none of the formal iconic quality that generally characterized the Symbolist portrait, and seem rather to exploit and extend the naturalist approach. He presents casual glimpses of personalities thoroughly absorbed in their own preoccupations and activities and in their characteristic domestic trappings. His portraits are

120
THÉO VAN RYSSELBERGHE:
Portrait of Maria Sèthe at the Harmonium. 1891. Oil on canvas, 46½ × 33½ in (118 × 85 cm). Antwerp, Musée Royal des Beaux-Arts

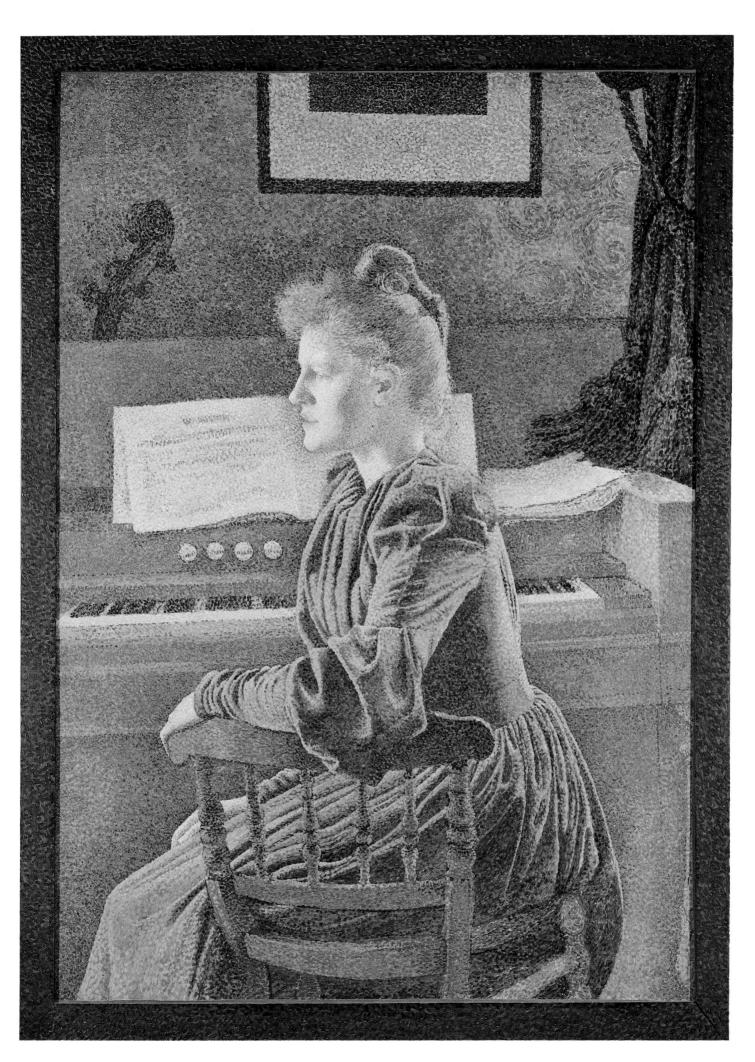

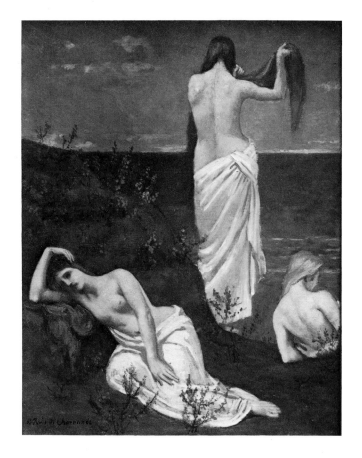

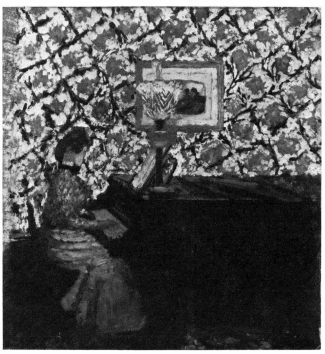

121
PIERRE PUVIS DE
CHAVANNES: *Girls by the
Seashore* (small version).
1879. Oil on canvas,
24 × 18½ in (61 × 47 cm).
Paris, Musée d'Orsay

122
ÉDOUARD VUILLARD: *Girl at
the Piano. c.* 1897. Oil on
board, 10½ × 10 in
(26 × 25 cm). New York,
Metropolitan Museum of
Art, Lehman Collection

123
MAURICE DENIS: *Portrait of
Yvonne Lerolle in Three Poses.*
1897. Oil on canvas,
67 × 43¼ in (170 × 110 cm).
London, Tate Gallery

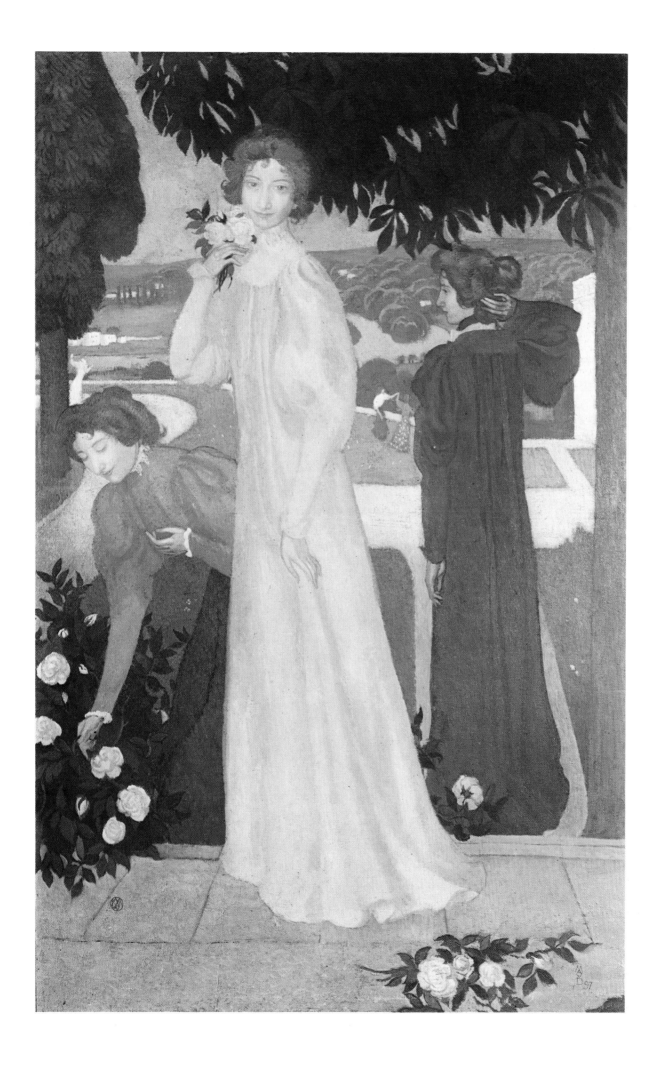

technically and compositionally unconventional in that the figures are given no more emphasis than any other aspect of their physical setting. And yet it would not be correct to assume that the subject was, for Vuillard, a simple pretext for colouristic experimentation. In the case of *Girl at the Piano* (fig. 122), for instance, we know that the sitter, Misia Natanson, was one whom Vuillard loved to paint and for whom he had a great affection. The details of piano, floral wallpaper, art nouveau furniture all help to evoke her talents, tastes and vibrant personality. Thus although at one level and because of its unfinished state this picture appears to be a pure exercise in colour and pattern, a hotchpotch of bold dabs of cream, red, dark green and yellow played off against the mid-toned buff board, at another level it is a highly detailed naturalistic portrait.

Another traditional genre that continued to flourish in the 'Post-Impressionist' era was the still-life. Indeed, it is probably for their paintings of apples and sunflowers respectively that Cézanne and Van Gogh are best known today. And just as artists had done in the past, it would seem that the vanguard artists of the late nineteenth century chose their still-life objects with care, using them partly as exercises to demonstrate technical prowess or stylistic innovation and partly for their inherent iconographic and symbolic significance. Much has been written about Cézanne's habitual choice of apples as a still-life motif (fig. 124). The prevalent view is that they were objects devoid of meaning, which merely enabled Cézanne to study subtle relations of colour and form. On the other hand, there is the necessarily speculative view that one can interpret his apples as a 'displaced erotic interest'. There may be valid elements in both explanations, but neither is sufficient in itself. In the case of Van Gogh, we know that he chose his still-life motifs from his day-to-day surroundings, studied them carefully as a naturalistic painter would, but also sought to invest them with expressive and often complex meanings. He painted a series of *Sunflowers* (figs. 101, 125) as decorations for

Gauguin's room in Arles, and later spoke of wanting the flowers to express 'an idea symbolizing gratitude'. We learn from Gauguin that yellow was Van Gogh's favourite colour, associated in his mind with the life-giving rays of the sun, which suggests that its dominance in the well-known *The Chair and the Pipe* (fig. 126) again carried symbolic overtones. Seen in isolation and without further information, one might read this as a straightforward naturalistic depiction of a rush chair, one of several which probably furnished his rooms at Arles. Yet the work was clearly also meant to serve as an emblematic self-portrait. The image presented of simple, healthy, rural existence was a statement about how Van Gogh wished to be seen, especially when considered in relation to its companion painting—the armchair Gauguin used when in Arles. It is likely that the idea of evoking personalities through empty chairs and personal effects was suggested to Van Gogh by a memory of Luke Fildes's wood engraving of the chair in which Dickens died, published in the London *Graphic* in 1870.

Still-lifes occur frequently in Gauguin's work, and they too reflect his general progression towards a more synthetic and Symbolist painting style towards the end of the 1880s. His *Still-Life with Profile of Laval* of 1886 (fig. 31) is already a curious assemblage of motifs and stylistic influences. The solidly painted red and green apples hark back to Cézanne, whose *Still-Life, Fruit Dish, Glass and Apples*, (fig. 63) Gauguin then owned. The bizarrely shaped ceramic pot was one made by Gauguin himself under the supervision of Chaplet, probably during the winter of 1886. Finally, the compositional device of the partially cut-off head seems to be indebted to Degas. As yet, however, this disturbing collage of stylistic influences seems to be no more than that—a challenge to the conventions both of portraiture and still-life. Three years later Gauguin produced a similarly bizarre juxtaposition of Meyer de Haan's head and a group of still-life objects, but now the subject was overlaid with overtly Symbolist connotations.

124
PAUL CÉZANNE: *Still-Life, Apples and Oranges.* 1895–1900. Oil on canvas, 29¹⁄₈ × 36⁵⁄₈ in (74 × 93 cm). Paris, Musée d'Orsay

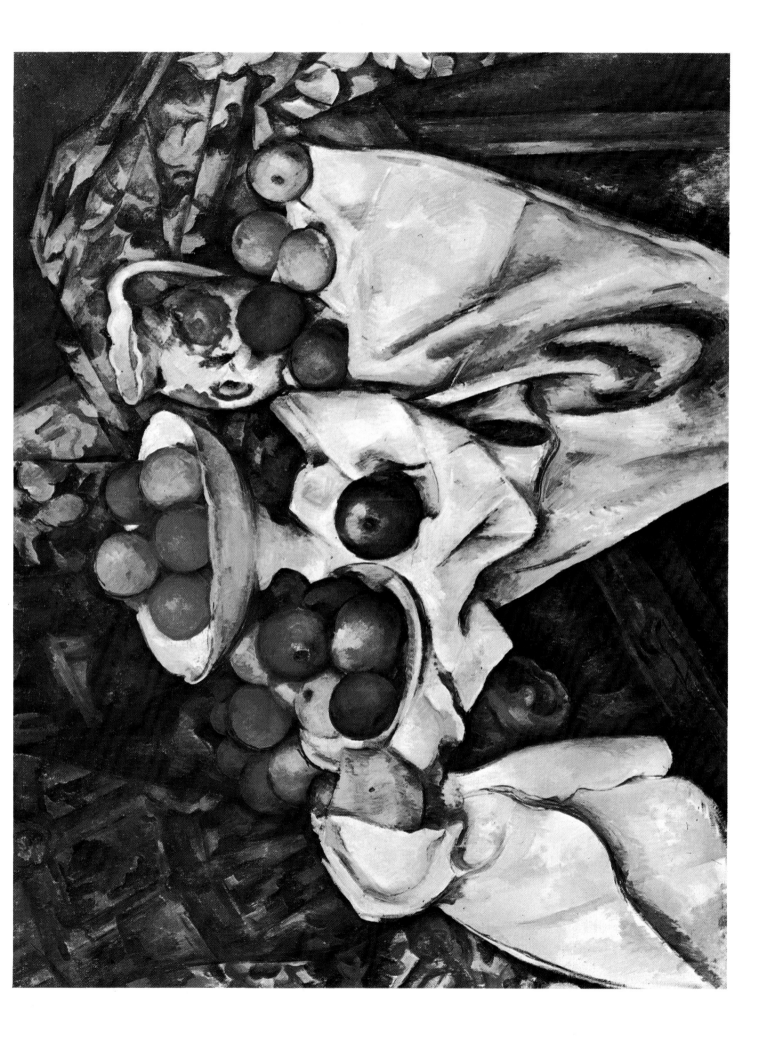

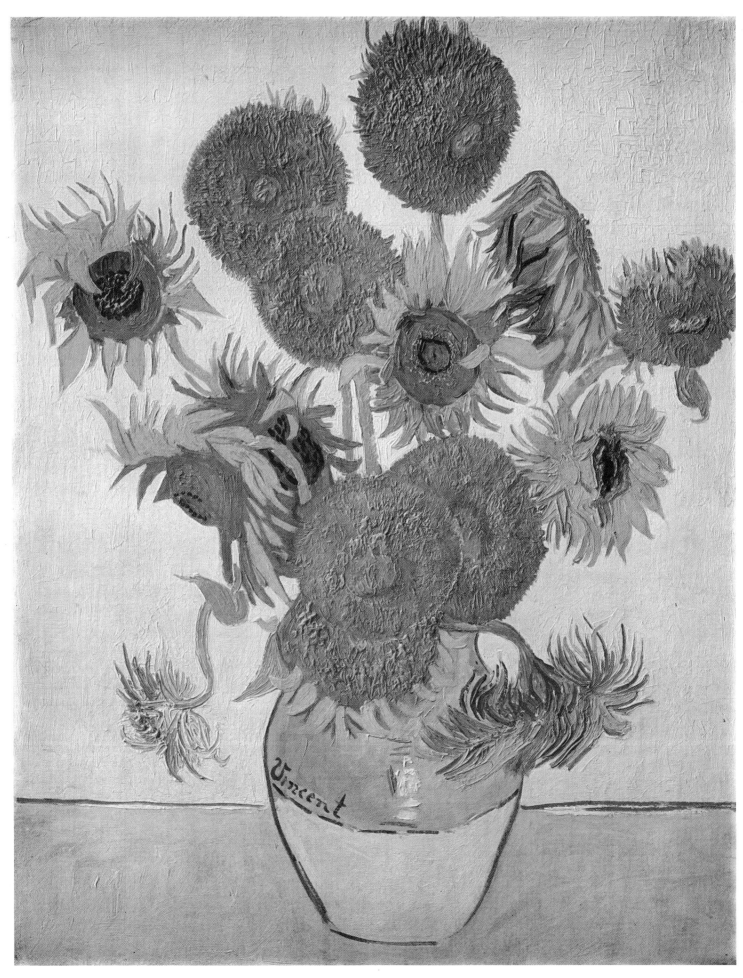

125 VINCENT VAN GOGH: *Sunflowers*. 1888.
Oil on canvas, 36¼ × 28¾ in (93 × 73 cm).
London, National Gallery

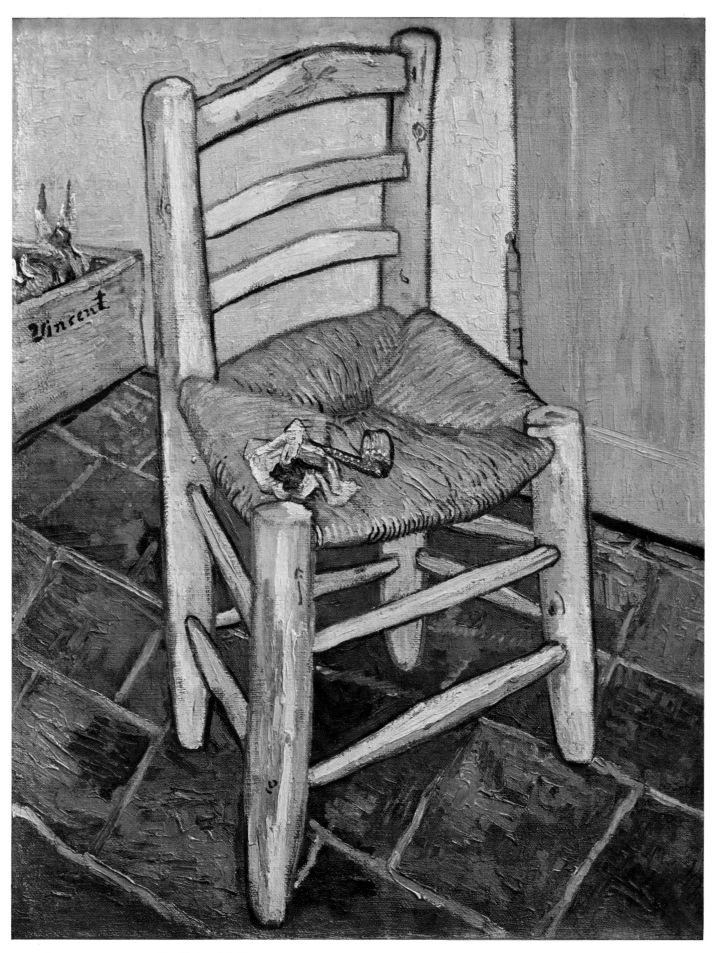

126 VINCENT VAN GOGH: *The Chair and the Pipe.*
1888–9. 36¼ × 28¾ in (93 × 73 cm)
London, National Gallery

10 'You're a Parisianist . . .'

Gauguin to Schuffenecker, 1888

It is clear, then, that those most traditional of genres, the portrait and the still-life, continued to flourish and to confront artists with new problems and challenges at the end of the nineteenth century. But just as it had been responsible for toppling the 'history subject', no longer felt to be relevant in the modern world, the nineteenth century had also stimulated a concentration on themes drawn from everyday life, on the one hand from modern urban life and on the other from peasant and rural life. Although a few tried their hands at themes from both the city and the country—and one thinks of Pissarro, Bernard and Van Gogh—on the whole artists in this period increasingly tended to specialize in one or the other for practical as well as artistic and ideological reasons. More concerned than their predecessors to produce lasting and definitive images, they realized that an extended period of familiarization with their chosen subject area was required. Thus they were less inclined to make numerous sketching trips as Monet and Renoir had done and more inclined to search for a location they could identify with and which could offer them a variety of possible pictorial motifs. It was only on his second visit to Brittany in 1888 that Gauguin began to feel truly engaged by the character of the people and landscape, and he found it impossible to adapt his imagination to absorbing the different character of Arles during his brief two-month stay there. He also took time to find his feet when he first went to Tahiti in 1891. Cézanne became more and more reluctant to leave his native Provence. Seurat

concentrated his working career on the capital, apart from regular summer trips to the easily accessible Channel coast. Apart from such practical and aesthetic factors the choice of what to paint was also affected by political and ideological considerations. It is worth remembering that in the 1880s and 1890s French political opinions became increasingly polarized. The Left, in the form of the socialist and anarchist movements, grew disenchanted with the broken promises of the supposedly radical Republic and resorted to sometimes violent means to make their views known; at the same time there was reaction from the Right, a backlash of monarchist, nationalist and conservative feeling embodied in a Catholic revival (the Ralliement), in increasing militarism and in rabid anti-Semitism. Artists were no more immune than any other professional group to the climate of social unrest and to the bitter hostilities that divided French society in the late 1890s as a result of the Dreyfus affair. Degas broke off relations with all Jews, including his old friend Pissarro, and Maurice Denis, a staunchly conservative Catholic, found himself ideologically at odds with his friends in the predominantly Jewish *Revue Blanche* circle, and even with his old Nabi comrade Vuillard.

One has to take account of such social and political circumstances if one is to appreciate the intricacy and mutability of artistic groupings, and if one is to rediscover the contemporary significance of certain types of imagery. This is especially important when one tries to understand the context in which independent artists approached the subject

127
FERRIER & SOLIER: A Parisian boulevard, post-Haussmann. *c.* 1870s. Stereoscopic photograph. New York, George Eastman House, International Museum of Photography

128
La Goulue, Grille d'Égoût, and Valentin le Desossé dancing the can-can. Late 1880s. From 'A Taste of Paris' by Theodora FitzGibbon, photographic restoration by George Morrison.

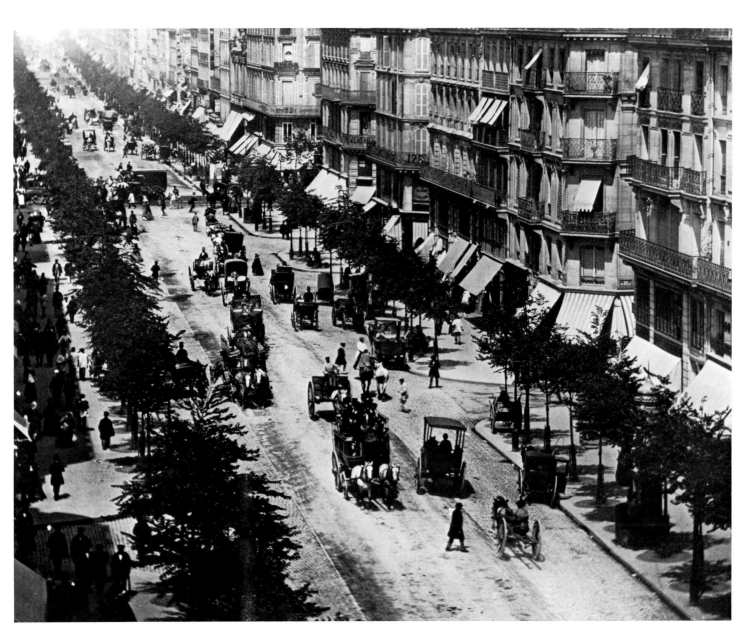

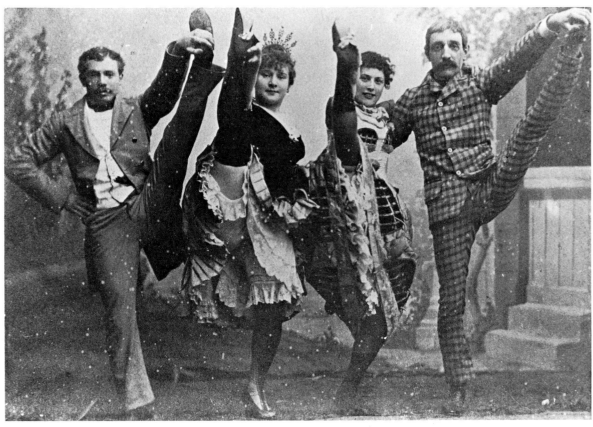

of the city in late nineteenth-century France and the meanings city life could hold for them.

Paris had been extensively rebuilt and modernized under the Second Empire, during the 1850s and 1860s. With Baron Haussmann as Prefect of the Seine, Paris turned from a largely medieval city with narrow streets and irregular buildings into a modern metropolis with broad boulevards flanked by the regular façades of apartment blocks (fig. 127). The population of the city and its suburbs, although nowhere near as large as that of London, grew markedly from the mid-century onwards, and by 1886 numbered over three million, just under 10 per cent of the total population of France. By the 1880s, with the building programme largely completed, it was possible for the critical observer to take stock of the social and political consequences of Haussmann's 'improvements'. And as one might expect, these were seen to be essentially for the benefit of the bourgeois class. Increasingly Paris was becoming a centre for commerce and tourism; indeed the image of 'gay Paris', so familiar today, was largely the invention of late nineteenth-century advertising. On the other side of the coin, the conditions of the working classes had not been improved. Nowhere was the widespread exploitation of the working classes more apparent than in the lot of working women, whose main job opportunities lay in servicing the 'pleasure capital' as domestic servants, laundresses, shop assistants, seamstresses, entertainers or prostitutes. To set against the lucky few working-class girls who made their fortunes and reputations in the cabarets— and the names of La Goulue (fig. 128) and Yvette Guilbert, both painted by Toulouse-Lautrec, spring to mind—there were vast numbers who sank without trace. If it was almost impossible to eke out a miserable existence as an honest woman, it was all too easy to be sucked into prostitution of varying kinds.

Artists of the 1870s had approached the subject of the city in a sporadic way, and mostly from the outside, from the landscap-ist's point of view. It was the writers of that time, with Zola leading the field, who made a more determined stab at investigating the human cost of rapid urbanization in novels such as *Le Ventre de Paris* (1873) and *L'Assommoir* (1877). By the 1880s advanced artists were beginning to catch up with the Naturalist novelists. One probable reason for this was the fact that the hub of Paris's artistic and intellectual life—traditionally the Latin Quarter on the Left Bank—had recently shifted to Montmartre, where rents were cheaper. Artists and writers were thus closer to the pulse of the city. Studios in Pigalle adjoined night-clubs, cafés, theatres, and brothels, and were also in close proximity to the working-class quarters of the northern suburbs. Seurat, Signac and Luce, in the wake of Raffaëlli, drew the industrial suburbs, but interestingly it was a foreigner to Paris, Vincent Van Gogh, who left one of the best topographical records of these working-class quarters (*Outskirts of Paris near Montmartre*, fig. 129). In general by this date advanced painters of Paris were more interested in the changing aspects of social life than in the changing look of the city, though a short-lived distraction was provided by the Eiffel Tower, which began to go up in 1887 (it was completed in time for the Universal Exhibition of 1889). Seurat, among others, was intrigued by its unfamiliar structure and outline (fig. 130).

As the novelty of the revitalized Paris wore off, it seems that avant-garde writers and artists began to approach it more critically. The artists of the 1870s had responded enthusiastically to Baudelaire's famous invocation to painters in his essay 'The Painter of Modern Life' to seize the present moment in its most ephemeral aspects. In a series of paintings Manet and the Impressionists had captured and for the most part celebrated the vivacity, colour, and heightened pace of city living. There was a marked difference in the younger generation's approach to many of the same themes. One is struck by the contrast between the good-humoured brilliance of Manet's *At the Café* (fig. 131), painted in 1878, and the subdued anonymity

129
VINCENT VAN GOGH: *Outskirts of Paris near Montmartre.* 1887. Watercolour on paper, 15½ × 21 in (39.5 × 53.5 cm). Amsterdam, Stedelijk Museum

130
GEORGES SEURAT: *The Eiffel Tower.* 1889. Oil on panel, 9½ × 6 in (24 × 15.2 cm). San Francisco, Fine Arts Museums

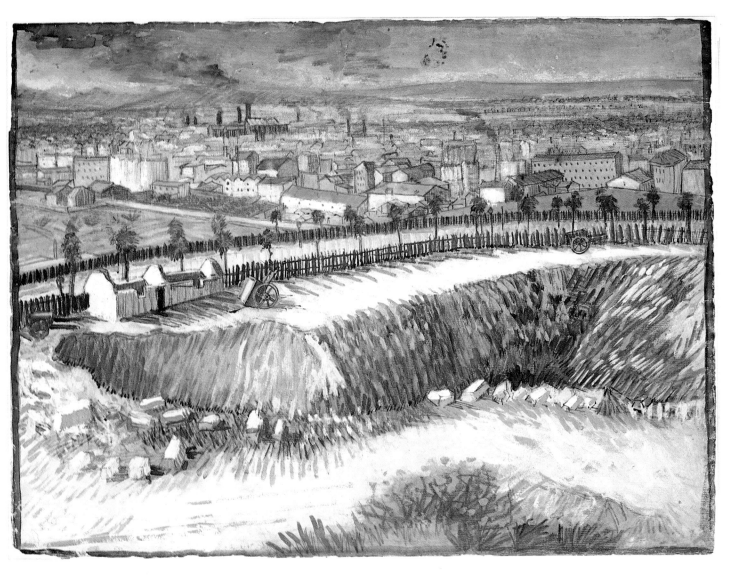

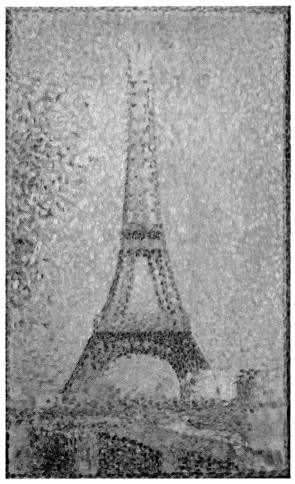

of the figures in Seurat's 1887 drawing *Au Concert Européen* (fig. 91), or the squalor and human degradation evoked by Lautrec's *À la Mie* of 1891 (fig. 133). The gaiety and charm of the young couples in Renoir's *Moulin de la Galette* of 1876 (fig. 132) look naïve and innocent beside the world-weary 'noctambules' and bored prostitutes in Lautrec's *The Dance at the Moulin Rouge* of 1890 (fig. 134). Then again the image created by Degas of the Cirque Fernando, which seems to draw a discreet analogy between his own technical virtuosity and that of the circus performer Miss Lala (fig. 135), seems straightforwardly naturalistic beside the mannered contrivance and false gaiety of Seurat's *Circus*, painted a dozen years later (fig. 140).

The ambition to paint a sizeable figural canvas on a modern Parisian theme preoccupied and united many young avant-garde artists in this period. We can learn a good deal by observing how the more adventurous of them went about it. Seurat's series of

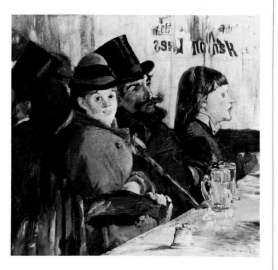

urban canvases provided a touchstone of quality, and can usefully be looked at alongside the more numerous, less finished urban images of Toulouse-Lautrec. Their strategies and achievements were very different, yet they both lived and had studios in the Pigalle district and drew their artistic

inspiration from the same raw material. They went to the same cafés and dance-halls to watch the immodest can-can. They saw the same Chinese shadow-plays at Rodolphe Salis's Chat Noir cabaret (fig. 136), and they watched the same clowns and bareback riders preforming at the tiny Cirque Fernando (fig. 138). They seem to have shared a fascination for the artificial world of nocturnal entertainment, but although their paths must have crossed they moved within different social circles. In dissimilar ways, and no doubt for dissimilar ideological motives, they both seem to have been bent on pointing up the superficiality and the underlying seediness of the world of the entertainer. Lautrec's approach was to concentrate on specific incidents and individuals. In the case of the lugubrious *Jane Avril* (fig. 137), the outrageous *La Goulue* (fig. 139) or the buxom lesbian clown *Cha-u-Kao* (fig. 147), he left characteristic impressions of the style of their performances as well as incisive records of the extent to which their private selves had been battered and brutalized by

135
EDGAR DEGAS: *Miss Lala at the Circus Fernando.* 1879. Oil on canvas, 46 × 30½ in (117 × 77.5 cm). London, National Gallery

136
WILLETTE: Decoration of the Chat Noir café, Paris

137
HENRI DE TOULOUSE-
LAUTREC: *Jane Avril Dancing.*
c. 1892. Oil on board,
33½ × 17¾ in (85 × 45 cm).
Paris, Musée d'Orsay

circumstances. Seurat by contrast adopted a more synthetic approach, attempting to distil the essence from each of the themes of artificiality he tackled (figs. 96, 140). Given their dissimilar results, it is all the more surprising that both artists were responding to influences from the same diverse artistic sources, on the one hand Japanese prints or popular illustrations and posters by artists such as Steinlen, Willette and Chéret (figs. 136, 141, 143), on the other the 'high art' of the Impressionists and in particular Degas. Chéret's influence can be detected, for instance, in the exaggerated, almost caricatural silhouettes of the clown, the ringmaster and the acrobat in Seurat's *The Circus*, as well as

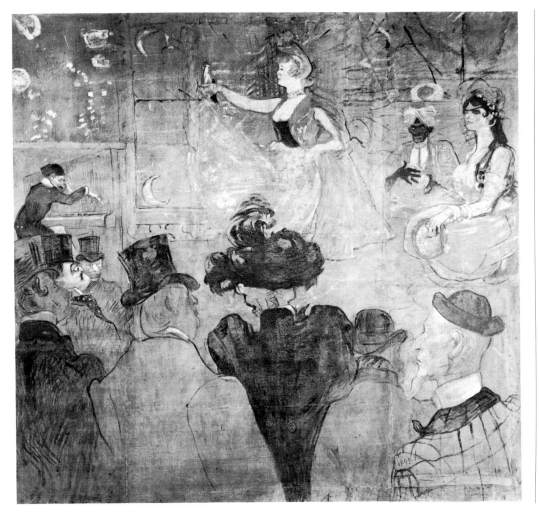

138
HENRI DE TOULOUSE-
LAUTREC: *Bareback Rider at the Circus Fernando.* 1888. Oil on canvas, 39³/₈ × 78³/₄ in (100 × 200 cm). Chicago, The Art Institute of Chicago

139
HENRI DE TOULOUSE-
LAUTREC: *La Goulue Dancing, La Danse de l'Almée.* 1895. Oil on canvas, 112¼ × 121¹/₈ in (285 × 307.5 cm). Paris, Musée d'Orsay

140
GEORGES SEURAT: *The Circus.* 1891. Oil on canvas, 73 × 59¹/₈ in (186 × 151.1 cm). Paris, Musée d'Orsay

in the colours, playful contours and silhouettes of Lautrec's *Au Divan Japonais.* The fact that they managed to produce such very different images is a testimony to the competing aesthetic approaches in the 1880s and 1890s, but it is also an indication of their very different backgrounds and personalities. Seurat, the cold, reserved, and punctilious bourgeois, the critical observer of life, had the necessary detachment to achieve the synthetic and definitive statement on the theme of urban leisure that was *La Grand-Jatte.* By contrast Lautrec, the eccentric aristocratic, had a humorous, extrovert nature that was remembered with affection by the many 'characters' of whom he left such a sympathetic, yet candid record. His attempt at producing a synthetic and

THÉÂTRE ROYAL
DES
Galeries Saint-Hubert
SAMEDI 8 JUILLET

aristide
Bruant
dans son cabaret

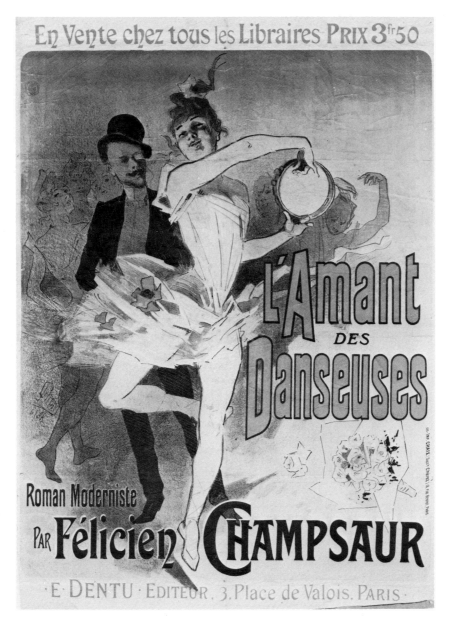

143
JULES CHÉRET: *L'Amant des Danseuses,* poster. 1888. Lithograph for the novel by Félicien Champsaur. 44⅞ × 33⅞ in (114 × 86 cm). Nice, Musée des Beaux-Arts

definitive statement on the theme of nocturnal entertainment was not as successful. *At the Moulin Rouge* (1892, fig. 144) was in a sense the summation of his work there over the three years since it had opened in 1889. The design of the picture (which incidentally incorporates various of Lautrec's friends, and himself, bowler-hatted, walking side-by-side with his tall lanky cousin, Tapié de Céleyran) evidently grew beyond the scale he had originally intended, and he had to join strips of canvas along the right-hand and bottom edges. Only then could he include the looming face of May Milton on the right, which so dominates the final picture. There remains something piecemeal and irresolute about this and all Lautrec's major works on canvas. Undoubtedly his great talents lay elsewhere—in direct observation and speedy execution—and these are best embodied in his graphics and posters.

Seurat and Lautrec stand for opposite yet

144
HENRI DE TOULOUSE-LAUTREC: *At the Moulin Rouge.* 1892. Oil on canvas, 48⅜ × 55¼ in (122.9 × 140.4 cm). Chicago, The Art Institute of Chicago

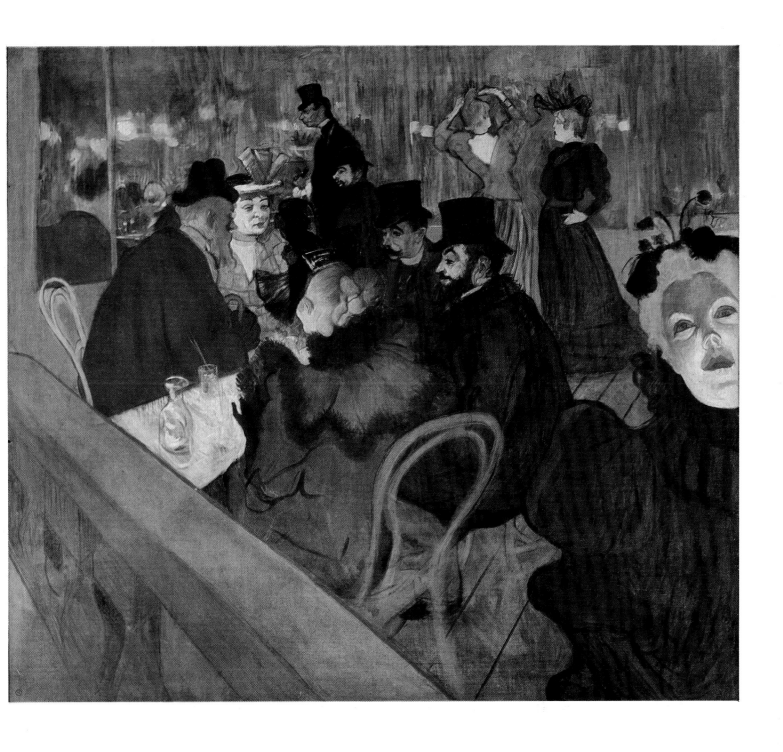

equally critical approaches to city life. Seurat conveys his meanings in complex indirect ways, and his pictures repay careful analysis both at the formal and at the iconographic level. Lautrec's methods are always direct and straightforward. One can illustrate this simply by looking at their different treatment of two 'types' from late nineteenth-century urban life—the prostitute and the clown. In 1886 *La Grande-Jatte* made veiled references to prostitution, particularly in the equivocal figure of the woman to the right of the composition; with her monkey on a leash she was recognizable at the time as a 'cocotte'. By the mid-1890s such ambiguity is left behind and we find Lautrec openly exposing the mundane and intimate side of brothel life in a series of paintings and prints (fig. 145). There had been much discussion of the prostitute as a subject in the intervening years, and a variety of attitudes permeate the works and writings of such artists as Degas, Bernard and Van Gogh. Degas's brothel monotypes, produced around 1880 and intended for private consumption, veer from the crude to the lyrical (fig. 148), while Bernard's series of watercolour illustrations, sent to Van Gogh in 1888, have overtones of smutty schoolboy humour in their caricatural style (fig. 146). Although Van Gogh seems never to have put down his feelings on canvas, he saw in the degraded isolation of the prostitute a potent symbol of the corrupt values of modern society, and a vivid parallel to the position of the artist. The clown too seemed to some an appropriate metaphor for the avant-garde artist. The subject of the circus had originally been brought to the fore by the Naturalist novelist Edmond de Goncourt in *Les Frères Zemganno* of 1879, but it lent itself quite readily to the anti-naturalist reinterpretation suggested by Seurat in his last major figure painting, *The Circus* (fig. 140). The audience, laughing at the clowns, could easily be seen as an equivalent of the public that derided avant-garde art. Lautrec's various representations of the female clown Cha-u-Kao are by contrast naturalistic; while Seurat concentrated on the artifice of the performance, they show those mo-

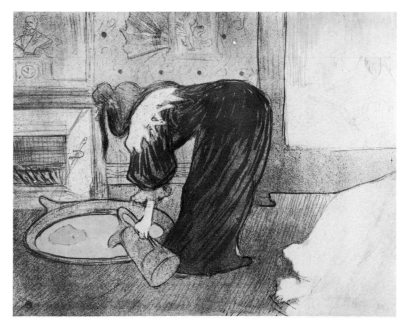

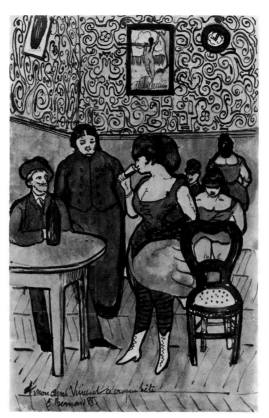

145
HENRI DE TOULOUSE-
LAUTREC: *Elles, Femme au Tub.*
1896. Lithograph,
16¼ × 21 in
(41.2 × 53.4 cm). London,
British Museum

146
ÉMILE BERNARD: *Brothel
Scene.* 1888. Watercolour,
12 × 7¾ in (30.5 × 19.7 cm).
Amsterdam, Rijksmuseum
Vincent Van Gogh

147
HENRI DE TOULOUSE-
LAUTREC: *Cha-u-Kao.*
1895. Oil on cardboard,
25¼ × 19¼ in (64 × 49 cm).
Paris, Musée d'Orsay

ments when the performance is over and the sad reality of private life is resumed. The themes of the circus and of prostitution are

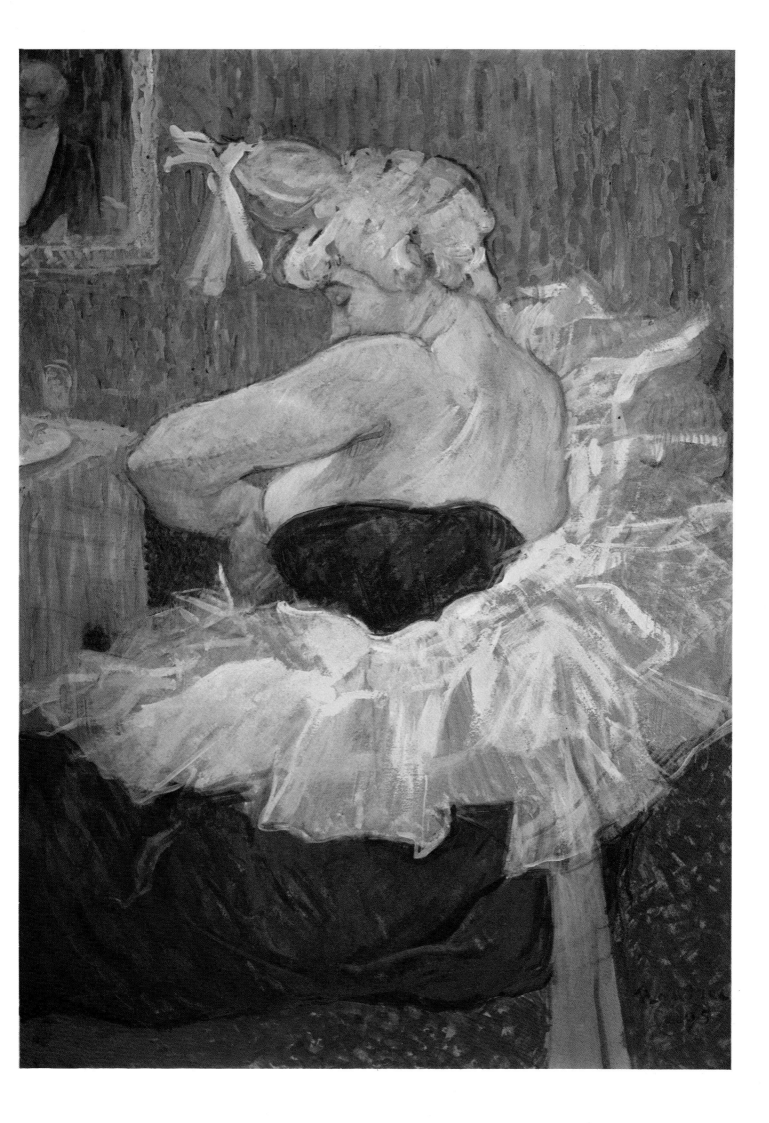

intriguingly combined in Lautrec's painting of *Cha-u-Kao* (1895, fig. 147), which shows her in a private room of a restaurant, apparently undressing for the titillation of an elderly client, whose reflection can be glimpsed in the mirror to the top left of the composition.

If Lautrec and Seurat were the most successful progressive painters of the city—achieving that delicate balance of emphasis between formal innovation and novelty of subjects—others of the younger vanguard, seeking to achieve the same balance, weighted their investigations too heavily to one side or the other. For example, Anquetin and Bernard seem to have wanted to establish themselves as painters of the city by means of a different though equally innovative stylistic route to Seurat's. Their first paintings in the cloisonnist manner in 1886–7 dealt predominantly with urban themes, but technique and subject do not seem to have jelled. Bernard's *Bridge at Asnières* of 1887 (fig. 38) took up much the same view, though from a point slightly further upstream, as Seurat had painted in *Une Baignade*. In this and a similar canvas Bernard seems to have wished to focus our attention on the figures of the rag-pickers, whose downtrodden existence had earlier been described by Huysmans and Raffaëlli; but the cloisonnist technique reduces them to black silhouettes, and they fail to add to the meaning of what remains essentially an exercise in bold structure, line and colour. Anquetin's *Avenue de Clichy, Five O'Clock in the Evening* (fig. 41) is a more successful work, for all that he exhibited it somewhat over-cautiously as an 'ébauche'. It shows a night-time pavement crowd outside a butcher's shop in the avenue where he had his studio. The whole scene is subjected to a dominant blue tonality, which is relieved in the small artificially lit area to the left of the composition by its colour-complementary, orange. But as we noted Anquetin was taken to task by the critics for choosing extraordinary and artificial effects to suit his stylistic preoccupations, rather than truly attempting a synthesis of reality. It may have been such criticisms that led him

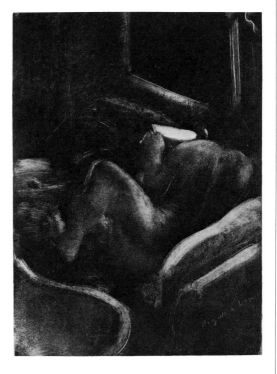

148
EDGAR DEGAS: *Woman Reading. c.* 1885. Monotype, 15 × 11 in (38 × 27.8 cm). Washington, National Gallery of Art

partially to renounce the cloisonnist style after 1890, while Bernard seems to have decided that this archaicizing style was better suited to such themes as the 'primitive' Breton peasants or classical and biblical images. Anquetin continued for a few years to concentrate on themes from *la vie parisienne* in a more fluid style, indebted to a considerable degree to Toulouse-Lautrec.

In the 1890s the Nabis Bonnard, Vuillard, and to a certain extent Vallotton set out to represent the externally visible ebb and flow of Parisian life, its streets, squares and parks, as well as its more private, domestic side. Vuillard's nine decorative panels on the theme of the public gardens, commissioned by Alexandre Natanson in 1894 (fig. 149), were probably his most ambitious undertakings in this vein. But it went against the grain for him to deliberate over his work, so the scheme is less of a definitive statement, more of an assemblage of captured incidents, charming momentary impressions of mothers and children, given some sort of compositional unity by the continuation of the central horizontal division throughout

149
ÉDOUARD VUILLARD: *The Two Schoolboys.* 1894. Peinture à la colle on canvas, 83½ × 38⅝ in (212 × 98 cm). Brussels, Musées Royaux des Beaux-Arts

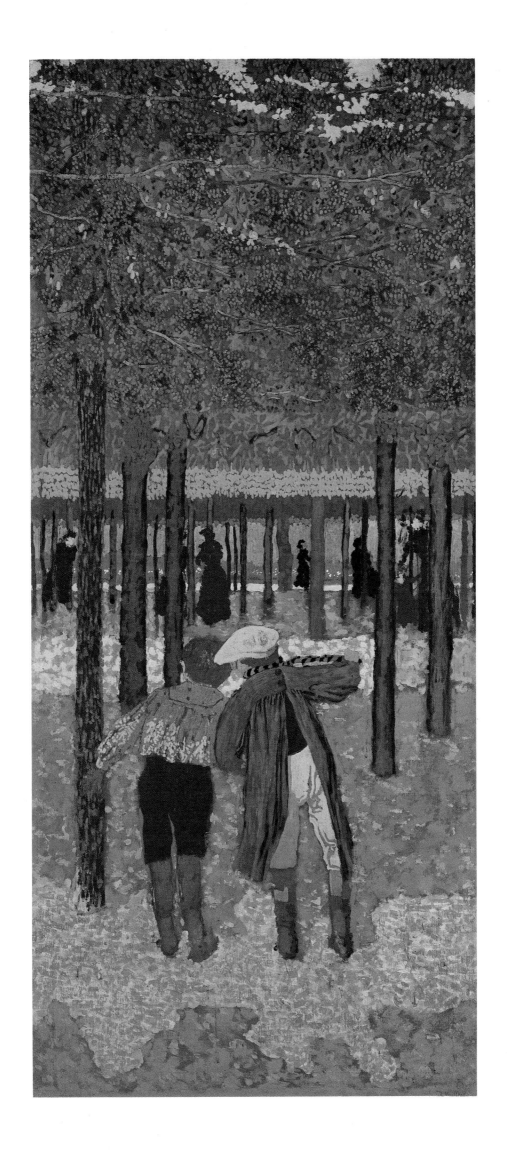

the nine panels. The technique of *peinture à la colle*, which produced a matt, fresco-like effect, was reputedly favoured by Vuillard because it helped keep his excessive facility under control, but it had another advantage for a spontaneous workman such as he was—it could be retouched and reworked almost ad infinitum—a very necessary property, given his distaste for elaborate preparatory work.

On the whole, however, the Nabis were happier reflecting the private side of modern urban life, and it is for their bourgeois domestic interiors and 'intimist' scenes that they are justly best known today. Although at one level this can be regarded as a reversion to a conventional range of subject-matter, the Nabis approached the theme of bourgeois domesticity with a more critical eye than, say, their Impressionist predecessors. It should not be forgotten that the Nabi artists, through their friend the actor-manager Lugné-Poë, were closely involved with the birth of Symbolist theatre in Paris. Some of the first performances in France of the dramas of Ibsen, Strindberg and Maeterlinck took place at Paul Fort's Théâtre d'Art and, after 1893, at Lugné-Poë's Théâtre de l'Oeuvre. These plays were characterized by their subtle fusion of other-worldly forces and mundane domestic situations, and became the talk of intellectual Paris. It is highly probable that the arrangements of figures and space, the uneasy tensions and claustrophobic atmospheres evoked by Vuillard, in his *Mother and Sister of the Artist* of *c.*1891 for example (fig. 54), owe their origin to his assiduous attendance at performances of Maeterlinck's *The Intruder* and Ibsen's *The Wild Duck*, both performed for the first time in 1891. Just as the Symbolist theatre grew organically out of the Naturalist theatre, for Lugné-Poë served his apprenticeship in Antoine's Naturalist Théâtre Libre before setting up his own company, so too certain aspects of Nabi symbolism were direct offshoots of the naturalist genre tradition.

In contrast to the élitist stimulus of Sym-bolist drama, another development that might be expected to have had a direct bearing on representations of Paris in the 1890s was the sudden upsurge of street-level political activism. Anarchists staged a number of bomb attacks, and this wave of violence culminated in 1894 in the assassination of President Carnot. Félix Fénéon was one of those arrested and imprisoned for his suspected involvement with such disturbances. A number of artists are known to have sympathized with the anarchist cause—they included several of the Nabis, in particular the Swiss Félix Vallotton, and most of the Neo-Impressionists—but this rarely went beyond a passive sharing of the anarchists' opposition to the existing social order and an aspiration towards a future when power would be shared by all in a free and equal society. Camille and Lucien Pissarro were among those who contributed propagandist illustrations to anarchist publications, and Vallotton made use of his incisive black-and-white woodcut technique to point up some of the injustices and uglinesses of modern urban reality (fig. 150). Although there is no documentary evidence, it seems likely that Seurat shared the anarchist views of his friends, and this may well explain the consistent irony one finds in his approach to the theme of the city.

Representing the unacceptable face of industrial society was one way in which an artist with left-wing sympathies could be true to his political ideals. Another way was by projecting an unreal, idyllic vision of what his ideal future society might be like, a vision almost invariably of men at peace and in harmony with nature. The Arcadian dream had had a long tradition in the history of art, and it enjoyed a marked resurgence in the 1890s in the works of such anarchist-sympathizers as Paul Signac and Henri-Edmond Cross. *L'Air du Soir* by Cross (fig. 57) can at one level be read as a picture with a political message, although its unnaturalistic use of colour and its Puvis-like mood and figures also belong within the trend towards the decorative that was so characteristic of the age.

150
FÉLIX VALLOTTON: *La Manifestation.* 1893. Woodcut, 8 × 12½ in (20.3 × 32 cm). Paris, Bibliothèque Nationale

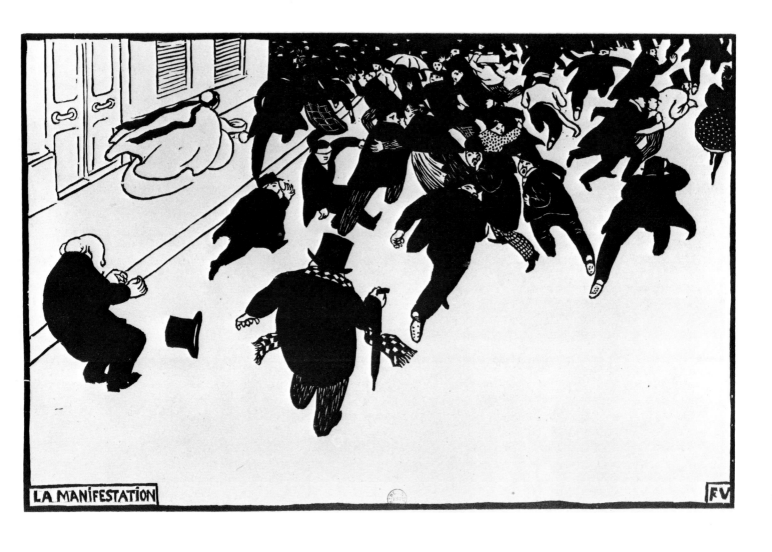

11 '. . . Give me the Country'

Gauguin to Schuffenecker, 1888

Many artists of the second half of the nineteenth century, both conservative and progressive in outlook, turned to the vast panorama of rural France and its varied peasant population for their subject-matter. There was a market among Parisian Salon-goers for rural images, preferably of a picturesque and sentimental kind. The new generation of city dwellers was happy to be diverted by images of the 'honest' life of the country, but did not want to be reminded of the harsher facts of peasant existence. Hence anodyne images of pretty peasant girls enjoying their seasonal tasks were much in demand, works such as Bouguereau's *Return from the Harvest* of 1879 (fig. 151) and, during the 1880s, the unashamedly commercial rustic paintings of Renoir. Even more reassuring in a sense than these blatantly fictional images was the pseudo-naturalism of Bastien-Lepage and Dagnan-Bouveret, which made their authors such huge reputations in the 1880s. Their images of rural labour were widely accepted by the Salon public as truthful and unembellished, whereas more discerning viewers found their painting insipid and suspected that they had carefully avoided showing any aspect of rural life that might prove unpalatable, any subject that might offend bourgeois sensibilities. Simultaneously, certain progressive artists such as Pissarro and Van Gogh were attempting to get closer to the realities of peasant existence as they saw them, while Zola in his novel *La Terre* (1887), set himself the task of tackling 'the whole rural question'. Using the fertile region of La Beauce as his setting (which had the advantage of exemplifying every type of farming from commercial to subsistence, from arable to dairy), he tried to present a truthful image of the 'customs, passions, religion, politics and nationalistic feelings' of the rural proletariat. He was heavily criticized, even by some of his former disciples, for what seemed excessive and unnecessary vulgarity in his treatment of village life and morality.

For progressive painters, part and parcel of wanting to present an honest image of peasant life was the use of a technique that was sincere, uncompromisingly frank and sometimes downright earthy, as in Van Gogh's *Peasant Woman Gleaning* of 1885 (fig. 152). Thus it was often ostensibly for technical rather than other reasons that such pictures were attacked. The criticisms levelled at Courbet and Millet in the 1850s and 1860s continued with minor adjustments to be levelled at Pissarro and Van Gogh in the 1880s. By this date, however, Millet at least was no longer a controversial figure. Following his death in 1875 and the publication of Sensier's biography in 1881, Millet's name had become synonymous with the concept of the peasant-painter. Already such images as the *Sower* and the *Angelus* had become 'classics', clichés almost, through widespread reproduction, and were fetching enormous sums on the art market where they were avidly sought by American collectors. The irony of this situation was not lost on Pissarro and Van Gogh, both of whom had reason to identify with Millet's earlier struggles to gain recognition and who felt themselves, in their different ways, to have taken up his yoke. Pissarro, however, had more

151
ADOLPHE BOUGUERAU: *The Return from the Harvest.* 1878. Oil on canvas, 94 × 64 in (238.7 × 162.6 cm). Jacksonville, Cummer Gallery

152
VINCENT VAN GOGH: *Peasant Woman Gleaning.* 1885. Black chalk on paper, 20¼ × 16¼ in (51.5 × 41.5 cm). Essen, Folkwang Museum

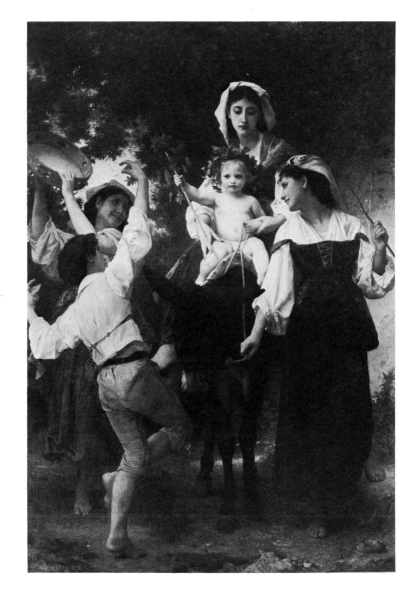

respect for Millet's drawings than for his now popular paintings, which he suspected of being too biblical (fig. 154).

It was around 1880 that Pissarro first began to give more prominence in his works to peasant figures, and at that time he was often judged to be following rather too closely in Millet's footsteps, a charge which he became anxious to refute, particularly after 1887 when it was revealed, through the publication of some of his letters, that Millet had not been as radical as Pissarro and his anarchist friends had thought—on the contrary, had been one of those who opposed the 'outrages' of the Commune in 1871. Notwithstanding Pissarro's professed indifference to the choice of subject-matter, painting the peasant was something he clearly felt had a moral value, something he could justify on ideological and stylistic grounds. It was a means of protesting against the unacceptable capitalistic social order by upholding values that he deemed to be true and honest; and as an artist it kept him in

touch with nature and reliant upon the 'sensations' which he equally felt to be true and honest (fig. 153). As we saw earlier, his more sympathetic critics admired him for the authenticity of his pictures of peasant life. And it was undoubtedly a mark of respect to Pissarro rather than to Millet when Degas

153
Camille Pissarro painting in an orchard at Éragny-sur-Epte. Late 1890s. Oxford, Ashmolean Museum

154
JEAN-FRANÇOIS MILLET: *The Sower.* c. 1850–1. Charcoal on paper, 5¾ × 8¼ in (14.5 × 21.2 cm). Oxford, Ashmolean Museum

155
VINCENT VAN GOGH: *The Sower.* 1888. Oil on canvas, 12⅝ × 15¾ in (32 × 40 cm). Amsterdam, Rijksmuseum Vincent Van Gogh

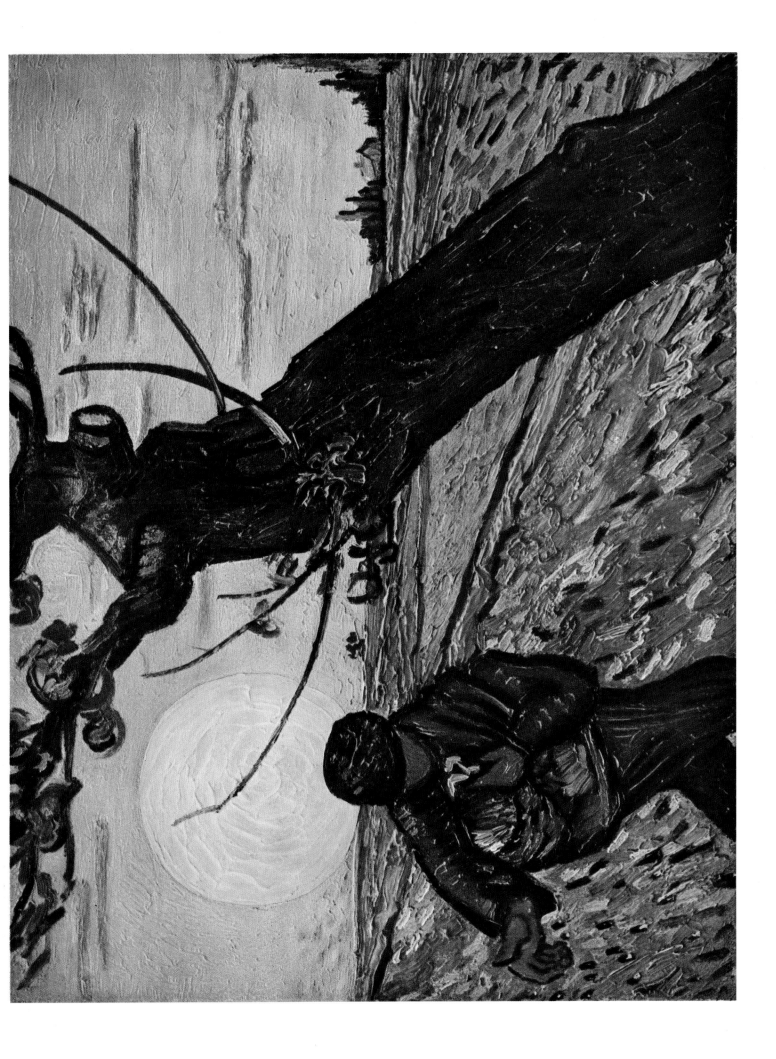

aptly summed up the difference between the two artists thus: 'Millet? His *Sower* is sowing for mankind. Pissarro's peasants are working to make a living.' However, it is interesting that the ideological stimulus of anarchism seems to have produced two types of peasant images in Pissarro's *oeuvre*: those that dwelt on the harsh facts of peasant life and those that projected a vision of a rural Arcadia. Images such as *The Potato Harvest* and *The Market at Gisors* (figs. 30, 156) stress the economic realities of workaday rural existence, whereas pictures like *Women Gleaning* 1889 (fig. 103), although accurate enough depictions of agricultural labour, were also interpreted at the time as idyllic visions of pastoral harmony.

Van Gogh's self-identification with Millet was considerably more emotive than Pissarro's. He was an enthusiastic reader of Sensier's book, and to a large extent tried to model his artistic ambitions and life-style on Millet, whose importance he felt lay in the fact that he had elevated the peasant subject from the level of 'genre' to make it 'the very core of modern art'. Van Gogh's earliest major figure painting, *The Potato Eaters* of 1885 (fig. 157), was his own bid to take up a position as a modern painter of peasants. It came as the summation of an intense period of work studying rural life. In his trowelling on of earth colours in the final painting, Van Gogh seems to have been trying to emulate the quality he had so admired in Millet's *Sower*, the impression that the peasant was 'painted with the very soil he is sowing'. Ever a fervent evangelist, Van Gogh wanted his picture to be seen by an urban public in order that it should awaken them to the honesty and value of the peasants' existence, the integrity of eating the humble fare one had worked to produce. Van Gogh's attitude to the peasant can be seen as both patronizing and naïvely traditionalist, essentially the attitude of the bourgeois townsman. One finds a similar attitude—curiosity mingled with distaste—in Guy de Maupassant's *Bel-Ami*, published in 1885 and later to be one of Vincent's favourite novels. There the hero takes his smart Parisienne mistress

Madeleine home to see his parents in Normandy and warns her that she'll find them crude and strange: 'They're peasants, real peasants, not like those on the musical comedy stage.' And as the couple sit down to an evening meal, the light of a candle exaggerates the grotesqueness of the peasants' gestures: 'From time to time a huge hand appeared raising a fork, which looked as big as a pitchfork, to a mouth which gaped open like some monster's gullet.'

Both Pissarro and Van Gogh invested their peasant images with particular moralistic meanings, in accordance with their aesthetic outlook and political beliefs. Gauguin on the contrary mostly neglected humanitarian and moralistic possibilities in his peasant pictures in favour of a personal and overtly Symbolist imagery. His stays in Brittany and in Martinique and his eventual flight to Tahiti were symptomatic, or so Gauguin was keen to broadcast, of his profound distaste for the corrupt values of Western urban society and of his belief in the existence of an untainted 'primitive' idyll. But as his letters and writings make clear, he was a hard-headed romantic, and if he chose to paint Breton peasants or South Sea islanders it was because he knew they suited his artistic purposes. When in 1888 he declared himself at home in Brittany and claimed to identify with the peasants' religious imagery and customs and their honest, 'primitive' way of life, it was partly because he was so anxious to steer an independent course and free himself from the influence of the 'Parisianist' works of Seurat and his associates; but with his élitist attitudes he had neither capacity nor desire to communicate with, or be understood by, the masses. It was with some satisfaction that he wrote to his friend Schuffenecker in 1888, shortly after completing the *Vision after the Sermon*: 'I am well aware that I will be *less and less* understood. What does it matter to me if I'm setting myself apart from the rest, for the masses I'll be an enigma, for a few I'll be a poet, and sooner or later quality finds its true place.' Thus Gauguin had no qualms about painting entirely imaginary subjects or about

156
CAMILLE PISSARRO: *The Market at Gisors*. 1887. Gouache and watercolour on paper, 12⅜ × 9½ in (31.5 × 24 cm). Boston, Museum of Fine Arts

157
VINCENT VAN GOGH: *The Potato Eaters*. 1885. Oil on canvas, 32 × 44¾ in (82 × 114 cm). Amsterdam, Rijksmuseum Vincent Van Gogh

reviving arcane religious and mystic imagery, even though they met with the moral disapproval of both Pissarro and Van Gogh.

In general terms, Symbolism encouraged the artist who wished his subject to evoke a vague mood, to suggest an unspecified 'deeper meaning' or 'essence' or 'idea', but it militated against the artist who had a specific message to convey or information to impart. Accordingly we find in the Symbolist-oriented landscapes of Gauguin and the Pont-Aven artists (Gauguin's *Tropical Vegetation, Martinique* of 1887, for example, or Lacombe's *Cliffs near Camaret* of 1893 (figs. 36, 59)), a tendency to treat the motif purely as decorative form. At the same time, in their landscapes with figures, such as the *Farmyard at Le Pouldu* of Meyer de Haan (fig. 43) and the Bretonneries zincographs of Bernard and Gauguin (figs. 39, 40), we find what has been aptly termed a 'decline in believable action, a slackening of an acceptable fiction of reality'. Their images tell us very little about the actual circumstances of farming in Brittany in the late nineteenth century. Unlike Pissarro and Van Gogh, who were anxious if not to become peasants at least to understand and live in close proximity to the peasants they were painting (Pissarro bought a house and some land in Eragny, kept livestock and seems to have lived in a manner acceptable to the local residents), with one or two exceptions the painters of Brittany do not seem to have attempted to be seen as anything but visitors. They stayed at inns, moving on when the mood took them, when their credit was exhausted or when the crowds of other tourists became too unbearable. They seem to have cared little about being integrated into the local community.

The lack of understanding between artists and local peasantry was exemplified by the local curé's refusal to hang Gauguin's *Vision after the Sermon* in his church. What perturbed the curé most was presumably its stylistic incomprehensibility—the artist's combination of flat figures, red earth and imaginary wrestlers—but his instinctive wariness of this bohemian outsider would

also have been well grounded. For all its seriousness of purpose and its integrity as an innovative image, Gauguin's *Vision* was scarcely the outcome of orthodox piety. He spoke of it quite candidly as being intended to convey the Breton peasants' 'rustic and superstitious simplicity'. Just as some artists found it difficult to adapt their stylistic initiatives to urban subjects, as we have seen, so painters of rural life fumbled with this delicate balance between subject and form. Gauguin's *Vision*, with its mixture of biblical imagery and Breton reality couched in the experimental language of cloisonnism, was an ambitious but finally unsatisfactory work. The more modest aims of Bernard's *Buckwheat Harvest* (fig. 37), also painted in 1888, were readily achieved because the artist's simplified style well matched the ritualistic aspect of this timeless agricultural task.

The tension between formal concerns and the desire—often tacit—to convey deeper meanings is also traceable in what might be called 'pure' landscape. Along with their dogged attachment to the natural motif, both Van Gogh and Cézanne brought to their landscapes much of their personal vision and so-called temperament. After his short and distracting stay in Paris, in early 1888 Van Gogh felt almost physically drawn back to the soil, where he had his artistic roots. But he was attracted to a new landscape, to the South of France, for several reasons. The South offered sun, which meant colour as used by the Japanese printmakers, by Delacroix in his paintings of North Africa, by Monticelli, by Cézanne and by Monet in their paintings of the Midi. Provence was, so Van Gogh believed, the nearest European equivalent to Japan. The South also offered the opportunity to tread in the footsteps of admired writers such as Daudet. Added to these preconceptions was the unforeseen and uncanny resemblance Van Gogh found between the flat Camargue landscape around Arles, with its rich cultivation, canals, drawbridges, windmills and tree-lined roads, and the landscape of his native Holland. Thus his realization of motifs such as the *Harvest at La Crau* (fig. 160), one of

158
ANDO HIROSHIGE: *Fuji Seen from the Outskirts of Koshigaya in Musashi Province.* Woodcut, $9\frac{7}{8} \times 15$ in (25×38 cm). Amsterdam, Rijksmuseum Vincent Van Gogh

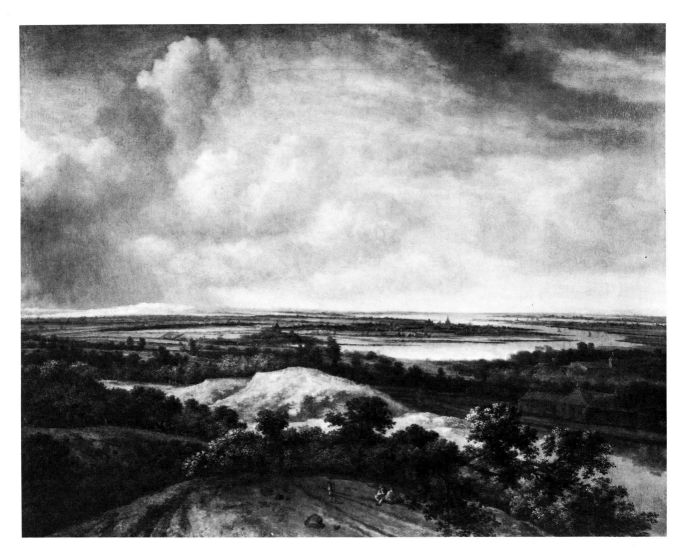

the more considered landscapes of his first summer in Arles in 1888, contained a mixture of stylistic reminiscences: the seventeenth-century Dutch painter Koninck, for the broad panoramic view (fig. 159), Cézanne for the heightened colour, and probably Hiroshige for the relation of working figure to nature (fig. 158). As in his Dutch work earlier in the decade, Van Gogh was chiefly concerned to depict cultivated man-made landscapes (figs. 161, 162). Although the points of human interest in *Harvest at La Crau* serve at one level simply as perspectival markers to establish recession, at the same time they animate and help to explain the work of the harvest.

By contrast, Cézanne seems to have made a point of selecting the more rugged aspects of the landscape around Aix-en-Provence, the untamed and unchanging Montagne Ste-Victoire for example. The paintings he made of the mountain in the later 1880s, such as the *Landscape with Viaduct* (fig. 164), incorporate standard compositional devices—the *repoussoir* trees—and use the man-made elements—the houses, the road, and the viaduct itself—to indicate depth by changes of scale. In his last paintings of the mountain, dating from *c.* 1904–6 (fig. 166), he minimized all references to human habitation; his meditation on the solitary and immutable bulk of the mountain had become

159
PHILLIPS KONINCK: *Dunes and River.* 1664. Oil on canvas, 37⅝ × 47⅝ in (95 × 121 cm). Rotterdam, Boymans Van Beuningen Museum

160
VINCENT VAN GOGH: *Harvest at La Crau.* 1888. Oil on canvas, 28½ × 36 in (72.5 × 92 cm). Amsterdam, Rijksmuseum Vincent Van Gogh

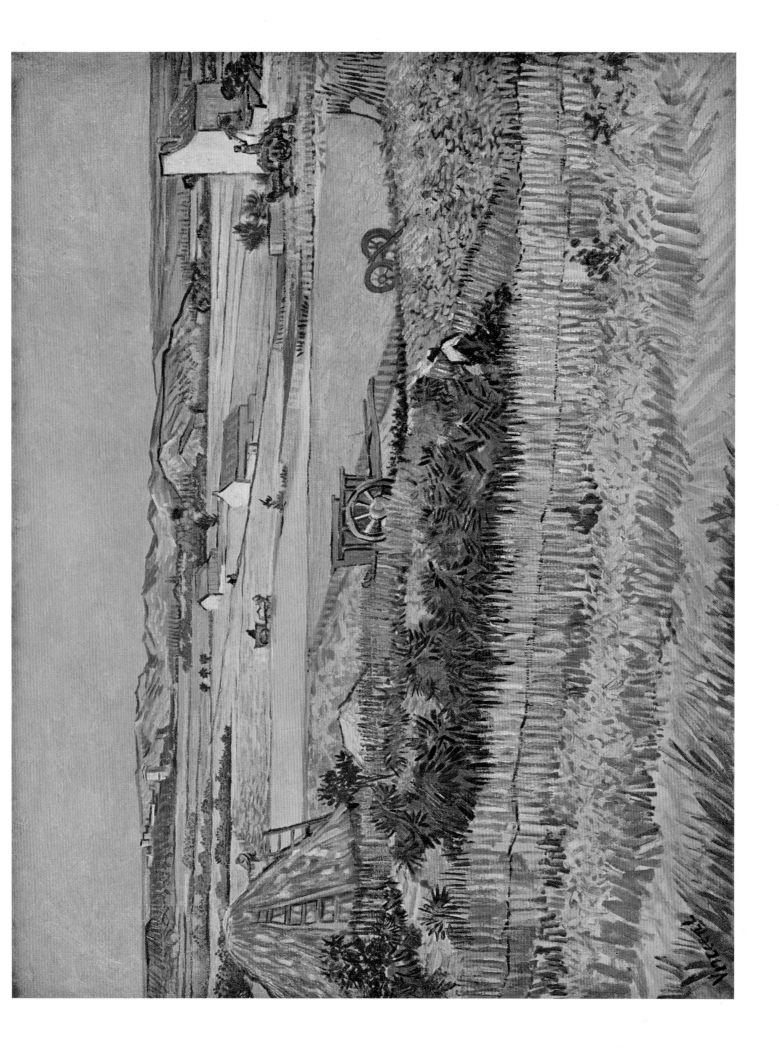

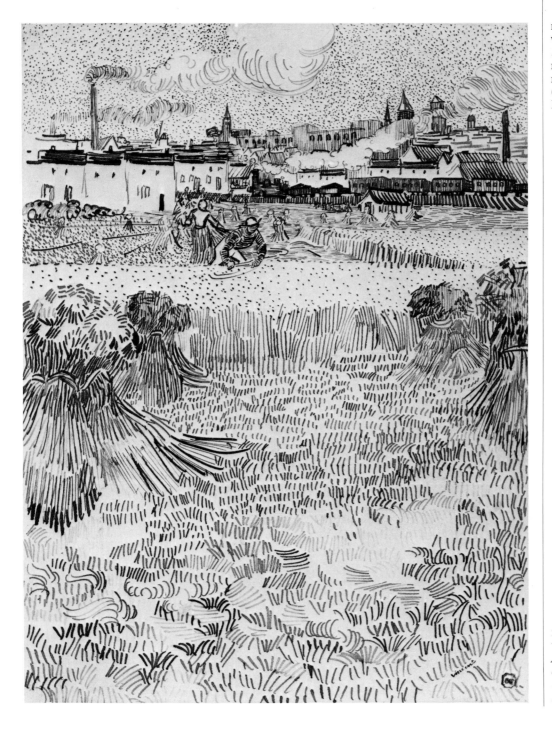

161
VINCENT VAN GOGH: *Arles:
View from the Wheatfields.*
1888. Pen and ink,
12³⁄₈ × 9½ in
(31.5 × 24 cm). Basel,
Kunstmuseum

162
VINCENT VAN GOGH: *View of
Arles with Orchards.* 1889. Oil
on canvas, 28¼ × 36 in
(72 × 92 cm). Munich, Neue
Staatsgalerie

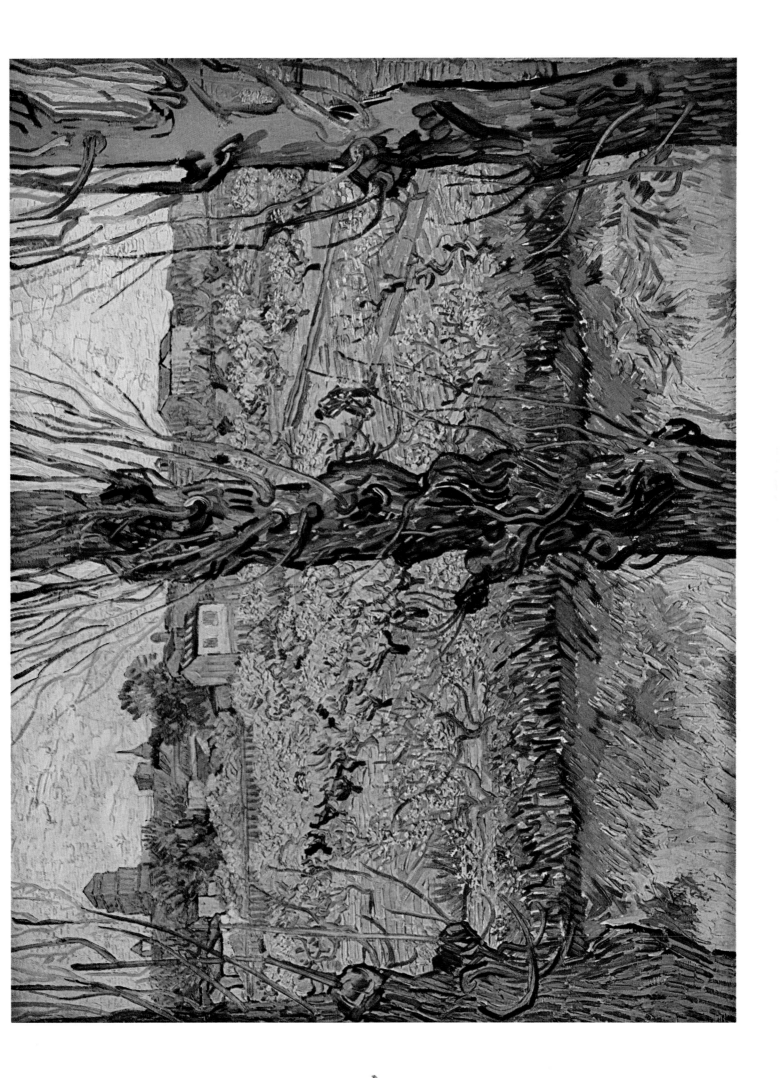

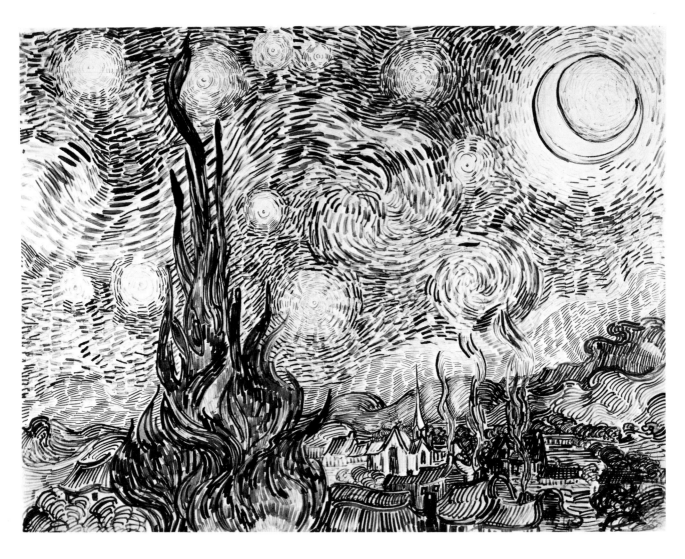

an almost obsessive infatuation. He now achieved a certain illusion of recession through the modulation of warm and cool colours laid down in characteristic patches, yet these patches, as has been frequently pointed out, have the simultaneous effect of drawing attention to the painted surface. And the fact that neither Van Gogh nor Cézanne made use of the traditional landscapist's device of aerial perspective, and kept their contours and colours clear and strong over the whole surface of the canvas, is another factor which binds their landscape images into a unified painted whole. These stylistic traits notwithstanding, the images chosen by both artists clearly held important

and often very personal meaning for them.

Van Gogh left no ambiguity about the meanings he meant his landscapes to convey: he compulsively expressed them in words as well as in paint. We know that he came to the characteristic southern vegetation of olive trees, cypresses and vines with the ambition to record it from a documentary point of view. But we also know that he invested these trees with more complex symbolic meanings (figs. 163, 165)—the olives, for example, because they reminded him of the Garden of Gethsemane, were intended to express the sadness and anguish of Christ's last days on earth. In fact they were his rejoinder to Gauguin's and Bernard's more

163
VINCENT VAN GOGH: *Starry Night*. 1889. Pen and ink on paper, 18½ × 24⅝ in (47 × 62.5 cm). Bremen, Kunsthalle

164
PAUL CÉZANNE: *Landscape with Viaduct*. 1885–7. Oil on canvas, 25¾ × 32⅛ in (65.5 × 81.7 cm). New York, Metropolitan Museum of Art

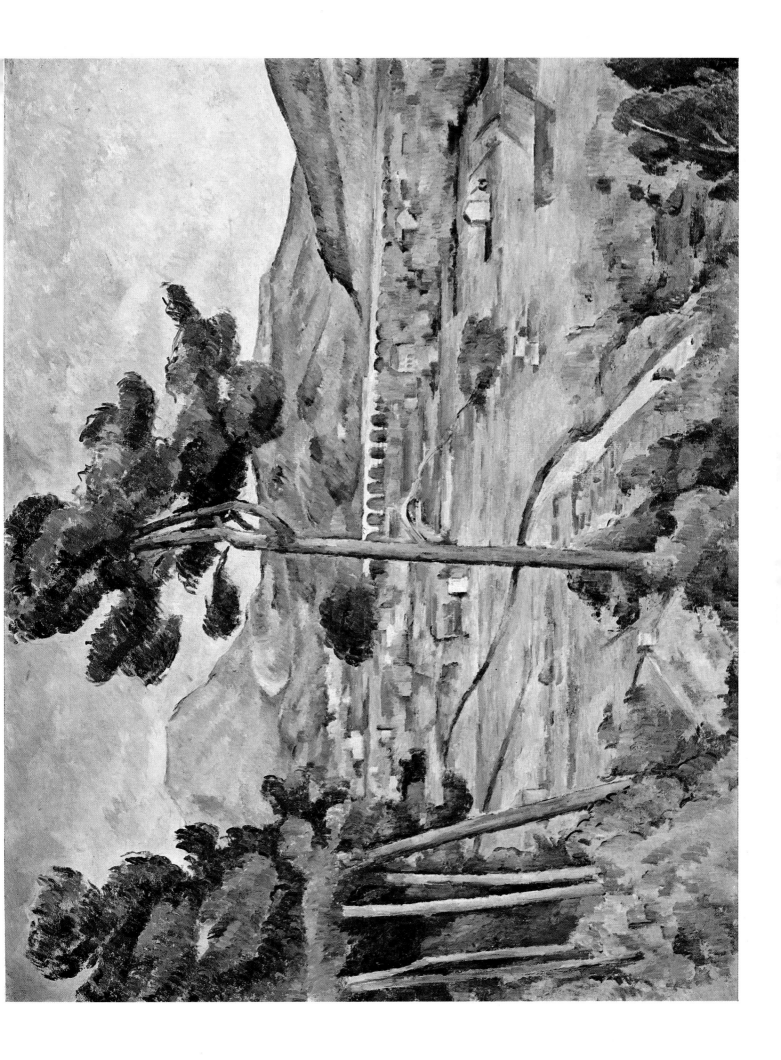

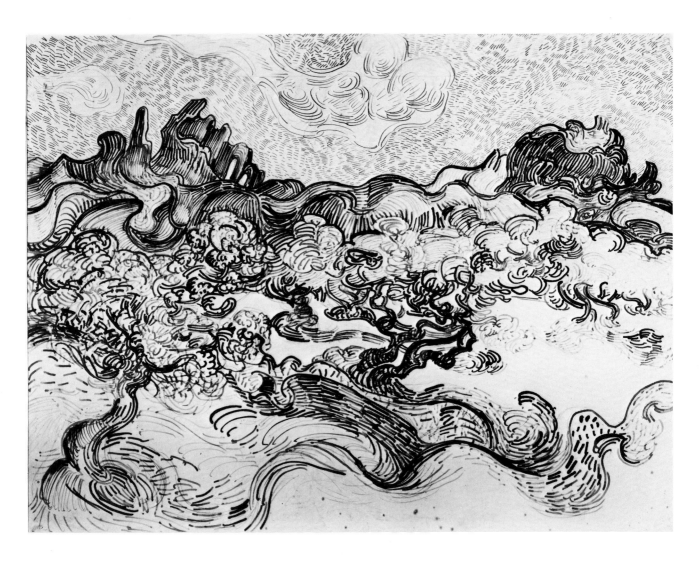

direct use of biblical subjects, as he made clear in a letter of 1889 to Bernard: '. . . one can give an impression of anguish without aiming straight at the historic Garden of Gethsemane, . . . it is not necessary to portray the characters of the Sermon on the Mount in order to produce a consoling and gentle motif.' Thus his fear of working from memory and his commitment to the natural world was in no sense a limitation on his imagination or indeed on his ability to evoke deeper meaning beyond the physical objects described. Likewise, Cézanne's late land-scapes, so often seen in terms of his stated ambition to 'do Poussin again after nature' (a remark given far more weight than it de-served by such commentators as Maurice

Denis in their anxiety to appropriate Céz-anne, to situate him within a supposed French classical tradition), these too should be seen as more than mere painterly exer-cises. Although he left no clear explanation of his intentions, as Van Gogh had done, his preoccupation in later life with painting the abandoned and crumbling Château Noir and the Bibémus quarry, overrun with thickets, seems to be the expression of an unspoken belief that man's achievements are as no-thing in the face of nature. In the late nineteenth century, landscape did not just serve artists as a pretext for refining their technical skills; it also stimulated the explor-ation of personal, symbolic and, in the case of peasant subjects, ideological meaning.

165
VINCENT VAN GOGH: *Olive Groves in the Alpilles.* 1889. Pencil, pen and ink, 18½ × 24⅝ in (47 × 62.5 cm). East Berlin, National Gallery

166
PAUL CÉZANNE: *Mont Sainte-Victoire. c.* 1904–6. Oil on canvas, 25⅝ × 31⅞ in (65 × 81 cm). Zurich, private collection

12 'Lilies, lilies, yet more lilies!'

Octave Mirbeau, 1895

Although the Symbolist movement in art was concerned with the re-emphasis of formal pictorial means over narrative ends, or of the decorated surface over the subject, it also paradoxically entailed a revival of certain hierarchical distinctions between different types of subject-matter. It is possible in the context of the 1890s to speak of 'Symbolist' imagery: this involved new departures as well as the resuscitation of some archaic traditions in the representation of the human figure and more especially in the representation of women. In 1891 Sâr Joséphin Péladan laid down the rules of his newly instituted Salon of the Rose + Croix, which itemized not only the sorts of subject that would be preferred, but also those that would not gain admission — that is, all subjects that were felt in some way to debase and demean the 'nobility' of the artist. He proscribed military scenes and scenes from modern life, naturalistic landscapes, still-lifes and portraits. Thus the peasants of Pissarro along with the brothels of Toulouse-Lautrec would have been banished. Broadly speaking, the subjects considered suitable were those inspired by religion, mysticism, legend and myth, dream, allegory, lyricism and the paraphrase of great poetry.

Péladan represented a conservative branch of the Symbolist movement and his dictates were scorned by most members of the artistic avant-garde. The artists he attracted were more likely to have shown previous work at the official Salons than at the *Indépendants*. Yet despite their disapproval of Péladan's brand of Symbolism and of his blatant selection by subject rather than by quality or stylistic criteria, the same sorts of iconographic tendencies so crudely promoted by Péladan can be found in the 1890s art of Gauguin, Bernard, Munch and certain of the Nabis, especially Denis, Sérusier, Ranson and Filiger. In their figure paintings they showed a preference for the universal rather than the particular, for the eternal themes of youth, motherhood, love, jealousy, life and death, rather than for the naturalistic depictions of specific individuals. They often took their inspiration from the Bible or from other religious sources, from literature and from fantasy dream-worlds. Avant-garde Symbolists and Péladan acolytes alike set about ransacking contemporary or near-contemporary authors for 'poetic' inspiration. They also turned to the Arthurian legends and to the grandiose opera dramas of Richard Wagner, which were once more being staged at the Paris Opéra after a thirty-year interval. Fantin-Latour specialized in lithographs on Wagnerian themes (fig. 167), and in his wake many Rosicrucian artists exploited these rich mines of symbolic imagery. Maurice Denis's lithograph *The Blessed Damozel* (fig. 168) has both poetic and musical affinities: inspired by a Rossetti poem, it was intended as frontispiece for the cantata on the same theme by the up-and-coming composer Claude Debussy.

Stylistically the 1890s are often represented as a chaotic free-for-all, with no significant new developments and a tendency for the innovatory styles of the previous decade to lose something of their identity. The increasing emphasis on subjects of mystical or religious character led young

167
HENRI FANTIN-LATOUR: *The Evocation of Erda*, from Wagner's *Siegfried*. 1886. Lithograph, 9 × 5⅞ in (23 × 14.9 cm)

168
MAURICE DENIS: *The Blessed Damozel*. 1893. Lithograph, 4½ × 11⅝ in (11.3 × 29.5 cm). Paris, Bibliothèque Nationale

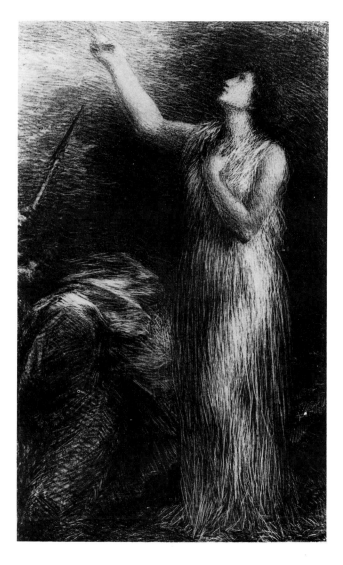

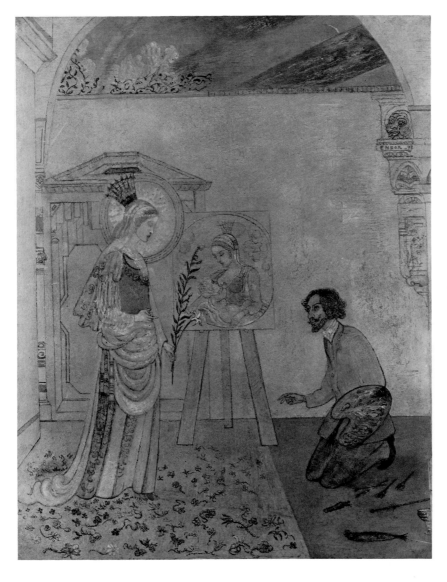

169
JAMES ENSOR: *The Virgin as
a Comforter.* 1892. Oil
on panel, 19 × 15 in
(48 × 38 cm). Brussels,
A. Taevernier Collection

artists in the 1890s to search for inspiration beyond the boundaries of avant-garde styles. Ensor's *Virgin as a Comforter*, Denis's *Mystère Catholique* and Filiger's *Lamentation over the Dead Christ* (figs. 49, 169, 170) are good examples of the ways in which progressive artists sought to inject new life into seemingly moribund Catholic imagery by recourse to blatantly primitive sources. In these cases the artists quote Fra Angelico and Giotto respectively. Séon's mythological fantasy *Despair of Chimera* (fig. 16), shown at the first Rose+Croix Salon in 1892, is an example of the many variations of Symbolist styles inde-

bted to either Moreau or Puvis de Chavannes. In this painting Séon seems to have managed to combine the two.

The theoretical stances of the 1880s were relaxed. The pointillists' use of the dot became increasingly arbitrary, bold and ornamental, no longer strictly obeying the colour laws of Chevreul and Henry. And Maurin's *Dawn of Love* (fig. 171), the right-hand panel from his triptych *Dawn* exhibited at the first Rose+Croix Salon, shows how the realism and incisive linearity of Degas and Lautrec could become mannered and weakened when applied to an unnaturalistic

170
CHARLES FILIGER:
*Lamentation over the Dead
Christ. c.* 1893. Gouache,
13 × 13¾ in (33 × 35 cm).
New York, Arthur G.
Altschul Collection

171
CHARLES MAURIN: *The
Dawn of Love. c.* 1891. Oil on
canvas, 31½ × 39⅜ in
(80 × 100 cm). London,
Piccadilly Gallery

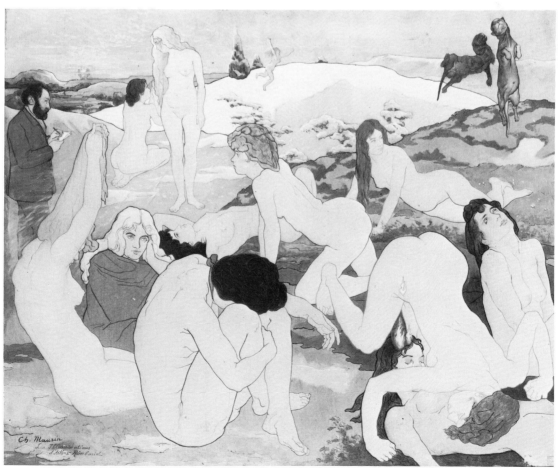

symbolic theme. As these developments indicate, if there was one unmistakable general stylistic trend in the 1890s, both in avantgarde and in more conservative art, it was the trend towards the decorative. This after all was the decade when the applied arts were revolutionized under the banner of Art Nouveau, and the boundaries between high and applied art were progressively broken down. Gauguin had set an example with his interest in ceramics, bas-relief carvings and wood-cuts, and the Nabis were quite prepared to turn their hands to designing stagesets, theatre programmes, wallpapers, and tapestries.

Women, a recurrent theme in Symbolist imagery of the 1890s, were generally subjected to one of two contemporary mythologies. They were shown either as virginal, pure, angelic creatures or as powerful sexual beings, 'femmes fatales', sinister and threatening to men. If Ensor's *Virgin as a Comforter* and Denis's *Avril* clearly exemplify the former category, Maurin's writhing female forms exemplify the latter. One even finds examples of this rather crude iconographic differentiation in the psychologically penetrating paintings and prints of the Norwegian Edvard Munch, whose expressive and simplified drawing style and use of bold flat colour areas have many parallels with Gauguin and the Nabis. Despite its title, his well-known colour lithograph *Madonna* of 1895–1902 (fig. 172) is unmistakably a kind of 'femme fatale', flaunting her body's potent fertility. Munch surrounded her with a decorative border of sperm motifs which conjoin with the female to produce the embryo in the lower left corner. Gauguin too became fascinated by the possibilities for producing images of women with symbolic overtones.

In his print *Les Cigales et les Fourmis* (fig. 173), produced in early 1889 for the Volpini show, Gauguin came back to the subject of the women of Martinique, whose graceful gait and languorousness had so appealed to him in 1887. He gave the subject a deeper meaning by recourse to a literary parallel, La Fontaine's well-known fable, *La Cigale et la*

Fourmi, which describes the grasshopper who has sung her way through the summer being forced to beg the hard-working ant for some food as the winter sets in. The fable had become a standard metaphor in late nineteenth-century Paris for the pleasureseeking and the hard-working modern woman. Salon artists treated the theme, and Moreau did a watercolour version as part of a complete series of La Fontaine illustrations (fig. 174). Gauguin seems to have omitted to represent the ant, thus doing away with the puritan work ethic that underlies the moral of the fable, seeking only to liken the relaxed approach to life of the Caribbean woman to

172
EDVARD MUNCH: *Madonna.*
1895. Lithograph,
23⅞ × 17½ in
(60.7 × 44.3 cm). Oslo,
Munch Museum

173
PAUL GAUGUIN: *Les Cigales et les Fourmis*. Zincograph, 7⅞ × 10¼ in (20 × 26.2 cm). London, British Museum

174
GUSTAVE MOREAU: *La Cigale et la Fourmi*. 1880–1. Watercolour on paper, 11 × 8¼ in (28 × 21 cm). Private collection.

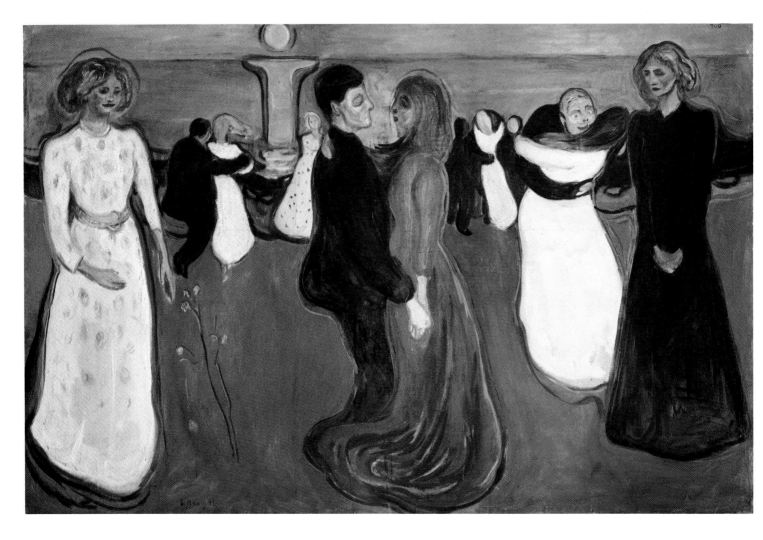

the happy-go-lucky attitude of the grass-hopper.

Munch and Gauguin are known to have met in Paris in 1893–5 during Gauguin's last stay in the capital, and for a short time they moved in the same tight-knit intellectual circle. In particular they were linked by their association with the playwright Strindberg, who not only provided the inspiration for much of Munch's subject-matter but also produced a memorable account of Gauguin's works in 1895. It is thus not such an extraordinary coincidence that both artists, while working at the end of the decade on opposite sides of the globe, should have produced comparable major mural-like paintings on the theme of the cycle of life. Munch's *Dance of Life* of 1899 (fig. 175) is a frieze-like arrangement of dancing couples by the water's edge. Flanking the amorous couple in the centre he places two solitary symbolic women, one in white, who has still to embark on the perils of life, the other in black, sad and withdrawn, scarred by her unhappy experiences. Whereas Munch's painting reads from left to right, Gauguin's enormous *Where Do We Come From?* (fig.

176) should be read, so we learn from one of his letters, from right to left. He passes from birth to maturity and temptation in the centre—the figure plucking fruit and the child eating it—to old age and death, symbolized by the white bird in the bottom left-hand corner. One is inclined to admire Munch for being able to adapt a familiar seen event, a modern-day midsummer celebration on the banks of Oslofjord, to convey his Symbolist purposes, while Gauguin had to travel half-way across the world and invent a complex esoteric and highly individualistic imagery to convey a very similar philosophical idea. His Tahitian idols were in fact largely his own inventions, modelled on Easter Island statues and oriental Buddhas. His use of animal imagery from his work of the late 1880s onwards was equally idiosyncratic and impenetrable to the ordinary spectator—the fox in *Soyez Amoureuses* (fig. 46), for instance, was intended by him as a symbol of perversity, while the immobile strange white bird in the lower left-hand corner of *Where Do We Come From?* was intended to represent 'the futility of words'. That the meaning of the animal

175
EDVARD MUNCH: *The Dance of Life*. 1899–1900. Oil on canvas, 49³⁄₈ × 75 in (125.5 × 190.5 cm). Oslo, National Gallery

176
PAUL GAUGUIN: *Where Do We Come From? Who Are We? Where Are We Going?* Oil on canvas, 54³⁄₄ × 147¹⁄₂ in (139 × 374.5 cm). Boston, Museum of Fine Arts

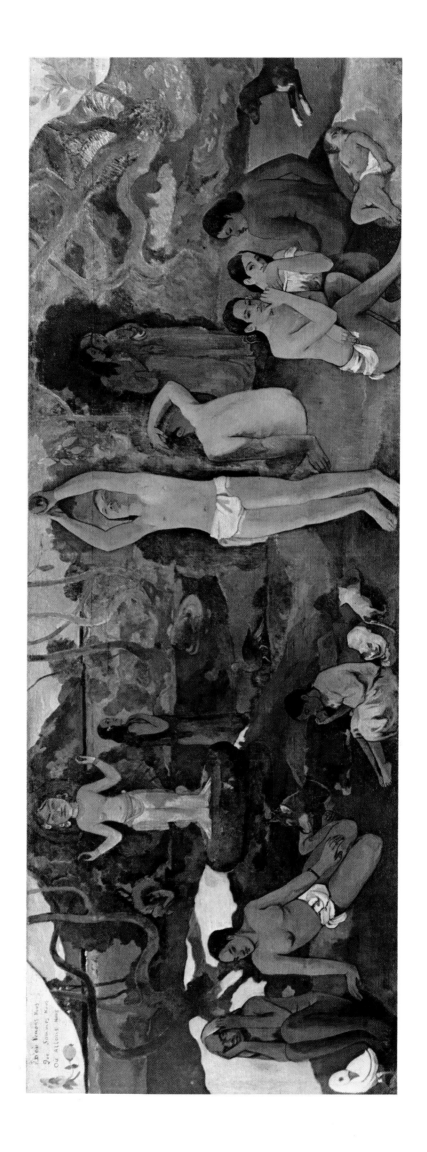

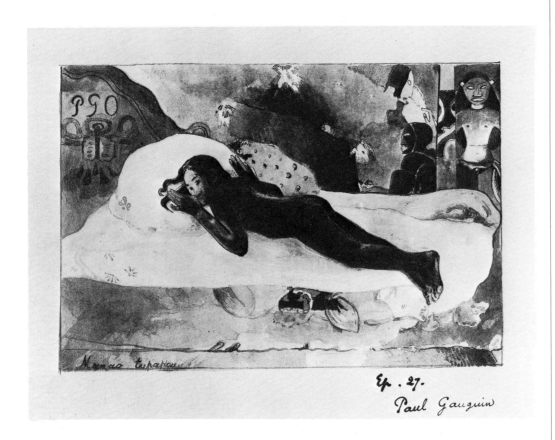

177
PAUL GAUGUIN: *Manao Tu-papau, The Spirit of the Dead Keeps Watch.* 1894. Woodcut, 8 × 13⅞ in (20.3 × 35.2 cm). London, British Museum

images would be lost on the ordinary spectator was intentional; Gauguin presumably believed that they helped heighten the dream-like strangeness of his work. But they were only the somewhat self-conscious literary part of his work; what he referred to as the 'musical part', the combination of lines and colours, is on a par with Munch's in expressive simplification, and surpasses him in richness of decorative effect.

Gauguin's attitude to religious imagery seems to have been somewhat cavalier. Whether he was dealing with Catholicism as in the *Vision*, the *Breton Calvary* and his early Tahitian painting *Ia Orana Maria*, or with the primitive religion of the islanders as in *Mahana No Atua* or *Where Do We Come From?* (figs. 179, 180), he treated the religious element essentially as a picturesque motif, a foil for his imagination, and was intrigued more by the outward forms of worship—the ritualistic gestures—than by the substance of religious beliefs. He could

thus adapt to changes of circumstances by making minimal adjustments to his pictorial style. Although Pissarro's views about Gauguin were always marked by his own personal and ideological prejudices, in 1891 they showed considerable historical perspicacity. He explained to Lucien that there were straightforward reasons for Gauguin's current success, both in selling his works and in mustering the support of the Symbolists. 'It is a sign of the times... The bourgeoisie, frightened, astonished by the immense clamour of the disinherited masses, by the insistent demands of the people, feels that it is necessary to restore to the people their superstitious beliefs. Hence the bustling of religious symbolists, religious socialists, idealist art, occultism, Buddhism, etc., etc. Gauguin has sensed the tendency.' Pissarro added, in self-defence: 'The impressionists have the true position, they stand for a robust art based on sensation, and that is an honest stand...'

178
MAURICE DENIS: *Jacob Wrestling with the Angel.* 1893. Oil on canvas, 18⅞ × 14⅛ in (48 × 36 cm). Switzerland, Josefowitz Collection

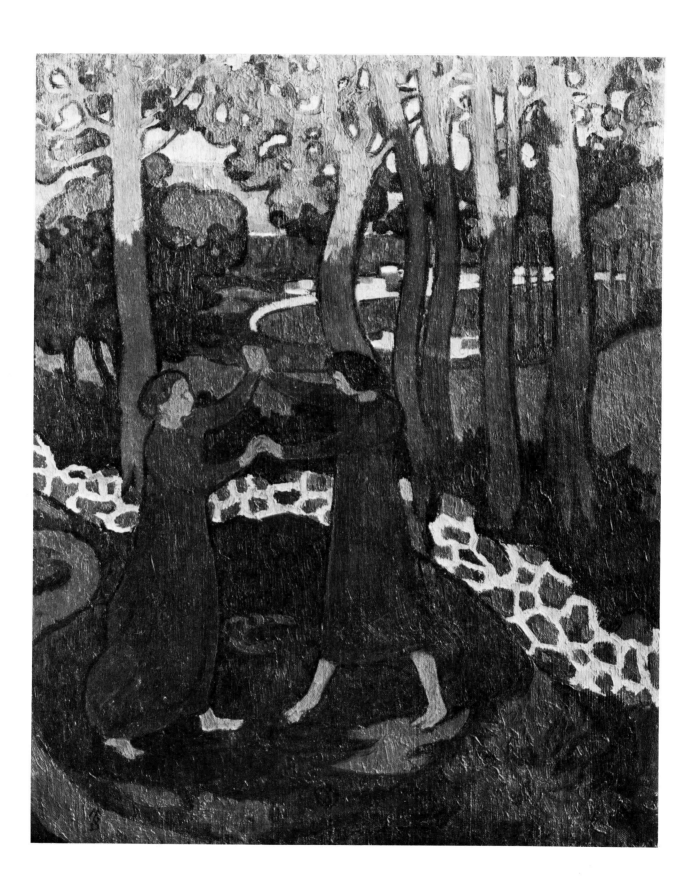

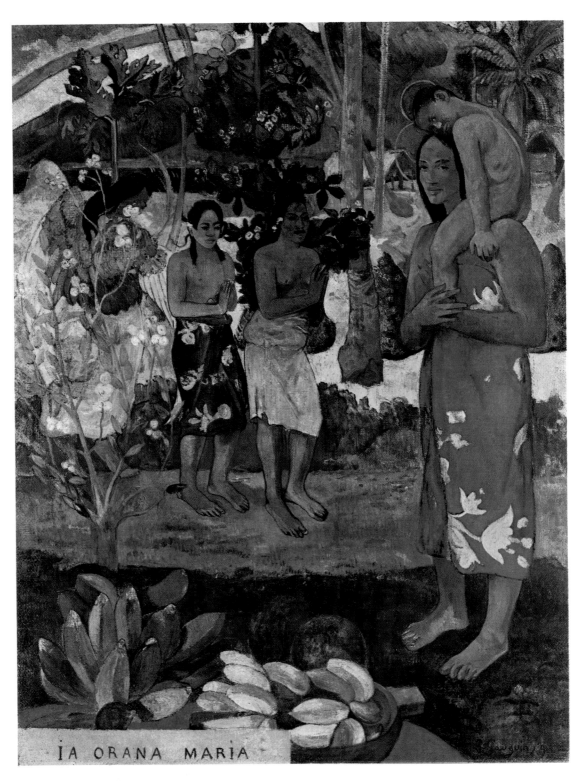

IA ORANA MARIA

179
PAUL GAUGUIN: *Ia Orana
Maria, Hail Mary.* 1891. Oil
on canvas, 44¾ × 34½ in
(113.7 × 87.7 cm). New
York, Metropolitan Museum
of Art

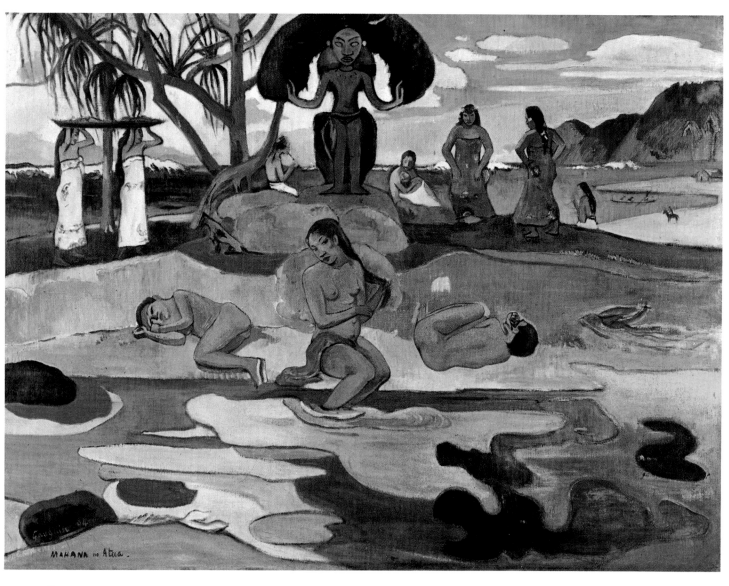

180
PAUL GAUGUIN: *Mahana
No Atua, The Day of God.*
1894. Oil on canvas,
27⅜ × 35⅜ in
(69.6 × 89.9 cm). Chicago,
The Art Institute of Chicago

Whether the causes were exactly those that Pissarro pinpointed, he was certainly right in identifying a mystic and religious revival at the beginning of the 1890s. Certain artists were more ideologically involved in this than Gauguin, notably Maurice Denis, whose strong Catholic faith became an increasingly dominant factor in his art and art criticism. He may have claimed in his 'Definition of Neo-Traditionism' that the decorated surface was more important than the subject, but as the decade wore on his own commitment to Catholic imagery became more and more obvious. It was not just aesthetic disagreements that made him turn down invitations to participate in the Rose+Croix Salon. His orthodox religious beliefs led him to look askance at the vague religiosity encouraged by Péladan. And when Denis set himself to paint a modern-day version of an Annunciation—as in *Mystère Catholique*—or of *Jacob Wrestling with the Angel* (fig. 178), the motifs meant something very real and very personal. Of course, such overt Catholicism at the time of the right-wing Ralliement was an expression of a political position, and Denis received patronage from such prominent right-wing Catholics as Baron Denys Cochin.

Artists and critics of radical persuasion, such as Pissarro and Mirbeau, might attack the Symbolist subject of the 1890s as opportunistic or twee, but they were partisan. A yearning for imaginative art after decades of Naturalism and a *fin-de-siècle* pessimism certainly helped form the canon of Symbolist subjects, but it was also moulded by ideological pressures—most notably by a revived Roman Catholicism—and sustained by a conservative art market that could see in the imagery of Denis and Séon a reassuring combination of progressive style with traditional content. The 1890s may have had none of the excitement of the 1880s—the rapid stylistic innovation, the competitive avant-gardes, the critical disputes—but they were nonetheless a decade of intricate and fertile complexity.

Conclusion

In the 1980s the term Post-Impressionism still seems inescapable because it is so convenient for grouping together the art of the last two decades of the nineteenth century. Yet it has no art-historical validity and does not really shed light on the art it describes. Those decades saw numerous attempts by young artists and critics to produce their own self-explanatory style labels—Neo-Impressionism, for instance, or Neo-Traditionism—as one after another Seurat, Gauguin and Cézanne were set up as heroes and potential leaders of the avant-garde, a role for which none of them was fully suited. Although such labels do not suffice to sum up the stylistic concerns of the era, each in its way tells us more than Roger Fry's. In the final analysis the character of this period must be judged by its diversity as well as by its richness. Impressionism was one of its ingredients, informing the working practices of Gauguin and Cézanne—in the latter's case to the end of his life—and prompting the subject-matter of Seurat and Toulouse-Lautrec. But the main currents of the era can be found in its aspirations rather than in its inheritance, in its search for an art of synthesis, an art of ideas and intellect as opposed to sensation, an art equipped to make use of the lessons of the distant as well as of the recent past, an art as suited to dealing with age-old imagery as to dealing with the novel subjects of the day.

Artists' Biographies

AMAN-JEAN, EDMOND (1860–1936). French painter. Studied under Lehmann at École des Beaux-Arts. Fellow student of Seurat. Shared studio in early 1800s. Seurat's drawing of Aman-Jean shown at Salon of 1883. With Seurat, visited Puvis de Chavannes's studio and helped him square up *The Sacred Wood* for Salon of 1884. Exhibited at Salon (*Ste Geneviève* in 1886), from 1890 at Salon de la Société Nationale, and at first two Salons de la Rose+Croix in 1892 and 1893.

ANQUETIN, LOUIS (1861–1932). French painter born in Normandy. Studied under Bonnat and then under Cormon. Fellow student of Toulouse-Lautrec, Bernard and Van Gogh. In 1886–7 began painting in 'cloisonnist' manner with Bernard – a starkly simplified style involving flat colour areas and heavy black outlines – so named by the critic E. Dujardin. Mainly painted city themes. After 1890 came under stylistic influence of Lautrec. By late 1890s turned to painting monumental works in baroque style. Exhibited with *Les Vingt* in 1888, at the Café Volpini in 1889 and in the 1890s at Le Barc de Boutteville's.

BASTIEN-LEPAGE, JULES (1848–84). French painter born at Damvillers in north-eastern France, a region whose landscapes he recorded in many of his paintings. From 1867 studied at École des Beaux-Arts under Cabanel. In 1875 won 2nd prize in Prix de Rome competition. Exhibited regularly at Salon and from 1878 showed series of peasant subjects, painted in high-toned naturalistic vein, which made his reputation. Died of cancer when at height of his fame. Strong influence on younger painters throughout Europe.

BERNARD, ÉMILE (1868–1941). French painter. Attended classes at École des Arts Décoratifs. In 1884 joined Cormon's studio and met Anquetin, Toulouse-Lautrec and Van Gogh. Expelled for insubordination in 1886. Travelled in Normandy and Brittany. Evolved 'cloisonnist' style in conjunction with Anquetin 1886–7. Worked closely with Gauguin 1888–91. Exhibited at Café Volpini in 1889, at the first Salon de la Rose+Croix in 1892 and at Le Barc de Boutteville's in 1892 and 1893. From 1893 travelled extensively and lived mainly in Egypt until 1904. Reverted to more traditional style based on study of Italian Renaissance. Visited and corresponded with Cézanne. Published numerous articles and reminiscences, in which he disclaimed all suggestions of stylistic indebtedness to Gauguin.

BONNARD, PIERRE (1867–1947). French painter, poster designer, illustrator. Abandoned law studies to concentrate on art. At Académie Julian met and joined the Nabis. Early style characterized by flat colour areas and bold, playful outlines; influenced by Gauguin and Japanese art (nicknamed 'le nabi japonard'). In 1890s exhibited

at *Indépendants* and Le Barc de Boutteville's. Closely involved with *La Revue Blanche* and with various illustrative projects. Favoured 'intimist' and Parisian subjects, often touched with humour. Later worked in oils on broader scale in decorative, loosely Impressionistic manner.

CÉZANNE, PAUL (1839–1906). French painter, born and died in Aix-en-Provence. Son of banker, embarked on law studies at Aix but abandoned them to study art in Paris. In 1860s painted still-lifes and imaginary themes in heavy baroque manner. Studied at Académie Suisse. Joined group of young painters centred around Manet and Zola, the latter a close childhood friend. Taught *plein-air* painting by Pissarro. Exhibited in 1874 and 1877 with Impressionists. Regularly submitted work to Salon but always rejected. From 1877 onwards rarely left native Provence. Evolved mature style, imposing more structured compositions, heightened colour modulations and systematized brushwork on to Impressionism. Favoured conventional genres, portraits, landscapes and still-life but also painted imaginary figure compositions. Works had major influence on younger artists in Paris, especially following important one-man show at Vollard's gallery in 1895.

CHÉRET, JULES (1836–1932). French poster designer and illustrator. Commercially trained in 1850s, during following decade worked in London. In 1866 returned to Paris and set up own studio, financed by perfumier Rimmel. By 1880s established as leading French poster designer. Developed lithographic printing in multiple colours and created flamboyant, exuberant designs often compared to Rococo prototypes. Held important one-man exhibition in 1889. Much admired by contemporary artists and writers of all aesthetic allegiances.

CROSS, HENRI-EDMOND (1856–1910). French painter, real name Delacroix. Settled in Paris in 1881. Early style influenced by Bastien-Lepage and then Manet and the Impressionists. Exhibited with *Indépendants* from 1884, with *Les Vingt* in 1889 and 1893 and at Le Barc de Boutteville's. Adopted pointillist technique in 1891 which he used with unnaturalistic decorative freedom. Worked mainly in Mediterranean from 1891. Painted landscapes and figure subjects as well as imaginary idyllic scenes, imbued with anarchist philosophy.

DAGNAN-BOUVERET, PASCAL (1852–1929). French painter. Pupil of Gérôme at Ecole des Beaux-Arts. Began exhibiting mythological subjects at Salon in 1876, but in 1879 changed to painting subjects from contemporary life, in naturalistic style, possibly in emulation of his friend Bastien-Lepage. From 1887 onwards exhibited series of pictures on religious and peasant themes.

DEGAS, EDGAR (1834–1917). French painter, sculptor and printmaker. Amplified his standard academic training in 1850s by extensive and imaginative copying after Old Master and other sources. By mid-1860s had abandoned history painting in favour of contemporary subjects from urban life. Throughout 1870s developed novel compositional devices of increasing austerity and virtuosity of draughtsmanship. Exhibited at all but one Impressionist exhibitions, including important group of nudes at 1886 show. After this date reluctant to exhibit but gave important private encouragement to younger artists.

DENIS, MAURICE (1870–1943). French painter and theorist, lived and worked in St-Germain-en-Laye. Educated at Lycée Condorcet. Studied art at Académie Julian and École des Beaux-Arts 1888–90. Founder member of Nabis with Sérusier. In 1890s exhibited at *Indépendants*, Le Barc de Boutteville's and, in 1892, with *Les Vingt*. Early work influenced by Gauguin, Japanese and Italian primitive art. Subject-matter reflected profound Catholicism. Conservative and anti-Dreyfusard in politics, after 1898 supported a return to classical principles in art. Writings included 'Definition of Neo-Traditionism' (1890), 'Cézanne' (1907). Articles collected in *Théories* (1912) and *Nouvelles Théories* (1922).

ENSOR, JAMES (1860–1949). Belgian painter, born and lived all his life in Ostend. Attended Académie Royale des Beaux-Arts in Brussels 1877–80. Founder member of *Les Vingt* in 1884, and exhibited regularly with them, and from 1893 at Salon de La Libre Esthétique. Difficult relations with artistic colleagues – isolated stylistically. Early work mainly still-lifes and interiors in loosely Impressionistic vein. Later produced brilliantly coloured fantastic subjects, often involving carnival masks.

FANTIN-LATOUR, HENRI (1836–1904). French painter, son of portraitist. Taught art by Lecoq de Boisbaudran and by copying Old Masters. In late 1850s became friendly with Degas, Manet and Whistler. On latter's prompting visited England and found important patrons there. From 1860s work divided between portraits and flowerpieces painted in naturalistic style and fantasy musical subjects, mostly inspired by Wagner. Involved with French etching revival, took up lithography after 1873, especially for musical subjects. These latter, admired by Symbolists, influenced Seurat and Redon. Exhibited regularly at Salon.

FILIGER, CHARLES (1863–1928). French painter of Swiss origin, born in Alsace. Trained as artist in Paris at Atelier Colarossi. In 1889 met Gauguin, Laval, Meyer de Haan and Sérusier in Le Pouldu. Drawn to mystic ideas. Exhibited regularly at Le Barc de Boutteville's in 1890s and at first Salon de la Rose+Croix in 1892. Concentrated on small-

scale Breton religious subjects, in style derived from Byzantine and other medieval art. Later life spent in poverty and obscurity. Committed suicide.

FORAIN, JEAN-LOUIS (1852–1931). French painter and illustrator. Early paintings of urban subjects show influence of his friend Degas. Exhibited with Impressionist group in 1879, 1880, 1881 and 1886. Best known in later life for satirical caricatures on social and political themes close in style to Daumier's. Anti-Dreyfusard.

GAUGUIN, PAUL (1848–1903). French painter, sculptor, ceramicist and printmaker. Born in Paris, spent childhood up to age of seven in Peru. In 1865 joined merchant navy and travelled widely. From 1871 to 1883 held various positions on Paris stock exchange. Amateur painter in touch with Impressionists and taught by Pissarro in 1870s, exhibited in the group's last five exhibitions. Lost job in 1883 and turned professional painter. Travelled widely, to Brittany (1886, 1888, 1889–90, 1894), Martinique (1887), Arles (1888) and Tahiti (1891–1903), returning to France for two years (1893–5). Leader of so-called 'Pont-Aven school'. Died on Marquesas Islands. In later 1880s developed characteristic synthetic and decorative style, partly in conjunction with Bernard, in response to Symbolist ideas. Style also influenced by Impressionists (Pissarro, Cézanne and Degas), Japanese and primitive sources.

VAN GOGH, VINCENT (1853–90). Dutch painter, son of a Protestant minister. Worked in art trade, as teacher and as lay preacher before taking up painting full-time in c. 1880. Brief period of study under Mauve, 1881–2. Early style and choice of motifs accorded with those of the Hague school. Worked in Nuenen, Brabant (1884–5) and Antwerp (1885–6) before moving to Paris (1886–8). Studied at Cormon's atelier. Met Bernard, Lautrec and Anquetin. Also met and worked with the Pissarros, Gauguin and Signac. Exhibited work in Paris in 1887 at Café Le Tambourin and Restaurant Du Chalet, and with *Les Vingt* in 1890. Moved to Arles in February 1888; joined by Gauguin for 2 months at end of year. After mental breakdowns took up voluntary residence in St-Rémy asylum, 1889–90. Moved to Auvers near Paris. Supervised by Dr Gachet until suicide in July. Mature style combined realist approach of Dutch training with heightened colour and contour, derived in part from Japanese art and recent cloisonnist experiments. Supported financially by his brother Theo.

HODLER, FERDINAND (1853–1918). Swiss painter born in Berne. Studied in Geneva under Barthelémy Menn. By late 1880s working in Symbolist mode, partly inspired by Puvis de Chavannes. Developed theory of 'parallelism', i.e. symmetrical figure compositions based on repetition of similar forms and colours. Also painted landscapes. In 1890s exhibited regularly in Paris at Salon de la Société Nationale des Beaux-Arts and at the Salons de la Rose+Croix.

KHNOPFF, FERNAND (1858–1921). Belgian painter and illustrator, founder member of *Les Vingt* group. Taught art by Xavier Mellery while studying law in Brussels. In 1879 visited Paris and encountered work of Gustave Moreau, which profoundly influenced his own style, as did English Pre-Raphaelites. Painted landscapes and portraits as well as subjects inspired by dream and mystery. Much admired by Belgian Symbolist poets; a friend of Sâr Péladan. Exhibited regularly with *Les Vingt* and at the Rose+Croix Salons.

LACOMBE, GEORGES (1868–1916). French painter and sculptor. Son of a wealthy family, taught painting by family friends who included Roll and Gervex. Studied at Académie Julian. From 1888 to 1897 regularly spent summers in Brittany (Camaret). 1892 met Sérusier and joined Nabi group. Exhibited with them at Le Barc de Boutteville's. In 1893–4 took up wood carving; style and Breton subject-matter close to Gauguin's and Sérusier's. Died in obscurity.

LAURENT, ERNEST (1859–1929). French painter, studied with Seurat and Aman-Jean under Lehmann at École des Beaux-Arts. Successful academic career: from 1883 exhibited regularly at Salon, winning travelling scholarship in 1885, Prix de Rome in 1889. Later style veered away from Impressionist influences towards nebulous chiaroscuro manner of Hébert and Carrière. Elected member of Institut in 1919. Thereafter taught at École des Beaux-Arts.

LAVAL, CHARLES (1862–1894). French painter, born in Paris, died in Cairo. Met Gauguin in 1886 and accompanied him to Martinique in 1887. Early member of Pont-Aven group. Exhibited at Café Volpini in 1889. Engaged to marry Émile Bernard's sister Madeleine, but forced by ill health to leave France. Last years spent in Egypt. Mature painting style and subject-matter developed in close conjunction with Gauguin.

MEYER DE HAAN, JACOB (1852–95). Dutch painter, son of wealthy Amsterdam family. In 1888 amateur enthusiasm for painting led him to abandon family firm and move to Paris. Stayed with Theo Van Gogh and met Vincent and Gauguin. Lived and worked alongside Gauguin in Le Pouldu, Brittany, in 1889–90, helping to support him financially. Style very similar to that of Gauguin. Planned to accompany Gauguin to Tahiti in 1891 but finances withheld by family. Returned to Amsterdam.

MONET, CLAUDE (1840–1926). French painter, born in Paris, brought up at Le Havre. Introduced to *plein-air* painting by Boudin in 1850s. Met Pissarro in Paris in 1859 and in 1862, at Atelier Gleyre, met Renoir, Sisley and Bazille. Exhibited at Salon in 1860s. At this time style indebted to Manet. From c. 1870 concentrated on small-scale, loosely brushed and bright-toned works. Exhibited with Impressionist group from 1874, with dealers (Durand-Ruel, Georges Petit, Theo Van Gogh), and again at Salon in 1880. Worked mainly in Seine valley, living at Giverny from 1883

to his death, but also travelled widely in France and Europe. Later favoured working on larger scale and in series, treating a single subject under varied weather and lighting conditions.

MOREAU, GUSTAVE (1826–1898). French painter, son of Parisian architect. Studied under Picot at École des Beaux-Arts. Admirer of Delacroix and from 1848–57 close disciple of Chassériau. In Rome 1857–9. Exhibited at Salon 1864–6, 1876, 1880; specialized in richly detailed paintings on mythological subjects. Stopped exhibiting at Salon in response to unfavourable criticism. Showed series of watercolours at Goupil gallery in 1886. In 1892–8 taught at École des Beaux-Arts. Among the pupils who enjoyed his teaching were Matisse, Marquet and Rouault. His works appealed most to literary men; admired in 1860s by Parnassians, in 1880s and 1890s by Symbolists, in 1920s by Surrealists.

PISSARRO, CAMILLE (1830–1903). French painter and printmaker. Born in Danish West Indies, settled in France in 1855. Primarily a landscape painter in 1860s; developed from manner of Barbizon school to close observation of natural effects, executed *en plein air*. Exhibited at all Impressionist shows, 1874–86. In 1880s, under influence of Degas and Millet, depicted more figure subjects, and from c. 1885–90 adopted Neo-Impressionist theories. Left-wing sympathies witnessed by social criticism of *Turpitudes Sociales* drawings (1889–90) and active support for anarchism in 1890s. As a Jew, pro-Dreyfus. Generous adviser to young artists, especially in 1880s, but own work increasingly conservative from c. 1890.

PISSARRO, LUCIEN (1863–1944). French (later naturalized British) painter, printmaker and book designer. Eldest son of Camille Pissarro. Taught painting by father and wood engraving by Auguste Lepère. Early member of Neo-Impressionist circle. Exhibited with Impressionists in 1886, *Les Vingt* in 1887 and 1892, and regularly at *Indépendants* 1886–94. Contributed drawings to *Le Courrier Français*, *La Vie Moderne*, etc. From 1890 settled in England. To 1912 mainly active as book designer, thereafter as painter.

PUVIS DE CHAVANNES, PIERRE (1824–1898). French painter, born in Lyons into well-to-do engineering family. Illness prevented him following family profession. Studied art with Delacroix, Couture and Chassériau. Exhibited regularly at Salon, after early rejections. From 1860s began to receive state commissions. Painted major decorative schemes for museums and town halls throughout France, including cycle on theme of Ste Geneviève for Panthéon in Paris. Despite official successes, critical recognition came mainly in 1880s and 1890s when Puvis was taken up by Symbolists. His work, characterized by unreal subjects, spare compositions and muted colour range, was a major influence on younger painters, including Gauguin, Seurat and the Nabis.

RAFFAËLLI, JEAN-FRANÇOIS (1850–1924). French painter, sculptor and printmaker. After working in variety of styles during 1870s settled in Parisian suburb of Asnières *c.* 1878. For next few years specialized in scenes of proletarian and *petit-bourgeois* suburban life. Exhibited with Impressionists in 1880 and 1881. One-man show held in 1884 a great success; thereafter exhibited at Salon, chiefly portraits and cityscapes. Writings on art (*Étude des Mouvements de l'Art Moderne et du Beau Caractériste*, 1884: *Le Laid dans l'Art*, 1885) stressed affinities with Naturalist literature. Illustrated Huysmans's *Croquis Parisiens*, 1880.

RANSON, PAUL (1862–1909). French painter, decorator, ceramicist and graphic artist. Attended Académie Julian from 1888 where he met Denis, Sérusier, Roussel, Bonnard and Vuillard. Meetings of Nabi group in early 1890s held in Ranson's studio in Montparnasse. Ranson introduced esoteric rituals and language. Interested in all aspects of decorative art. Mature style, characterized by linear arabesques and flat patterning, shows influence of Gauguin and Japanese art. Regularly exhibited at Le Barc de Boutteville's and at *Indépendants* in 1890s. In 1908 founded Académie Ranson.

REDON, ODILON (1840–1916). French painter and graphic artist. Born in Bordeaux; maintained lifelong connections with that region. In 1859 enrolled as student of architecture at École des Beaux-Arts, then, for brief period, studied painting with Gérôme. Failed examinations and returned home. In 1863–5 taught by engraver Bresdin. In 1870 fought in Franco-Prussian War. From 1865 to 1890 concentrated on black-and-white work – charcoal drawings and lithography – developing idiosyncratic range of dream-like themes, often inspired by natural botanical forms. In 1880s came gradual recognition and sales of lithographic albums. Much admired by Symbolist poets. Exhibited with *Indépendants*, with Impressionists in 1886 and with *Les Vingt* in 1886 and 1890. In 1890s turned to using more colour – in form of pastel and then oils.

RENOIR, PIERRE-AUGUSTE (1841–1919). French painter. Apprenticed as porcelain decorator. Studied art at Atelier Gleyre in 1860s. Early style influenced by Courbet. From late 1860s, with Monet, Sisley and Bazille, began *plein-air* landscape work but his preference was for figure painting. Exhibited at Salon in 1860s and again 1878–83, 1890. Exhibited in four of Impressionists' shows and with *Les Vingt* in 1886, 1890. After 1876 enjoyed success as society portraitist. Painted in southern France and Algeria, eventually settling in Provence. Style in 1870s highly coloured, fluent and vaporous. In 1880s subjected himself to discipline of 'Ingriste' drawing. In later works, concentrated on bather theme, working in highly coloured florid style.

VAN RYSSELBERGHE, THÉO (1862–1926). Belgian painter. Founder member of *Les Vingt*, 1884, and of La Libre Esthétique, 1894. With secretary

Octave Maus, vital link between Paris-based artists and Belgian exhibition groups. By 1888 painting in Neo-Impressionist manner, mainly portraits and landscapes. In mid-1890s made designs for furniture and applied arts (some in collaboration with Henri Van de Velde); also book illustrations. From early 1900s gradually moved away from Neo-Impressionism. Left-wing in political views; in 1890s made illustrations for anarchist press.

SÉRUSIER, PAUL (1864–1927). French painter, born in Paris. Studied art at Académie Julian, exhibiting at Salon in 1888 a Breton subject painted in conventional realist manner. Later that year met Gauguin at Pont-Aven and under his instruction painted highly synthetic landscape, *The Talisman*. This, and aesthetic theories it suggested, drew group of interested students at Julian's who took name of Nabis. Continued to visit Brittany regularly, eventually settling there, but also involved in full range of Nabi activities in decorative field. Exhibited in 1890s at *Indépendants* and Le Barc de Boutteville's. Of a theoretical turn of mind, visited School of Beuron and became interested in sacred systems of proportion and colour relationships. Publicized his theories in *ABC de la Peinture* (1921). Taught at Académie Ranson.

SEURAT, GEORGES (1859–1891). French painter and draughtsman. Born in Paris into well-to-do bourgeois family. In late 1870s trained at École des Beaux-Arts under Lehmann. 1879–80 military service. For next few years developed novel manner of tonal drawing and experimented with colour theory (Chevreul, Rood, etc.) in small paintings. Presence of *La Grande-Jatte* at 1886 Impressionist exhibition established him as leading figure of Parisian avant-garde. This position sustained by regular exhibition at *Indépendants* (1884–91, retrospective 1892) and *Les Vingt* (1887, 1889, 1891, retrospective 1892) of large figure compositions, as well as marines painted during summer campaigns on Channel coast. Later work influenced by theorist Charles Henry, increasingly criticized as too arcane.

SIGNAC, PAUL (1863–1935). French painter. Son of well-to-do family. Self-taught as artist. Met Seurat 1884, and introduced him to writers and Impressionist painters. Early adherent, and chief recruiter and propagandist, of Neo-Impressionist circle. Exhibited with Impressionists 1886, *Indépendants* 1884–1935, and *Les Vingt* 1888, 1890 (made member 1891). Significant writer on art, notably *D'Eugène Delacroix au Néo-Impressionisme* (1899). Mainly landscape painter. Left-wing in political views; in 1890s made illustrations for anarchist press.

STEINLEN, THÉOPHILE-ALEXANDRE (1859–1923). Swiss draughtsman, illustrator and painter. Born Lausanne. Settled in Paris 1881. From this time until 1887 closely involved with the cabaret Le Chat Noir and its illustrated paper. During 1880s and 1890s illustrations also published in *Gil Blas Illustré*, *Le Mirliton*, etc. Drawings for Aristide

Bruant's *Dans la Rue*, 1889. In 1890s made posters and drew for anarchist press.

TOULOUSE-LAUTREC, HENRI DE (1864–1901). French painter and printmaker. Born into aristocratic family. Taught by Bonnat 1882 and Cormon 1882-*c.* 1885. From second half of 1880s much involved with creative activity in Montmartre, including poster design for Aristide Bruant's cabaret Le Mirliton; illustrations for *Paris Illustré*, *Le Courrier Français*, etc. First poster 1891; subsequently won substantial reputation for prints. By mid-1890s belonged to *Revue Blanche* circle, with Nabis. Exhibited with *Indépendants* regularly from 1889 and with *Les Vingt* (1888, 1890, 1892), La Libre Esthétique (1894–7); held one-man shows in 1893 and 1896.

VALLOTTON, FÉLIX (1865–1925). Swiss painter and printmaker. Born in Lausanne, studied in Paris from 1882 onwards at École des Beaux-Arts and Académie Julian. In 1890s worked mainly in medium of woodcut, evolving style of simplified, unmodelled forms and stark contrasts of black and white. This somewhat 'japonist' style also affected his painting. Included in first Salon de la Rose + Croix in 1892. Joined the Nabis and exhibited regularly with them at *Indépendants* and Le Barc de Boutteville's.

VUILLARD, ÉDOUARD (1868–1940). French painter. Educated at Lycée Condorcet; studied art, after abandoning idea of army career, at École des Beaux-Arts and Académie Julian. Joined Nabi group in 1889, becoming close friend of Bonnard. Early style characterized by bold, almost caricatural drawing, flat colour areas and decorative patterning. Completed several mural commissions. Favoured domestic and Parisian subjects, which he frequently imbued with mood of mystery. Close friend of actor Lugné-Poë and *Revue Blanche* circle. Exhibited in 1890s at Le Barc de Boutteville's. In later career produced more naturalistic portraits.

WHISTLER, JAMES ABBOT MCNEILL (1834–1903). American painter and printmaker, trained in France at Académie Gleyre. In late 1850s a follower of Courbet along with Legros and Fantin-Latour. Settled in London in 1859 but throughout life regularly visited and exhibited work in France. Produced portraits and seascapes of sober tonality, applying oil paint in thinned layers. Often gave paintings musical titles. Style indebted to 17th-century Dutch and Spanish art, especially Velázquez, and to Japanese printmakers. Exhibited with *Les Vingt* in 1884, 1886 and 1888, and had considerable influence on Belgian Symbolists. Exhibited in Paris in 1890s at Salon de la Société Nationale des Beaux-Arts.

WILLETTE, ADOLPHE (1857–1926). French draughtsman and printmaker. Pupil of Cabanel. From 1881 closely involved with Chat Noir cabaret, especially with its famous shadow plays. In 1880s and 1890s regular contributor to illustrated periodicals, notably *Le Courrier Français*. Also designed posters.

Chronology

1874
First exhibition of Société Anonyme des Artistes Peintres, Sculpteurs, Graveurs, etc. (later known as Impressionists), incl. Cézanne, Degas, Guillaumin, Monet, Morisot, Pissarro, Renoir, Sisley.

1876
Second Impressionist exhibition, incl. Degas, Monet, Morisot, Pissarro, Renoir, Sisley.

1877
Third Impressionist exhibition, incl. Cézanne, Degas, Guillaumin, Monet, Pissarro, Renoir, Sisley.

1879
Jules Grévy elected President. Republican majority in Senate. Jules Ferry, as Minister of Education, introduces reforms and secularization.
Universal Exhibition.
Fourth Impressionist exhibition, incl. Cassatt, Degas, Forain, Monet. Pissarro.

1880
French annexation of Tahiti. Full amnesty to exiles of Commune. First ministry of Ferry.
Huysmans: *Croquis Parisiens* publ. with illus. by Raffaëlli.
Zola: 'Le Naturalisme au Salon' publ. in *Le Voltaire*, June.
Fifth Impressionist exhibition, incl. Cassatt, Degas, Forain, Gauguin, Guillaumin, Morisot, Pissarro, Raffaëlli.

1881
French protectorate over Tunisia. Fall of Ferry. Ministry of Gambetta.
Sensier: *La Vie et l'Oeuvre de J-F. Millet* publ.
Rood: *Modern Chromatics* publ.
Sixth Impressionist exhibition, incl. Cassatt, Degas, Forain, Gauguin, Guillaumin, Morisot, Pissarro, Raffaëlli.

1882
Crash of Union Générale savings bank. Directors arrested (incl. Feder, Durand-Ruel's backer). Many small-time savers lose money. Fall and death of Gambetta.
Seventh Impressionist exhibition, incl. Gauguin, Guillaumin, Monet, Morisot, Pissarro, Renoir, Sisley.

1883
Second ministry of Ferry.
Huysmans: *L'Art Moderne* publ.
Death of Manet. Monet settles in Giverny.
Durand-Ruel holds one-man shows, Monet (March), Renoir (April), Pissarro (May).

1884
Trade Unions legalized.

Huysmans: *À Rebours* publ.
La Revue Indépendante founded by Fénéon.
La Revue Wagnérienne founded by Dujardin and De Wyzewa.
Death of Bastien-Lepage.
Studio sale of Manet. Gauguin moves to Copenhagen. Friendship between Seurat and Signac. Van Gogh in Nuenen.
Feb.–March, first *Les Vingt* exhibition in Brussels, incl. Ensor, Khnopff, Van Rysselberghe; guests incl. Whistler.
Salon jury turns down Seurat's *Une Baignade, Asnières*.
May–July, *Groupe des Artistes Indépendants*, incl. Cross, Dubois-Pillet, Redon, Schuffenecker, Seurat (*Une Baignade, Asnières*), Signac.
Dec., first exhibition of *Société des Artistes Indépendants*, incl. Cross, Dubois-Pillet, Guillaumin, Redon, Schuffenecker, Seurat, Signac.

1885
Severe reversal in Tonkin campaign. Fall of Ferry. Grévy re-elected President. French protectorate over Madagascar.
Aristide Bruant opens cabaret *Le Mirliton*, frequented by Toulouse-Lautrec.
Gauguin returns to Paris. Visits Dieppe, where meets Degas, and London. Seurat spends summer in Grandcamp. Pissarro meets Seurat and Signac and begins to paint in Neo-Impressionist manner.
Redon: *Hommage à Goya* (lithographs) publ.
Feb.–March, *Les Vingt* exhibition in Brussels, incl. Ensor, Khnopff, Van Rysselberghe; guests incl. Fantin-Latour, Raffaëlli.
May–June, Georges Petit's Exposition Internationale, incl. Monet.

1886
Moréas: 'Manifeste du Symbolisme' publ. in *Le Figaro Littéraire*, Sept.
Kahn: 'La Réponse des Symbolistes' publ. in, *L'Événement*, Sept.
Zola: *L'Oeuvre* publ.
Loti: *Pêcheur d'Islande* publ.
Fénéon: *Les Impressionnistes en 1886* publ.
Van Gogh arrives in Paris. Cézanne breaks off friendship with Zola. Seurat spends summer in Honfleur. Gauguin visits Pont-Aven, Brittany. Monet visits Belle-Isle.
Feb.–March, *Les Vingt* exhibition, incl. Ensor, Khnopff, Van Rysselberghe; guests incl. Degas (did not send), Monet, Redon, Renoir, Whistler.
March–April, Durand-Ruel, New York, Work in Oil and Pastel by the Impressionists of Paris, incl. Degas, Monet, Pissarro, Renoir, Seurat, Signac.
May–June, eighth Impressionist exhibition, incl. Cassatt, Degas, Forain, Gauguin, Guillaumin, Morisot, Pissarro, L. Pissarro, Redon, Schuffenecker, Seurat (*La Grande-Jatte*), Signac.

June–July, G. Petit, incl. Monet, Renoir.
Aug.–Sept., *Indépendants*, incl. Cross, L. Pissarro, Redon, Seurat (*La Grande-Jatte*), Signac.

1887
Resignation of Grévy. Sadi-Carnot elected President.
Zola: *La Terre* publ.
Antoine founds Théâtre Libre. R. Salis sets up Chinese shadow theatre at Chat Noir cabaret.
Gauguin and Laval in Panama and Martinique.
Feb.–March, *Les Vingt* exhibition, incl. Ensor, Khnopff, Van Rysselberghe; guests incl. Pissarro, Raffaëlli, Rodin, Seurat (*La Grande-Jatte*).
March–May, *Indépendants*, incl. Cross, Maurin, L. Pissarro, Redon, Seurat, Signac.
Spring(?), Café Le Tambourin exhibition of Japanese prints organized by Vincent Van Gogh.
May–June, G. Petit, incl. Monet, Pissarro, Renoir (*Bathers*).
Nov.–Dec., Durand-Ruel, Puvis de Chavannes (retrospective).
Nov.–Dec.(?), Van Gogh organizes exhibition at Restaurant du Châlet, incl. Anquetin, Bernard, Van Gogh, Toulouse-Lautrec.

1888
General Boulanger rallies opposition to republican government from left and right.
Eiffel Tower under construction.
Henry: *Cercle Chromatique* publ.
Redon: *Tentation de Saint-Antoine* (lithographs) publ.
Van Gogh moves to Arles. Seurat spends summer in Port-en-Bessin. Gauguin and Bernard work together in Pont-Aven. Gauguin joins Van Gogh in Arles for two months. Nabi group founded at Académie Julian.
Feb.–March, *Les Vingt* exhibition, incl. Ensor, Khnopff, Van Rysselberghe; guests incl. Anquetin, Degas (did not send), Forain, Guillaumin, Signac, Toulouse-Lautrec, Whistler.
March–May, *Indépendants*, incl. Anquetin, Cross, Van Gogh, Maurin, L. Pissarro, Seurat, Signac.

1889
Election of Boulanger as Deputy of the Seine. After failure to seize power, flight of Boulanger.
Eiffel Tower completed for Universal Exhibition.
Republican victory in elections.
Huysmans: *Certains* publ.
Le Moderniste Illustré founded by Aurier.
Moulin Rouge cabaret opened in Montmartre.
Seurat spends summer at Le Crotoy. Gauguin in Brittany, joined by Sérusier and Meyer de Haan. Van Gogh voluntarily enters St-Rémy asylum.
Feb.–March, Boussod & Valadon (Theo Van Gogh), Monet.
Feb.–March, *Les Vingt* exhibition, incl. Ensor, Khnopff, Van Rysselberghe; guests incl. Cross,

Gauguin (*Vision after the Sermon*), Monet, Pissarro, Signac.

May onwards, Universal Exhibition; French section incl. Aman-Jean, Béraud, Dagnan-Bouveret, Fantin-Latour, Maurin, Puvis de Chavannes, Raffaëlli; centennial exhibition of French art incl. Bastien-Lepage, Béraud, Cézanne, Fantin-Latour, Manet, Monet, Pissarro, Puvis de Chavannes, Raffaëlli.

May–June, Café Volpini, Groupe Impressionniste et Synthétiste, incl. Anquetin, Bernard, Gauguin, Laval, Schuffenecker.

Sept.–Oct., *Indépendants*, incl. Anquetin, Filiger, Van Gogh, L. Pissarro, Seurat, Signac, Toulouse-Lautrec.

1890
Cardinal Lavigerie starts the Ralliement.
Mercure de France founded by Vallette.
M. Denis: 'Définition du Néo-Traditionnisme', publ. in *Art et Critique*, Aug.
Théâtre d'Art founded by Paul Fort.
Gauguin in Brittany and Paris. Van Gogh moves to Auvers. Befriends Dr. Gachet. Commits suicide. Seurat spends summer at Gravelines.
Feb.–March, *Les Vingt* exhibition, incl. Ensor, Khnopff, Van Rysselberghe; guests incl. Cézanne, Dubois-Pillet, Van Gogh, L. Pissarro, Redon, Renoir, Signac, Toulouse-Lautrec.
Feb.–March, Boussod & Valadon (Theo Van Gogh), Pissarro.
March–April, *Indépendants*, incl. Anquetin, Cross, Filiger, Van Gogh, L. Pissarro, Van Rysselberghe, Seurat, Signac, Toulouse-Lautrec.
April–May, École des Beaux-Arts, La Gravure Japonaise.
May onwards, first exhibition of splinter Salon, the Société Nationale des Beaux-Arts, founded by Meissonnier, Puvis de Chavannes, Carrière and Rodin, incl. Anquetin, Cross, Dagnan-Bouveret, Forain, Gauguin, Puvis de Chavannes.

1891
Aurier: 'Le Symbolisme en Peinture – Paul Gauguin', publ. in *Mercure de France*, March.
Péladan: *Salon de la Rose + Croix, Règle et Monitoire* publ.
La Revue Blanche founded by Natanson brothers.
Symbolist banquet. Performance at Théâtre d'Art, incl. Maeterlinck's *The Intruder*, for benefit of Gauguin and Verlaine.
Deaths of Seurat and Theo Van Gogh. Gauguin goes to Tahiti.
Feb., Hôtel Drouot, Gauguin sale.
Feb.–March, *Les Vingt* exhibition, incl. Ensor, Khnopff, Van Rysselberghe; guests incl. Chéret, Filiger, Gauguin, Van Gogh, Pissarro, Seurat.
March–April, *Indépendants*, incl. Anquetin, Bernard, Bonnard, Cross, Denis, Dubois-Pillet, Van Gogh (retrospective), L. Pissarro, Van Rysselberghe, Seurat, Signac, Toulouse-Lautrec, Vallotton.
May, Durand-Ruel, Monet (*Haystacks* series).
Aug.–Sept., Château de St. Germain-en-Laye, first Nabi group exhibition, incl. Bonnard, Denis, Ranson, Roussel, Sérusier, Vuillard.

Dec., first Le Barc de Boutteville exhibition, Peintres Impressionnistes et Symbolistes, incl. Anquetin, Bernard, Bonnard, Cross, Denis, Filiger, Gauguin, Van Gogh, Manet, Ranson, Roussel, Sérusier, Signac, Toulouse-Lautrec, Vuillard.

1892
Series of bombings. Arrest and execution of anarchist Ravachol. Cholera outbreak in Paris suburbs. Panama scandal.
Aurier: 'Les Peintres Symbolistes', publ. in *Revue Encyclopédique*, April.
Death of Aurier. Signac 'discovers' Saint-Tropez. Denis in Perros-Guirec, Brittany, first of many visits.
Feb.–March, *Les Vingt* exhibition, incl. Ensor, Khnopff, Van Rysselberghe; guests incl. Denis L. Pissarro, Seurat, Toulouse-Lautrec.
Feb., Durand-Ruel, Pissarro (retrospective); Monet (*Poplars*).
March–April, Durand-Ruel, first Salon de la Rose + Croix, incl. Aman-Jean, Bernard, Filiger, Hodler, Khnopff, Maurin, Séon, Vallotton.
March–April, *Indépendants*, incl. Anquetin, Bernard, Bonnard, Cross, Denis, L. Pissarro, Ranson, Van Rysselberghe, Seurat (retrospective), Signac, Toulouse-Lautrec.
April, Le Barc de Boutteville, Van Gogh (retrospective) organized by Bernard.
May, second Le Barc de Boutteville exhibition, incl. Bernard, Bonnard, Denis, Filiger, Ranson, Sérusier, Signac, Toulouse-Lautrec, Willette.
Aug.–Oct., Château de St. Germain-en-Laye, second Nabi exhibition, incl. Bernard, Denis, Ranson, Sérusier, Vuillard.
Nov., third Le Barc de Boutteville exhibition, incl. Anquetin, Bonnard, Chéret, Cross, Denis, Filiger, Gauguin, Pissarro, Ranson, Roussel, Séon, Sérusier, Toulouse-Lautrec, Vuillard, Willette.
Dec.–Jan., Hotel Brébant, Neo-Impressionist exhibition, incl. Cross, Pissarro, Seurat, Signac, Van Rysselberghe.

1893
Bombing in Chambre des Députés. Vaillant, an anarchist, arrested.
Théâtre de l'Oeuvre founded by Lugné-Poë.
Gauguin returns to France. Death of Père Tanguy. Vollard opens gallery in rue Laffitte.
Feb.–March, final *Les Vingt* exhibition, incl. Ensor, Khnopff, Van Rysselberghe, Signac; guests incl. Bernard, Cross, Toulouse-Lautrec.
March–April, *Indépendants*, incl. Anquetin, Bernard, Bonnard, Cross, Denis, L. Pissarro, Ranson, Van Rysselberghe, Signac, Steinlen, Toulouse-Lautrec, Vallotton.
March–April, second Salon de la Rose + Croix, incl. Aman-Jean, Khnopff, Séon.
April, fourth Le Barc de Boutteville exhibition, incl. Anqetin, Bonnard, Denis, Filiger, Pissarro, Ranson, Roussel, Sérusier, Signac, Toulouse-Lautrec, Vallotton, Vuillard.
Sept.–Oct., Le Barc de Boutteville, Les Portraits du Prochain Siècle, incl. Anquetin, Bernard, Cézanne, Filiger, Gauguin, Van Gogh, Raffaëlli, Vallotton, Vuillard.

Oct.–Nov., fifth Le Barc de Boutteville exhibition, incl. Bonnard, Denis, Gauguin, Vallotton, Vuillard.
Dec.–Jan., 20 rue Laffitte, Neo-Impressionist exhibition, incl. Cross, L. Pissarro, Signac, Van Rysselberghe.

1894
Execution of Vaillant. Arrest and execution of anarchist Émile Henry after bombing at Café Terminus, Gare St. Lazare. Assassination of President Sadi-Carnot in Lyons. Imprisonment of Fénéon for suspected involvement with anarchist bombings. Captain Dreyfus condemned of treason.
Pissarro in Belgium to avoid reprisals against anarchist sympathizers. Gauguin in Paris.
March, sixth Le Barc de Boutteville exhibition, incl. Anquetin, Bonnard, Denis, Filiger, Gauguin, Lacombe, Ranson, Sérusier, Vuillard.
Spring, first exhibition of La Libre Esthétique in Brussels, with important decorative arts section, incl. Chéret, Denis, Ensor, Gauguin, Khnopff, Morisot, Pissarro, L. Pissarro, Puvis de Chavannes, Ranson, Redon, Renoir, Van Rysselberghe, Signac, Sisley, Toulouse-Lautrec.
April–May, *Indépendants*, incl. Cross, Denis, L. Pissarro, Signac, Toulouse-Lautrec.
April–May, third Salon de la Rose + Croix, incl. Khnopff.
July, seventh Le Barc de Boutteville exhibition, incl. Anquetin, Bernard, Bonnard, Chéret, Denis, Toulouse-Lautrec.
Nov.–Dec., eighth Le Barc de Boutteville exhibition, incl. Anquetin, Bonnard, Denis, Filiger, Lacombe, Sérusier, Toulouse-Lautrec.

1895
Félix Faure elected President.
Bing opens gallery, L'Art Nouveau.
Gauguin returns to Tahiti. Death of Berthe Morisot.
Feb., Hôtel Drouot, Gauguin sale.
April, Salon de la Société Nationale des Beaux-Arts, incl. Denis, Ranson (and in each subsequent year up to 1899).
April–May, fourth Salon de la Rose + Croix, incl. Maurin, Séon.
Sept., tenth Le Barc de Boutteville exhibition, incl. Anquetin.
Nov.–Dec., Vollard, Cézanne one-man show.
Dec.–Jan. 1896, Bing, Salon de l'Art Nouveau, incl. Aman-Jean, Anquetin, Bonnard, Cross, Denis, Khnopff, Lacombe, Pissarro, Raffaëlli, Ranson, Roussel, Van Rysselberghe, Sérusier, Signac, Toulouse-Lautrec, Vuillard, Whistler.

1896
Mellério: *Le Mouvement Idéaliste en Peinture* publ.
Death of Verlaine.
Jan., Durand-Ruel, Bonnard, first one-man show.
Feb., Salon de l'Art Nouveau, incl. Anquetin, Bonnard, Roussel, Vallotton.
March, Durand-Ruel, Morisot (retrospective).
March, eleventh Le Barc de Boutteville exhibition, incl. Denis, Lacombe, Sérusier.

March–April, fifth Salon de la Rose+Croix, incl.
 Séon.
April–May, *Indépendants*, incl. Cross, Munch,
 Signac.
Summer, twelfth Le Barc de Boutteville
 exhibition, incl. Denis, Guillaumin, Roussel.
Nov., thirteenth Le Barc de Boutteville exhibition,
 incl. Roussel.

1897
Dreyfus Affair reopened.
Gauguin: 'Noa-Noa', publ. in *La Revue Blanche*,
 Oct.
Death of Le Barc de Boutteville.
March, sixth Salon de la Rose+Croix, incl.
 Khnopff, Maurin, Séon.
April–May, *Indépendants*, incl. Cross, Munch,
 Signac, Toulouse-Lautrec.
June–July, fourteenth Le Barc de Boutteville
 exhibition.
Dec., fifteenth and final Le Barc de Boutteville
 exhibition, incl. Toulouse-Lautrec.
Dec.(?), Vollard exhibition, incl. Bonnard,
 Lacombe, Ranson, Roussel, Sérusier, Vallotton,
 Vuillard.

1898
Zola: 'J'Accuse . . .' publ. in *L'Aurore*. Suicide of
 Lt.-Col. Henry, implicated in Dreyfus Affair.
L'Action Française founded.
Denis: 'Les Arts à Rome ou la Methode
 Classique', publ. in *Le Spectateur Catholique*,
 Oct.–Dec.
Deaths of Mallarmé and of Puvis de Chavannes.
 Gauguin attempts suicide after completing
 Where Do We Come From?
April, Vollard exhibition, incl. Bonnard, Denis,
 Ranson, Roussel, Sérusier, Vallotton, Vuillard.

April–June, *Indépendants*, incl. Cross, Signac.
May–June, Vollard, second Cézanne one-man
 show.
Dec., Vollard, Gauguin one-man show.

1899
Death of President Faure. Govt. of republican
 defence under Waldeck-Rousseau.
Dreyfus retried and found guilty with extenuating
 circumstances.
Signac: *D'Eugène Delacroix au Néo-Impressionnisme*
 publ.
March, Durand-Ruel exhibition, Hommage à
 Redon, incl. Bernard, Bonnard, Cross, Denis,
 Filiger, Lacombe, Ranson, Roussel, Van
 Rysselberghe, Sérusier, Signac, Vallotton,
 Vuillard, Redon.
Oct.–Nov., *Indépendants*, incl. Cézanne, Cross,
 Signac.

1900
Universal Exhibition held in Paris.
Verlaine: *Parallèlement*, illus. by Bonnard, publ. by
 Vollard.
April–Oct., centennial exhibition of French art,
 incl. Bastien-Lepage, Cézanne, Degas, Fantin-
 Latour, Gauguin, Guillaumin, Manet, Maurin,
 Monet, Moreau, Morisot, Pissarro, Puvis de
 Chavannes, Raffaëlli, Renoir, Seurat, Sisley,
 Vallotton.
Dec., *Indépendants*, incl. Schuffenecker, Signac.

1901
Death of Toulouse-Lautrec.
March, Bernheim-Jeune, Van Gogh.
April–May, *Indépendants*, incl. Bonnard, Cézanne,
 Cross, Denis (*Hommage à Cézanne*), Ensor,

Lacombe, Ranson, Roussel, Van Rysselberghe,
 Sérusier, Signac, Vallotton, Vuillard.

1903
Deaths of Gauguin and of Pissarro.
Salon d'Automne founded by Desvallières, Piot,
 Rouault, F. Jourdain (president).
Oct.–Nov., inaugural exhibition of Salon
 d'Automne, incl. Aman-Jean, Bonnard,
 Gauguin, Matisse, Vallotton, Vuillard.

1904
April, Durand-Ruel, Pissarro (retrospective).
Oct.–Nov., Salon d'Automne, incl. Cézanne
 (separate room), Puvis de Chavannes (separate
 room), Redon (separate room), Renoir (separate
 room), Toulouse-Lautrec (separate room).

1906
Death of Cézanne.
Oct.–Nov., Salon d'Automne, incl. Gauguin
 (retrospective).

1907
Denis: 'Cézanne', publ. in *L'Occident*, Sept.
Bernard: 'Souvenirs sur Paul Cézanne', publ. in
 Mercure de France, Oct.
Oct.–Nov., Salon d'Automne, incl. Cézanne
 (retrospective).

1910
Denis: 'Cézanne' (trans. by Roger Fry), publ. in
 The Burlington Magazine, Jan.–Feb.
Nov.–Jan. 1911, Grafton Galleries, London,
 Manet and the Post-Impressionists, exhibition
 organized by Roger Fry, incl. Cézanne, Denis,
 Derain, Gauguin, Van Gogh, Manet, Matisse,
 Picasso, Redon, Sérusier, Seurat, Signac,
 Vallotton, Vlaminck.

Selected Bibliography

There is a vast literature dealing with different aspects of the Post-Impressionist period. The list below is intended to indicate my own main sources of reference and to direct the reader to a selection of the more useful recent books, articles and exhibition catalogues. A much fuller bibliography, which includes most publications on Gauguin, Van Gogh and Seurat up to 1977, can be found in J. Rewald, *Post-Impressionism*, New York 1979.

BAEDEKER, K., *Paris and Its Environs*, London, 1881 and 1900

Belgian Art, 1880–1914, The Brooklyn Museum of Art, 1980

BODELSEN, M., *Gauguin's Ceramics*, London, 1964

BODELSEN, M., 'Gauguin the Collector', *The Burlington Magazine*, Sept. 1970

BOWNESS, A., *Gauguin*, London, 1971

CÉZANNE, P., *Letters*, ed. John Rewald, trans. Marguerite Kay, London, 1941

Cézanne: The Bathers, exh. cat., Basel, Kunstmuseum, 1989

Cézanne, The Late Work, ed. W. Rubin, The Museum of Modern Art, New York, 1977

Le Chimin de Gauguin, exh. cat., Saint-Germain-en-Laye, Musée départemental du Prieuré, 1985.

Degas, exh. cat., Paris, Grand Palais; Ottawa, National Gallery of Canada; New York, Metropolitan Museum of Art, 1988–9

DE LA FAILLE, J.B., *The Works of Vincent Van Gogh — His Paintings and Drawings*, New York, 1970

DENIS, M., *Journal, 1884–1943*, 3 vols., Paris, 1959

DENIS, M., *Théories, 1890–1910*, Paris, 1912

DORRA, H., and REWALD, J., *Seurat, L'Oeuvre Peint, Biographie et Catalogue Critique*, Paris, 1959

FÉNÉON, F., *Oeuvres Plus que Complètes*, 2 vols., Paris–Geneva, 1970

French Symbolist Painters, Arts Council of Great Britain, 1972

The Art of Paul Gauguin, exh. cat., Washington, National Gallery of Art; Chicago, Art Institute; Paris, Grand Palais, 1988–9

GAUGUIN, P., *Lettres à sa Femme et à ses Amis*, ed. M. Malingue, Paris, 1946 (English edn., London, 1949)

VAN GOGH, V., *The Complete Letters . . .* 3 vols., Greenwich, Conn., 1958

Van Gogh à Paris, exh. cat., Paris, Musée d'Orsay 1988

Van Gogh in Arles, exh. cat., New York, Metropolitan Museum of Art, 1984

Van Gogh in St Rémy and Auvers, exh. cat., New York, Metropolitan Museum of Art, 1986–7

GOLDWATER, R., *Symbolism*, New York, 1979

Le Groupe des Vingt et son Temps, Rijksmuseum Kröller-Müller, Otterlo, 1962

GUY, C., 'Le Barc de Boutteville', *L'Oeil*, April 1965

HERBERT, E., *The Artist and Social Reform: France and Belgium, 1865–1898*, New Haven, 1961

HERBERT, R., 'City vs. Country: The Rural Image in French Painting from Millet to Gauguin', *Artforum*, Feb 1970

HERBERT, R., *Seurat's Drawings*, New York, 1962

HOBBS, R., *Odilon Redon*, London.1977

HUYSMAN, J.-K., *L'Art Moderne*, Paris, 1883

HUYSMAN, J.-K., *Certains*, Paris, 1889

Japonisme in Art, An International Symposium ed. Y. Chisaburo, Tokyo, 1980

JAWORSKA, W., *Gauguin and the Pont-Aven School*, Boston, 1972

LOVGREN, S., *The Genesis of Modernism: Seurat, Gauguin, Van Gogh and French Symbolism in the 1880s*, Uppsala, 1959

MAUNER, G., *The Nabis, their History and their Art 1888–1896*, (Columbia University dissertation, 1967), New York and London, 1978

MAUS, M. O., *Trente Années de Lutte pour l'Art, 1884–1914*, Brussels, 1926

The Nabis and the Parisian Avant-Garde, exh. cat., New Brunswick, The Jane Voorhees Zimmerli Art Museum, Rutgers University, 1988–9

Neo-Impressionism, catalogue by R. Herbert, The Solomon R. Guggenheim Museum, New York, 1968

The New Painting: Impressionsim 1874–1886, exh. cat., Washington, National Gallery of Art; The Fine Arts Museums of San Francisco, 1986

ORTON, F., and POLLOCK, G., 'Les Données Bretonnantes: La Prairie de Représentation', *Art History*, Sept. 1980

PISSARRO, C., *Lettres à son Fils Lucien*, ed. J. Rewald, Paris, 1950 (English edition, New York and London, 1943)

POLLOCK, G., and ORTON, F., *Vincent Van Gogh, Artist of his Time*, Oxford, 1978

Post-Impressionism, Royal Academy of Arts, London, 1979–80

REWALD, J., *Paul Cézanne*, New York, 1948

REWALD, J., *Post-Impressionism, from Van Gogh to Gauguin*, Museum of Modern Art, New York, 1956 (revised edn., 1979)

REWALD, J., 'Theo Van Gogh, Goupil and the Impressionists', *Gazette des Beaux-Arts*, Jan.–Feb. 1973

ROOKMAAKER, H.R., *Gauguin and Nineteenth Century Art Theory*, Amsterdam, 1959 (2nd edn., 1972)

ROSKILL, M., *Van Gogh, Gauguin and the Impressionist Circle*, London, 1970

RUSSELL, J., Vuillard, London, 1971

SHIFF, R., *Cézanne and the End of Impressionism*, Chicago, 1984

SIGNAC, P., *D'Eugène Delacroix au Néo-Impressionnisme*, Paris, 1899 (new edn., ed. F. Cachin, Paris, 1964)

SIGNAC, P., 'Extraits du Journal Inédit . . . 1894–1899', ed. J. Rewald, *Gazette des Beaux-Arts*, July–Sept. 1949, April 1952, July–Aug. 1953

SIMOND, C., *Paris de 1800 à 1900, la Vie Parisienne au 19e Siècle*, 3 vols., vol. 3, 1870–1900, Paris,1901

THOMSON, B., 'Camille Pissarro and Symbolism', *The Burlington Magazine*, Jan. 1982

THOMSON, B., *Gauguin*, London,1987

THOMSON, B., *Vuillard*, Oxford, 1988

THOMSON, R., 'Camille Pissarro, *Turpitudes Sociales* and the Universal Exhibition of 1889', *Arts Magazine*, April 1982

THOMSON, R., *Seurat*, Oxford, 1985

THOMSON, R., *Toulouse-Lautrec*, London, 1977

Toulouse-Lautrec: Paintings, catalogue by C. Stuckey, The Art Institute of Chicago, 1979

VOLLARD, A., *Souvenirs d'un Marchand de Tableaux*, Paris, 1937

WELSH-OVCHAROV, B., *Vincent Van Gogh and the Birth of Cloisonnism*, Art Gallery of Ontario, 1981

WHITELEY, L., 'Accounting for Tastes', *Oxford Art Journal*, no. 2, 1979

WILDENSTEIN, D., *Claude Monet, Biographie et Catalogue Raisonné*, 3 vols., (incomplete), 1 (1840–81); 2 (1882–6); 3 (1887–98), Lausanne and Paris, 1974, 1979

WITTROCK, W., *Toulouse-Lautrec: The Complete prints*, 2 vols. London, 1895

ZELDIN, T., *France 1848–1945*, 4 vols., Oxford, 1979–80

Index